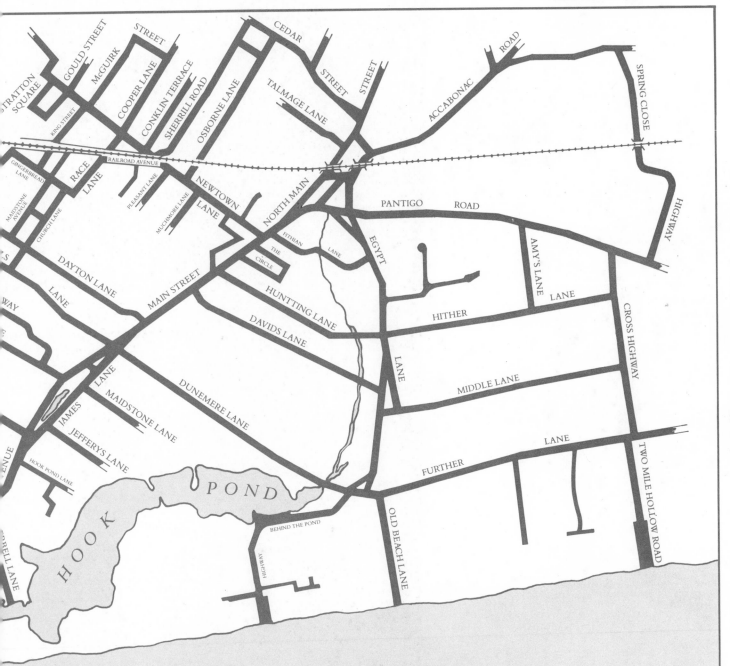

East Hampton's Heritage

An Illustrated Architectural Record

East Hampton's Heritage

An Illustrated Architectural Record

EDITED BY
Robert J. Hefner

ESSAYS BY
Clay Lancaster–Robert A.M. Stern

PHOTOGRAPHS BY
Harvey A. Weber

DESIGNED BY
Edward P. Diehl

W. W. NORTON & COMPANY

NEW YORK • LONDON

IN ASSOCIATION WITH

THE EAST HAMPTON LADIES VILLAGE IMPROVEMENT SOCIETY

Published simultaneously in Canada by George J. McLeod Limited, Toronto.

Printed in the United States of America

FIRST EDITION

The text of this book is composed in Bembo.
Manufacturing by Murray Printing Company.

W. W. Norton & Company, Inc., 500 Fifth Avenue, New York, N. Y. 10110
W. W. Norton & Company Ltd., 37 Great Russell Street, London
WC1B 3NU

ISBN 0 393 01572 6 cloth edition
ISBN 0 393 30058 7 paper edition

1 2 3 4 5 6 7 8 9 0

Contents

ACKNOWLEDGMENTS . 7

EAST HAMPTON'S EARLY ARCHITECTURE:
 1680–1860
 Clay Lancaster . 9

ONE HUNDRED YEARS OF RESORT
 ARCHITECTURE IN EAST HAMPTON:
 THE POWER OF THE PROVINCIAL
 Robert A.M. Stern . 55

INVENTORY
 Domestic Architecture 1680–1860 133
 Domestic Architecture 1860–1981 156
 Public, Religious, and Commercial Buildings 207

INDEX . 219

Acknowledgments

Many individuals and organizations have shared in the preparation of this book. Most important has been the unfailing support of the Ladies Village Improvement Society and its president, Mrs. John Kennedy. The LVIS, founded in 1895, has played a leading role in maintaining the landscape and preserving the character and beauty of East Hampton. Averill D. Geus, Chairman of the LVIS Landmarks Committee, was instrumental throughout the project. Without her persistent advocacy and hard work this book would not have been possible. We are also thankful for the support of the members of the Landmarks Committee, with a special thanks to Mrs. Frederick Owen.

We are grateful to Joan K. Davidson, president of the J.M. Kaplan Fund, Inc., and to her fellow trustees for their generous support. Mrs. Davidson's early interest and guidance throughout the project added immeasurably to this book. We are also thankful for the interest and support of the Rock Foundation, Inc. Dean F. Failey and Everett T. Rattray also gave valuable advice during the planning of this book.

The present effort of the Ladies Village Improvement Society to document East Hampton's architecture began in 1978 with an architectural survey and resulted in the nomination of twelve historic districts in the village to the National Register of Historic Places. This survey was cosponsored by the Incorporated Village of East Hampton. It was conducted by Robert Hefner and Alison Hoagland with the assistance of Clare Callaghan and Gretchen Luxenberg. The inventory section of this book is based on that survey. The inventory of early houses also incorporates the findings of Clay Lancaster's investigations, and the inventory of resort houses is informed by the research of Robert A.M. Stern. Susan Klaffky provided invaluable assistance preparing and editing the inventory section of the book.

We were fortunate to have Harvey Weber as the photographer for the book. Harvey also did most of the copy work and printed most of the glass negatives for the book. Oscar Shamamian and José Sanabria executed most of the measured drawings reproduced here.

For much of the information on the Mulford House we owe credit to Daniel M.C. Hopping, who is currently conducting an investigation of that important early house. Anne Weber has done a full set of measured drawings of the house for Mr. Hopping's study.

Some local individuals and organizations gave specially valuable assistance during the preparation of the book. The Long Island Collection of the East Hampton Free Library is one of the finest collections of local history on Long Island and was a major resource for the book. Dorothy King, the librarian, went out of her way to be of assistance. The archives of the *East Hampton Star* contain a wealth of negatives and photographs of local houses and we are grateful to Helen S. Rattray for being so generous with these as well as allowing us to examine the old volumes of the *Star* in their collection. C. Frank Dayton helped in many ways: by sharing his collection of old East Hampton photographs, by contributing his wealth of knowledge of the houses, and by generously providing office space for the editor. The East Hampton Historical Society gave us access to their collections and buildings and also provided office space for the project. Mrs. James Griffiths and Kathrine Parsons allowed us to borrow from their large collections of original architectural plans of East Hampton houses. The Griffiths Collection is now in the East Hampton Free Library.

We also wish to thank the following for providing photographs for the book: the Brooklyn Public Library; the Queens Borough Public Library; the Avery Memorial Library, Columbia University; the Suffolk County Historical Society; the New York Public Library; the Long Island Historical Society; the New York Historical Society; the Nassau County Historical Museum; the East Hampton Town Clerk's Office; The Huntting Inn; the Historic American Building Survey; the Old Print Shop, New York; Mayers and Schiff Associates, P.C.; Neski Associates, Architects; Robert A.M. Stern; Elizabeth Bogert; Elizabeth Burroughs Kelley; Averill D. Geus; Mrs. Doris Schleisner; Mr. and Mrs. William M. Donnelley; Adele Hedges Townsend; Ormand de Kay; Donald M. Halsey; Richard Wood; Aldredo de Vido; Norman Jaffe; Richard Meier; Jaquelin T. Robertson.

Robert Hefner

East Hampton's
Early Architecture:
1680–1860
Clay Lancaster

East Hampton's
Early Architecture:
1680–1860
Clay Lancaster

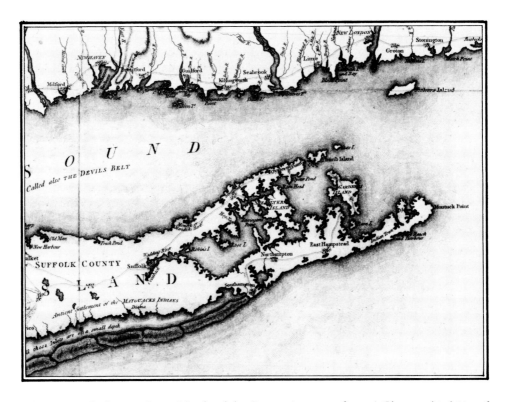

Plate 1. Detail of eastern Long Island and the Connecticut coast from *A Chorographical Map of the Province of New-York,* 1779 by Claude Joseph Sauthier. The New York Historical Society.

The Seventeenth Century

On 29 April 1648 the governors of the New Haven and Connecticut colonies purchased some 31,000 acres on Long Island from the Montauk Indians. The territory acquired was the South Fork from the east boundary of Southampton to Nether Hills, the near side of present Montauk. Payment included twenty coats, two dozen each of hoes, hatchets, knives, and looking glasses, as well as a hundred muxes, or tools used for drilling clam and periwinkle shells for making wampum.[1] In 1651, for the sum of thirty pounds, four shillings, and six pence, the two governors deeded the tract to English emigrants, some of whom had been here a decade and had established a settlement called Maidstone. The name was changed to East Hampton in 1662, two years before New Netherland surrendered to the British. New Netherland had included the west end of Long Island and although all of the island became part of New York, the eastern colonists retained their close commercial and cultural ties with New England for over a century.

The East Hampton settlers federated themselves into a proprietary, whereby they acted in unison, divided land and other resources in equal portions, and shared privileges alike. Roadways and outlying woods as well as pastures for grazing stock were owned jointly. The proprietors laid out home sites to either side of a road bordered by an oblong green or common. Beginning above the west end of Hook Pond, where a bog was dug out to become Town Pond, for watering animals, the common extended northeast-wardly about a mile. Its axis corresponded to present Main Street in the village of East Hampton (Plate 2).

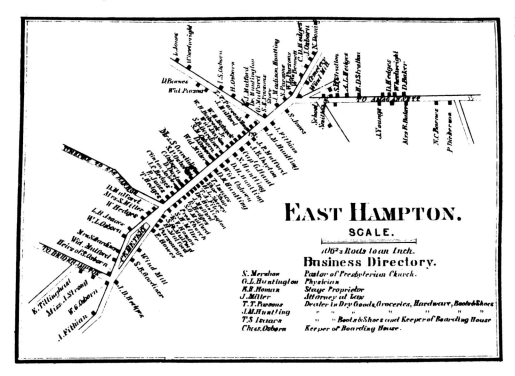

Plate 2. The original settlement pattern of East Hampton remained distinct when this map was published in 1858. Detail from a *Map of Suffolk Co., L.I., New York*, 1858 by J. Chace, Jr. Courtesy of the Suffolk County Historical Society.

Fences were erected to prevent one man's livestock from damaging another's property. One type of fence was made of "logg" or upright poles called "palasadas," another was the zigzag type called "worme," and lastly there were "rayle" fences. Rail fences at least forty-six inches high and with no more than five inches between the three lower rails were declared standard in 1655. Four years later, each man was required to set his initials on the inside of the post at each end of his fence to facilitate enforcing penalties should he allow the fence to deteriorate.

The settlers had erected shelters for themselves first thing after their arrival. The earliest record of constructing a community building dates from 1656, and it was for a meeting house to serve both secular and religious gatherings.[2] The building was to be "26 foote longe, 20 foot broade and 8 foote stoode" or tall. It was to have a thatch roof and be enclosed by a fence. Building expenses were defrayed by tithes set in proportion to the value of holdings belonging to the community's twenty-seven yeomen. The first meeting house is thought to have stood east of the burying ground adjoining Town Pond at the end of the common. It was enlarged in 1682 by the addition of a gallery, which probably necessitated the raising of the roof, as there was installed new "sideing up the Gable End." The town records list sums paid for such materials as "bords," "nayles," and glass, and remuneration to carpenters. The meeting house again was repaired in October of 1696.

Two years later, on 23 May 1698, the question was raised whether to repair or build a new meeting house. The first vote was in favor of rebuilding, but at the next session the decision was reversed and refurbishing the old building carried. But the extent of the repair work amounted to fabricating a virtually new building. Thatching was replaced by wood shingles on the roof, and the forging of a wrought-iron vane implies that there was a superstructure or steeple on which it was mounted.

Mills for grinding the townspeople's grain were a necessity. The earliest were sponsored by the proprietors. In late November of 1653 they contracted with Vinson Meigs to replace their ox-powered grist mill with a tide mill to be built on "the Creeke yt [that] runes Down into our harbor." The citizens agreed to furnish and move structural timbers and millstones to the mill site, pay Meigs fifty pounds in four installments, and let him have twenty acres of adjoining land. Meigs was to keep the mill in working order and grind the communitarians' grain without additional charge. If he contemplated selling the mill, the town was to have the first refusal on its purchase. There are references during the 1660s of expenditures for repairs and rules for the use of mills, as the people ground their own corn and wheat. Whether tide or wind mills is not stated, but whichever they were, they had disappeared by the summer of 1678, when twenty-five persons banded together to erect a horse mill to "suply of our families with meale."

The next community building was ordered on 23 May 1654, when it was recorded that the house that "stands in the Comon agst Joshua Galickes shalbe brought to some Convenient place in the midel of the towne for a prison." This may have been a hut built for shepherds or cowherds. The transplanted building probably was used mostly for brief incarceration of criminals pending trial or execution of their sentences, as confinement meant the expense of

their board. It was replaced in 1698, when sixteen pounds were paid to William Schellinx for building and furnishing a new prison.

In November of 1654, it was agreed that Thomas Baker would use his house for an inn or tavern. Having previously been chosen as the place for religious meetings, the building must have been among the more ample at East Hampton. By custom there was but one hostel in each town for the reception of strangers, and Baker's served East Hampton many years. The house stood directly opposite present St. Luke's Church on Main Street.

The first recorded school here was held in 1655 at Samuel Parson's house. By 1682 a special building had been set aside for a schoolhouse, as the town paid five shillings for "puting up ye Schoolhouse windo," six shillings and six pence for "bords," and three shillings for a pane of glass.

A town house was built during the last year of the seventeenth century. That its construction occurred a year after the renovation of the meeting house signifies a step forward in the separation of church and state. The Reverend Thomas James had apparently reflected the sentiments of his flock by combining the two in his sermons and practices, which were declared seditious to the Crown. One assumes that the old meeting house and new town house were on common land and close to one another, constituting the religious and temporal nucleus of the community.

By 1687 East Hampton had grown to the point where it elected twelve trustees to manage town affairs, reserving the calling of general meetings for special decisions. At this time the population count stood at 502, of which 25 were slaves. Because of the large size of the lots (many of them ten acres or more), houses were widely spaced. Most faced south, rather than toward the road, so that as yet there was no conventional village pattern. However, dwellings had advanced over the first primitive shelters, and there was community control over possible fire hazards. In 1656 two inspectors had been appointed to see that chimneys "be well Daubed & kept cleare of swepinge," and henceforth repaired or newly built chimneys had to be "catted." Cats were rolls of mud bound with straw, which were packed in a timber framework to form the flue. It was fireproof only until the mud dried out and crumbled. Such a chimney was on the outside wall of the house.

By the fourth quarter of the seventeenth century substantial frame residences were built; they were multistoried, with access to the various levels provided by developed stairways, and a number of rooms had fireplaces to a central masonry chimney. Such "English houses" were constructed by specialized joiners, carpenters, masons, plasterers, and glazers. The house frame consisted of posts at the corners of the building and principal room divisions. They were set on horizontal sills, in turn resting on masonry foundations, and they supported girts and beams on which joists were laid, and plates that carried the roof timbers. The framework determined the building form, and its members were heavy and cumbersome. They were cut out and partly assembled on the ground, and their raising was a community project. Young and old gathered together with slender poles to assist in elevating the various sections in sequence, with apprentices stationed on top to drive in the pins that locked the mortice-and-tenon joints together. The professional builders who had fashioned the framework then laid the floors and covered the walls with

clapboards and the roof with shingles. By this time the walls were sometimes shingled, a device introduced by the Dutch or Belgians at the far end of Long Island and first adopted by the English in Connecticut. Interior batten or plastered lath-on-stud walls, and enclosed or open stairways were built within.

Such a house was that of the Reverend Nathaniel Huntting, who succeeded Mr. James after his death in 1696. Early in 1698, the town voted to build a house for Mr. Huntting, but facts pertaining to its construction are obscure. The building stands on the south corner of Main Street and present Huntting Lane. Old photographs show that it was two-and-a-half-storied, its facade was three-bayed, and it had a center door (Plate 3; I-2).★ The house had a central chimney and a lean-to at the rear that changed to a lower roof pitch and was presumably a later addition. The inner framing is partly intact in the first- and second-story rooms to the east of the original chimney, both with a summer beam running crosswise with chamfered lower edges. Here also are several chamfered posts with bracket capitals, the one existing in the old parlor having four rows of articulated beads in the head (Plate 4). That in the chamber above is simpler. Chamfers in the summer beams run to the plates and have a rounded center molding. Chamfers on plates and posts are flat and are stopped by lamb's-tongue returns to the square form a few inches short of the timbers' convergence. East Hampton's second minister officiated for half a century, and his family occupied the house for nine generations. The building was later enlarged to become the south pavilion of present Huntting Inn.

Plate 4. Nathaniel Huntting House. Detail of post in parlor. Photograph by Harvey A. Weber.

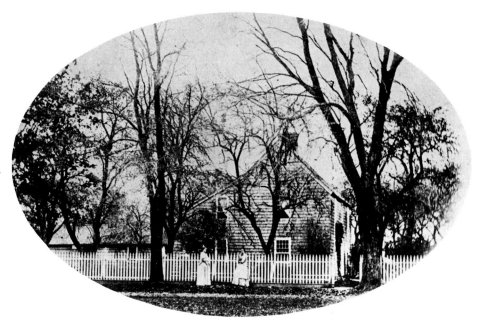

Plate 3. Nathaniel Huntting House, 94 Main Street, ca. 1699, with eighteenth-century lean-to addition. Courtesy of the Huntting Inn.

★Reference I refers to Inventory entries at the back of this volume.

14

A post with bracket capital similar to that in the Huntting house is under the summer beam in the west room of the Mulford–Huntting house. The building originally stood on the east side of Main Street and now is on Hither Lane. Here the summer beam is transverse, rather than crosswise, which is characteristic of Massachusetts houses.[3]

The best example of a seventeenth-century, English type in East Hampton is the Mulford house (Plates 5,6; I-1), next north of Home, Sweet Home on James Lane near its junction with Main Street. The building has been considerably altered, including the addition of a lean-to at the rear and rebuilding of the east section. It has been suggested that the latter was necessitated because of damage wrought by a hurricane early in the eighteenth century.

Captain Josiah Hobart acquired the property in 1676, and probably it was he who then built the dwelling.[4] It was a double house or one having rooms on both sides of the chimney. It measured approximately twenty-one by forty-one feet in plan and contained two full stories and garret. Its sills were set on stones but remained close to the ground. Outer walls would have been covered with clapboards, which at that time would have been exposed to the weather from three to five inches and were overlapped at the corners of the building. Those remaining on the west flank are considerably wider, have a bead along the lower edge, and abut vertical corner boards, which are later characteristics The front wall contained a batten door, to right and left of which were leaded casement windows of three lights with transoms, repeated directly above, and there were smaller windows over the door and in twin gables at garret level. Openings in the south facade were a source of solar heat

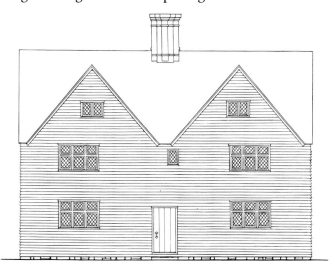

Plate 5. Front elevation of the Mulford House, 12 James Lane, conjectural restoration, seventeenth century. Drawn by Clay Lancaster from a drawing by Anne Weber.

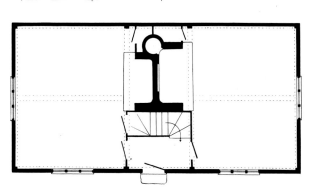

Plate 6. Mulford House. Plan of the first floor, conjectural restoration. Drawn by Clay Lancaster from a plan by Anne Weber.

to rooms in early homes. The fenestration may have had either small rectangular or lozenge-shaped panes of glass.

The layout of the Mulford house is normal for its period, resembling that archetypal example, the Fairbanks house (*ca.* 1638) at Dedham, Massachusetts.[5] The East Hampton building is about a fourth larger, and summer

beams run crosswise in the first story and west room above. The front door opens into what in the seventeenth century was called a porch. Rather than the present obvious replacement, the Mulford house probably had an enclosed stairway with winders or wedge-shaped steps at base and summit, as in the Fairbanks house. The hall, or general living room, was to the east, and the slightly larger parlor to the west. The fireplace wall in the latter has characteristic molded vertical sheathing of the period, with grooves that continue uninterruptedly down the doors. They are hung on narrow wrought-iron strap hinges with cusped ends, some mounted on surface upright pintles of similar shape, and one on sunken pintles. The present mantel enframes a closed-in fireplace, replacing a larger original. The fireplace back of it in the hall probably was bigger and may have included an oven in the rear corner. The chimney girt in the parlor has short chamfers with lamb's-tongue cuttings near either end, as has that in the chamber above. Attached summer beams, other girts, plates, and posts display the usual long cuts.

The Mulford house garret presents some of its most interesting and revealing features. It is reached by a rebuilt staircase whose first flight rises behind a door centered on the inner side of the second-story passage over the porch; from a square landing, steps branch east and west to the third floor. Old rafters, in the west end, are spaced seven feet nine inches apart and support four purlins front and rear, to which sheathing boards parallel to the rafters are nailed. Collar beams connect each pair of rafters five and a half feet from the floor. A unique refinement is chamfers with lamb's tongues cut into the under edges of the lower section of the rafters and collar beams. The latter have had about six inches deleted from their south ends, which have been reset or newly fastened to the front rafters, indicating that the whole roof structure has been lowered in pitch. Simultaneous with this change the front gables would have been removed, and probably the lean-to was added then as well. The contour of the west front gable can be seen in later nailing boards filling a triangular space in the front roof plane. Only a short section at the near base can be seen of its companion. The east end of the roof has been rebuilt in a different manner. The force of the storm that necessitated this change is indicated by damage to the outer side of the mortise in the rear rafter east of the chimney, where the collar beam was wrenched from its socket. The Mulford house has the only seventeenth-century roof of rafter-and-purlin construction that has come to light in East Hampton.

Josiah Hobart died in 1711, and his executors sold the property to Samuel Mulford the following year. The Mulfords continued to live here until World War II, and their name generally is associated with the building. It was acquired by the East Hampton Historical Society in 1948.

The Early Eighteenth Century

The important public-building enterprise of the early eighteenth century was the new meeting house. It was proposed at the town meeting held on 22 November 1715, and the diary of the Reverend Nathaniel Huntting furnishes us with the information that he baptized the first child in the building on 25 May 1718.[6] It stood on the east side of Main Street, three doors above the Mulford house and nearly opposite the site of Clinton Academy. Its framing timbers were cut on Gardiner's Island and were the contribution of the proprietor of that estate. For this generosity the church provided him with a pew for himself and his assigns.

In the absence of the actual building and with the earliest written description dating from the 1880s after successive renovations, our knowledge of the original form is largely conjectural. It was a meeting-house type with an entrance at the center of the five-bayed, south front. Windows were in two tiers, indicating an upper gallery, and containing double sashes of fifteen panes each.[7] The building probably was gable-ended. At a town meeting on 20 August 1719 it was agreed that "the pews in the meeting house shall be seated with men at the west end, and with women at the East end of the house." Nine months later Samuel Gardiner was given leave to "make a pew . . . at or on the foot of the East gallery stairs," suggesting twin staircases to the left and right of the building.[8] The pulpit must have been centered on the north wall, opposite the doorway.

Fifteen years later the building was greatly enlarged and acquired an Anglican church form. It now faced west. Its entrance was at the base of a new tower centered on the street facade. There were arched openings in the belfry and a hexagonal steeple surmounted by a red-cedar spire. This was topped by an iron pole bearing a copper vane with cutout numbers signifying the years of the town's settlement and building's erection: *1649/1717* (Plate 8). A square-faced clock, set on the diagonal under the west belfry opening, displayed the date 1735, which may have applied to the tower as well as the clock itself. The walls must have remained unpainted in the eighteenth century, as the only record regarding the subject is limited to the trim.

The west corners of the old building were projected forward to accommodate stairways accessible from the entrance vestibule in the tower, ascending to the galleries. The church measured forty-five by eighty feet, of which latter dimension about fifteen feet constituted the front addition. Benches were shifted to face the new pulpit location in the east end. There was still a separation of the sexes. The women must have had difficulty seeing, for on 4 January 1769 the Trustees agreed to cut the seat backs lower, and on 7 August 1770 they appointed David Baker to "engage joyners to raise the floor" in the female section. In April 1799 the Trustees decided to have "upper Galeries put up with Banisters," probably for Negroes, who had occupied "ye Second Gallery on west side" in the original building.[9]

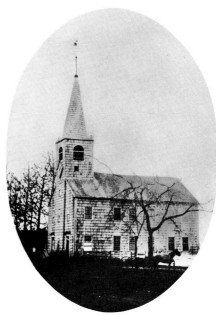

Plate 7. Presbyterian Meeting House, Main Street, 1717, enlarged in 1735 and altered in 1822. Demolished 1871. Courtesy of the East Hampton Historical Society.

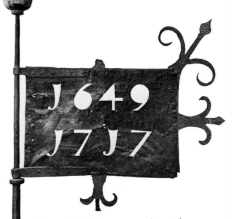

Plate 8. Weather vane from the Presbyterian Meeting House. Photograph by Joseph Adams. Courtesy of the East Hampton Historical Society.

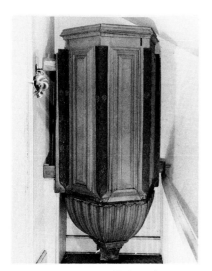

Plate 9. Pulpit installed in the Presbyterian Meeting House in the mid-eighteenth century. Photograph by Joseph Adams. Courtesy of the East Hampton Historical Society.

The metal vane and wood face of the clock are now in the Clinton Academy Museum. Also in this collection are two pulpits that had been in the building. The earlier is compact, consisting of a hollow prism, with a bolection-framed panel on each face, and a narrow carved board on each corner ornamented with tri-lobed leaves and berry clusters in low relief, painted dark gray and red (Plate 9). The polygon rises from an inverted dome-shape of scallop-shell treatment, springing from a complex bracket, the lower members of which include additional floral motifs. The flatish carving is reminiscent of mid-eighteenth-century work in the Connecticut Valley, and it has been suggested that this pulpit dates from the regime of Dr. Samuel Buell, a native of Coventry, Connecticut, who was ordained in East Hampton on 29 August 1759 and was minister for fifty-two years. The pulpit must have had stairs to either side and a sounding board over it.

The meeting house was remodeled in 1822 (Plate 7). At this time, the door in the tower was exchanged for a mismatched window, and entrances were opened in the west walls to either side. The congregation thereafter entered the building alongside the gallery stairways. The old vestibule was provided with seating for Negroes. Two aisles led to the later pulpit, which, like the galleries, was supported on round columns. It was wider than its predecessor, having a paneled breakfront of convex and concave shapes. It originally was more elaborate than at present, as in 1836 the Trustees "sold the old trimmings of the pulpit to David Sherry for one dollar."[10] The pulpit had stairs at either end, between which was the deacons' seat, with the communion table in front. Narrow seats interlaying the two aisles were divided down the center. They were called slips and were entered from the aisle side. Pews to the left and right remained unchanged. There was still a vision problem; on 6 April 1830 the Trustees authorized the raising of the back seats in the gallery, allowing those occupying them "an easy view of the person speaking." The building had whitewashed walls inside, and its exterior was painted in 1832 at a cost of some $180. It was underpinned with stone in 1835. The record of this work was the last time the Trustees referred to the building as a meeting house. It was a "church" when a stove was installed in 1837, and it remained so when a new stove was added and a chimney erected the following year. Springs were put in the formerly stationary upper window sashes so that they could be lowered in 1845.[11] The form of worship had changed from Puritanism to Calvinism to Presbyterianism, and it was as the Presbyterian Church that the structure was razed in 1871.

A decade after the meeting house was first finished and a few years before its enlargement, a new town house was built (Plate 10; I-218). It was proposed at a meeting of the community on 8 January 1730, "ye dimentions of sd hows to be Eighteen feet square and seven and a half betwen Joynts," that is, in height, from floor to ceiling joists. It was to be financed by a tax of "three penc pr ye pound according to ye Estimate made by ye Assessors." A week later it was agreed that the town house be located next to the "publique pound," presumably on the common at the north end of Main Street. It henceforth was referred to as the school house, indicating its daytime use. Toward the close of the eighteenth century the building was moved down Main Street to a site opposite the cemetery, where it served as a district school, public hall and church. It was taken back near its original site, behind the Methodist Church,

Plate 10. Town House, 149 Main Street, 1731–33. This photograph was taken when the town house stood in front of the Jeremiah Miller house (I-29) at 117 Main Street. Photograph by Mary Buell Hedges. Courtesy of Adele Hedges Townsend.

in 1901, and to its present situation, just north of Clinton Academy, when it was acquired by the East Hampton Historical Society in 1958.

On 23 January 1715 John Stratton sold Samuel Dayton four acres of land on the north side of Pantigo Road a hundred yards beyond the sheep pound. Whether the small, one-and-three-quarters-storied "English-type" house now on the property was built before or after this transaction cannot be determined (I-4). The room west of the entrance contains chamfered posts and beams, with lamb's-tongue stops, and the post supporting the north end of the transverse summer beam has a bracket head, a bit plainer than those in the chamber of the Huntting house. This seventeenth century feature, in such a simple house, is probably an archaism. The stairway has been changed, occupying a good deal of the former chimney area, and the roof was heightened and then brought down in back as a lean-to, part of which has been removed.

The lean-to house, in modern times known as the *saltbox* was in existence in New England as a newly built type as early as the 1680s and perhaps lean-tos were added to preexisting English houses before this.[12] The saltbox belongs properly to the first half of the eighteenth century, especially in remote communities like East Hampton. Lean-tos seem to have originated as one- or one-and-a-half-storied extensions to earlier buildings. The lean-to proper doubled the area of the first story. It housed a kitchen with a fireplace and an oven, a buttery, a pantry, and one or two small chambers. The triangular space above afforded additional chambers at the outer side(s) with storage space adjoining. The two levels at the back were connected by a steep, straight stairway, usually ascending toward the front of the house for head room at the upper level. Having a separate kitchen, which eliminated cooking from the hall, the lean-to allowed more gracious living than the English-type house permitted. The cellar, formerly away from the residence, now was usually located beneath part of the lean-to, and it could be reached by steps under the rear stairway, with outside access as well.

Elements of the lean-tos showed new refinements. Clapboards ended against vertical corner-boards rather than abutting one another. Facade gables disappeared. Windows changed from leaded casements to wood-muntin sashes with rectangular panes. The front cornice acquired substantial eaves, and in East Hampton it was carried on a plastered cove of a foot radius, with a base molding and a cornice. The principal stairway changed from enclosed to open. Awkward winder steps were replaced by straight flights, accompanied by newel posts and handrails, and later included banisters. Restrictions against cutting great timbers from public lands indicate the approaching depletion of virgin forests near settlements, and the larger structural members began to diminish or disappear.[13] Ample summer beams gave way to less carefully shaped joists that ran from girt to girt, to whose undersides were nailed laths that were coated with plaster. Rafters were reduced in size and drawn closer together, to within from five to three feet, and substantial purlins vanished.[14] Posts continued to protrude in the corners of the rooms, and those horizontal members that remained exposed were embellished with a small round bead along edges formerly chamfered. Fireplaces in the front rooms became smaller, allowing more space for the large one in the kitchen. In some cases the inside walls of front rooms angled out for this purpose. Noncooking fireplaces (and even some for cooking) tended to have splayed sides because they fit together more readily and threw out heat more efficiently. Many had a crane to hold a kettle for brewing tea in the parlor or bedroom. Inner walls continued to be sheathed in vertical boards, variously cut to be fitted together by overlapping, tongue-and-groove, or feather edge. Horizontal flush boards were used as dado up to windowsill level. The lean-to era saw the development of paneled (in place of batten) doors, and paneled walls, reaching an apex at midcentury. Hardware remained essentially the same as in the sixteen hundreds, though tending toward simpler shapes.

More than a fourth of East Hampton's surviving houses that predate the middle of the nineteenth century are lean-tos. About half of these were subsequently moved, and of those in which the frame has remained intact, many of the original features have been obliterated.

Three of the town's best examples of lean-tos were located on the west side of North Main Street beyond the present Long Island Railroad overpass. The first stood on the near corner of Cedar Street and is thought to have been built in 1715. By the end of the eighteenth century it belonged to Nathaniel Dominy (1737–1812), first of three generations of fine craftsmen of clocks and furniture to occupy the premises (Plates 11,12). The house originally was a minimum or "single" lean-to house and consisted of a porch with staircase in front of the chimney, a parlor to the south, and a kitchen behind the chimney. A small chamber and milkroom were located beyond a back stairway in the southwest corner. A single bedroom and garret were above. This house was *doubled,* or made bilterally symmetrical around the chimney, by an addition on the north end. The space where a front stairway had been was used for the early Dominy clock shop. A new detached or semidetached clock shop must have been constructed soon afterward. The northwest corner of the house later was extended for a carpentry shop. Stairs had not been replaced in front of the chimney when the building was demolished in 1946.[15] A cellar was under the southwest corner of the house.

Plate 11. Dominy House, North Main Street, ca. 1715. Demolished 1946. The left half of the house is the original structure. Photograph by the Historic American Building Survey, 1940.

Plate 12. Dominy House. Plan of the first floor, conjectural restoration. Drawn by Clay Lancaster from a plan by Daniel M.C. Hopping for the Historic American Building Survey, 1940.

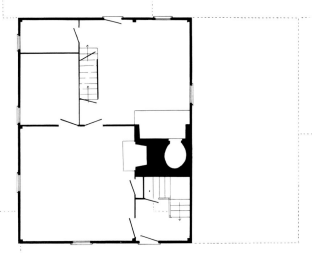

The old dwelling next south of the Dominy complex, the Jonathan Osborn house (Plate 14, I-16), was remarkably like the original part of the Dominy house, only it had a one-storied, shed-roofed addition on the north side. This was virtually a continuation of the rear lean-to brought around the corner and along the flank. Its attachment next to the chimney end permitted a fireplace in the principal room of the new section. The house was unusual among local single lean-tos in having two front windows in the parlor and parlor chamber. A cradle board, or wood sheathing in the lower part of the wall to the rear of the parlor fireplace, prevented denting from the sharp rockers of a cradle. The Jonathan Osborn house was moved to 9 Mill Hill Lane in 1926.

The third example in this alignment, still standing at 91 North Main Street near Talmage Lane, is the Isaac Hedges house (Plate 13, I-6), said to date from 1739. It was built as a double house and was about equal to the Dominy house after the latter was enlarged. An unusual feature is the angling out of the inner walls in the two front rooms to provide for a sufficiently large fireplace in the kitchen, a trait also used in the William Barnes house at 48 Egypt Lane. The fireplace wall in the parlor is paneled. The mantel is plain, consisting of a molded frame; the opening is topped by a shallow shelf. The fireplace in the north room has a deep plain frieze above, with advanced blocks at the ends, and a more ample shelf, which is a prevalent later-eighteenth-century type in East Hampton. In the end blocks of this mantel are small flat-headed brass knobs, such as are found on most mantels of this period in Nantucket houses, for hanging objects. Both fireplaces in the lower front rooms of the Isaac Hedges house contain cranes. The porch stairway has been changed, the facade altered from three to five bays, and additions have been made at the rear.

The Samuel Hutchinson house (I-12), which stood a hundred yards past the Stratton–Dayton house on Pantigo Road, is very much like the Dominy house and it too was doubled in size. It was moved to Further Lane in 1949. The Joseph Osborn house (I-15), once sited at the bend on the west side of Ocean Avenue between Woods and Pudding Hill lanes, was a single type whose plan is an inversion of the others discussed. It was moved to Pudding Hill Lane in 1888.

Plate 13. Isaac Hedges House, 61 North Main Street, early-to-mid-eighteenth century. Courtesy of the East Hampton Star.

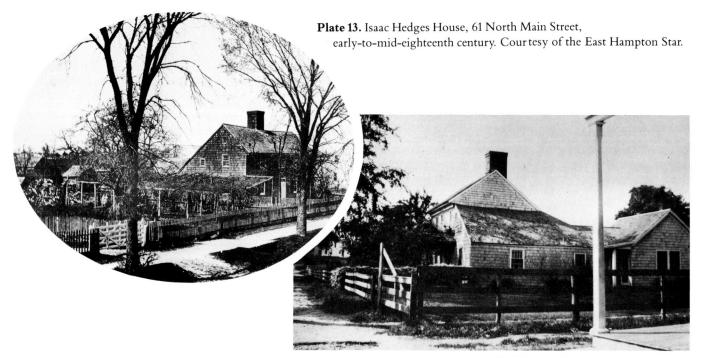

Plate 14. Jonathan Osborn House, 9 Mill Hill Lane, early-to-mid-eighteenth century. The Osborn House is shown here at its original location on North Main Street. It was moved to Mill Hill Lane in 1926. Photograph by Eugene L. Armbruster, 1923. Courtesy of the Queens Borough Public Library.

On Main Street facing Town Pond is the Isaac W. Miller house, which remains a single lean-to (Plates 15, 16; I-14). It retains an attractive front staircase around a squarish well. The closed stringer is boldly molded, and handrails interlay square posts, without banisters. The building was renovated-restored by New York architect Aymar Embury II for his own summer home in 1929. He had the angle in the north wall of the parlor straightened, reversed the direction of the back stairway, and made other changes. During the 1929 remodeling a fireplace was found in the north face of the chimney to serve an addition that was never built.[16] One wonders how often such unrealized "doubling" was thus anticipated.

Although the two specimens of double lean-tos discussed have remained in place, a good many have been shifted about. The "Osborne Office" at 135 A Main Street was moved back on its lot at the end of the nineteenth century. The Osborn house, known locally as "Rowdy Hall" (I-10) for its connection with early artists who boarded there, was once on the east side of Main Street south of the Presbyterian Church. It was transported to Gay Lane and then to the south corner of Davids Lane and Egypt Lane, where it now stands. The David Fithian house (I-19), which stood on the east side of Main Street facing Newtown Lane, was hauled back and turned to face northward on Fithian Lane in 1919. The William H. Babcock house (I-9), originally sited on Main Street south of the present White's pharmacy, was relocated on Middle Lane in 1964.

Among those on their original sites is the William Barnes house (I-7) at 48 Egypt Lane, earlier compared to the Isaac Hedges house. It is believed to have been built about 1722. The building was altered by Ruger Donoho after 1904

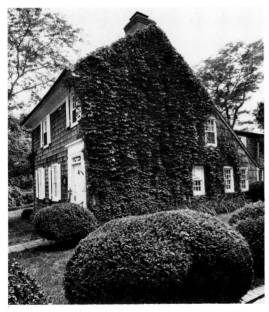

Plate 15. Isaac W. Miller House, 223 Main Street, early eighteenth century. Photograph by Harvey A. Weber.

Plate 16. Isaac W. Miller House. Stairway. Photograph by Harvey A. Weber.

and sold to his friend and fellow artist, Childe Hassam, who made it his summer home and studio. Although the fireplaces were left intact in the great chimney, the stairway was removed and the porch opened up to the adjoining front rooms. Partitions in the lean-to proper were taken out, and a free-standing open staircase of several flights was installed in the south end. An open porch on the left flank, and a gambrel-roofed ell in back equal to the original house in size, were added.

One of the contestants in East Hampton for the honor of having inspired John Howard Payne's nostalgic song, "Home, Sweet Home," is the lean-to at 135 A Main Street (Plates 17, 18; I-8), known as the "Osborne Office." William Payne, father of the poet, lived here when he taught at Clinton Academy, beginning in 1785. Although John Howard was born six years later, essayists and artists of the late nineteenth century wrote about, drew and painted the building as the source of inspiration for the song. It resembled the Isaac Hedges house on North Main Street in having a three-bayed facade and similar interior arrangement. The upper windows are smaller than those below having six- as opposed to twelve-paned sashes. Resembling the Mulford house, this building has enclosed garret stairs ascending from the center of the hall over the porch and split in two flights, left and right. The kitchen fireplace protruded into the room in primitive simplicity, and it featured a trammel suspended from a slide bar to hang the pots over the fire. In 1898 owner Joseph S. Osborne had the building moved back from the street for use as his office. Only the south parlor fireplace was included in the rebuilt chimney. The house contains a treasury of early wrought-iron hardware

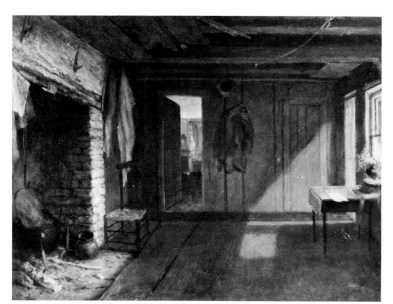

Plate 17. Osborne Office. Kitchen. Painting by J.M. Falconer, ca. 1880. Courtesy of the Old Print Shop, New York.

Plate 18. Osborne Office, 135A Main Street, early-to-mid-eighteenth century. Photograph by H.K. Averill, Jr., 1880. Courtesy of C. Frank Dayton.

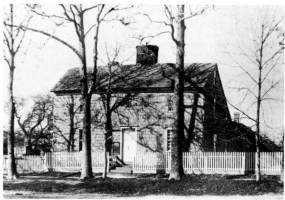

(Plate 19). There are strap hinges with cusp or spiral ends, surface-mounted or hinged pintles, butterfly and turnip-ended H hinges, cusped Suffolk thumb latches, and a goose-headed hook with twisted shaft.

The second contestant for the subject of "Home, Sweet Home" is the house at 14 James Lane (Plate 20, I-5), where Sarah Isaacs lived before she married William Payne. Payne had moved to New York City in 1790 and it is not certain whether Sarah accompanied him or stayed at her family's home until John Howard was born. In any event, the lyricist would have known the building well. It is the most distinguished lean-to in East Hampton. During the early years of the twentieth century, it was owned by Gustav Buek, who assembled a fabulous collection of early Americana, including the earliest authenticated chest made in New England. The property is now a museum and is owned by the Incorporated Village of East Hampton. Standing just south of the Mulford house, it would seem to date from the second decade of the 1700s with paneling installed in the parlor at midcentury. The building is not strictly symmetrical; rooms on the west side are five feet broader than those on the east. The lower story of the facade is four bayed, with two windows to the parlor, a single window above them, making the second story three bayed. Major upper windows have eight-over-twelve-paned sashes, as against twelve-over-twelve below. The front door opens out, which in lean-to houses is usually the case when centered in the porch (as here); when set to one side (as in the Dominy house plan), the door opens in. Crowning the front is a plastered cove. A hatch stairs to the cellar under the southeast corner of the house, now in front, was originally on the flank. The lean-to roof comes down to a low ceiling line at the back, a fraction over seven feet inside.

The staircase is exceptionally attractive (Plate 21). It rises around a square open well in three flights of four steps each. Molded, closed stringers interlay plain newel posts with turned pendants. Finials on the posts are new, except for the baluster-shaped newel at the base. Slender turned banisters (some replaced) support a shaped handrail. From the upper passage a similar flight ascends to a boxed-in continuation to the garret, so arranged that the batten door to this enclosure may open out without obstructing the entrance to the east chamber. There is evidence that banisters were once exposed to the garret. All members are mortise-and-tenoned together and fastened with pins. Side walls are the inner faces of paneling in the adjoining rooms.

The near wall in the hall or dining room to the east is sheathed in vertical boards and a section of more advanced paneling lies beyond. Both types are feather-edged together. Other walls, between posts, girts, and washboard (baseboard), are plastered. Vertical battens continue into the rear part of the house as partitions between small chambers and back stairs, and horizontal boards of irregular widths, with beaded edges, are on outer walls.

The present cooking fireplace in the kitchen was installed early in this century. Its face is flush with the side of the enclosed stairway adjoining, and there is an oven at the front, on the left, in the manner of fireplaces of around 1800. An oil painting by J.M. Falconer, dated 1880, shows the old fireplace as set back, its oven at the rear, and with a press on the far side (Plate 22). This one can be accepted as the proper type for the house, and it probably was the original.

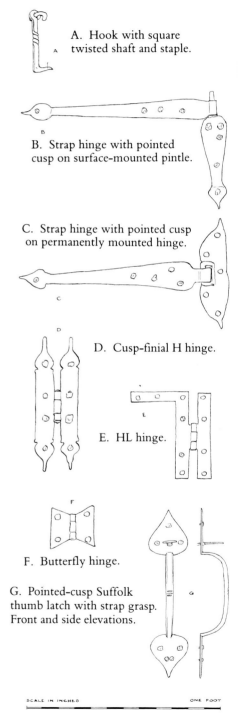

Plate 19. Osborne Office. Sketch of eighteenth-century wrought-iron hardware. Drawn by Clay Lancaster.

A. Hook with square twisted shaft and staple.

B. Strap hinge with pointed cusp on surface-mounted pintle.

C. Strap hinge with pointed cusp on permanently mounted hinge.

D. Cusp-finial H hinge.

E. HL hinge.

F. Butterfly hinge.

G. Pointed-cusp Suffolk thumb latch with strap grasp. Front and side elevations.

SCALE IN INCHES ONE FOOT

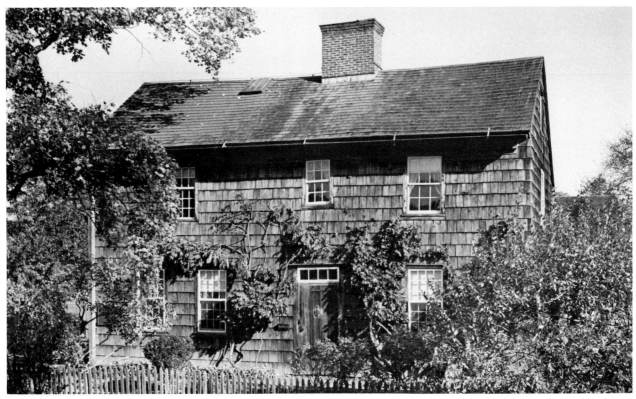

Plate 20. Home, Sweet Home, 14 James Lane, early-to-mid-eighteenth century. Photograph by Harvey A. Weber.

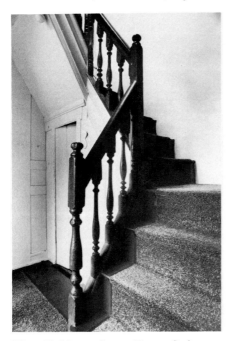

Plate 21. Home, Sweet Home, Stairway. Photograph by Harvey A. Weber.

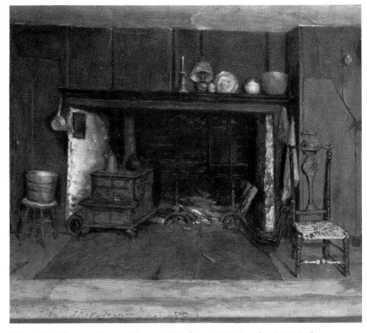

Plate 22. Home, Sweet Home, Kitchen. Painting by J.M. Falconer, 1880. Courtesy of the Old Print Shop, New York.

Esthetically rewarding is the woodwork in the parlor (Plate 23). It combines fluted pilasters and arched panels of a type proper to the Connecticut River Valley around the middle of the eighteenth century. The east wall is completely covered, except for the chimney opening, and it is unified by the procession of pilaster shafts that become subtly farther apart outward from the fireplace focus; their summits create a rhythmic breakfront of the cornice. The pair of pilasters over the fireplace are narrower and shorter. Horizontal panels in each bay are level with the top of the exposed brickwork, and they carry across the near side of the north wall as far as the centered twin doors. Plastered above, this dado section serves as a cradle board. Pilasters flank the pair of doors and each of the three windows in the room. In the northwest corner is a built-in cupboard, featuring a shell-topped niche with arched glass doors, and containing three butterfly shelves for displaying china. Pilasters matching those elsewhere are to either side, and a miniscule pair and cornice enframe a paneled door to a storage space below. A fluted keystone over the arch prompts a projection to the cornice, responding to that over the pilasters.

The parlor chamber on the second floor has a wall of rectangular panels (Plate 24). They are long and narrow over the fireplace, and tall and two-tiered to left and right. The unusually wide feather edge (one and three-fourths to

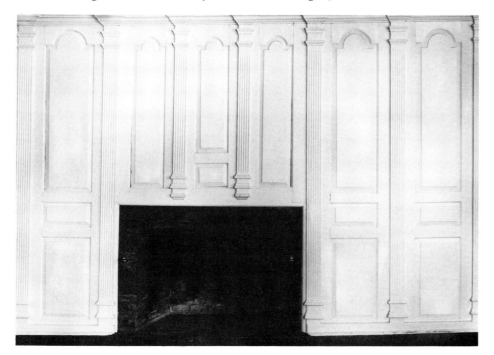

Plate 23. Home, Sweet Home, West Parlor.
Photograph by Harvey A. Weber.

Plate 24. Home, Sweet Home, west parlor chamber.
Photograph by Harvey A. Weber.

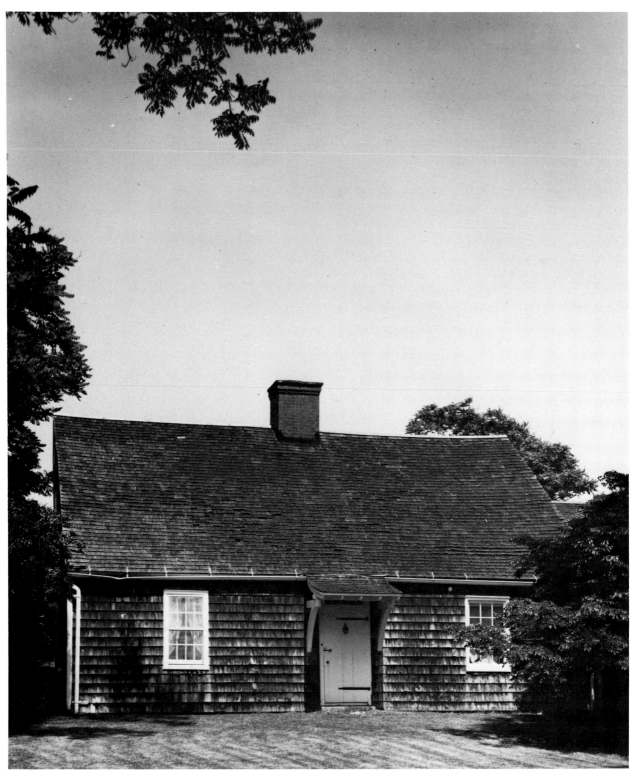

Plate 25. Miller House, Apaquoque Road, mid-eighteenth century. Photograph by Harvey A. Weber.

two inches) surrounded by surface-mounted moldings is a characteristic of early articulated paneling, contemporary with the vertical sheathing in the lower rooms. Here in the upper chamber the chimney opening is encompassed by a bolection molding, as is the slightly projecting hearth of bricks laid above floor level. As is common to second-story rooms in lean-to houses, corner posts flare out toward the top to provide a wider bearing surface for the plates.

Doors throughout the house are hung on H and H–L hinges and are equipped with Suffolk latches. The door between dining room and kitchen has circular plates to the thumb latch, and a trefoil-ended lift latch. The door between parlor and kitchen has a crescent-shaped pintle plate.

A unique lean-to in East Hampton is the four-bayed Noah Barnes house (I-17) on Georgica Road built about 1741. The front of the Barnes house is less than two-storied and lacks upstairs windows except in the flanks, a type which can be found in New England. Also unusual for a lean-to is the summer beam in the west room. The old cellar, under the southeast corner of the house, is enlarged to a full basement.

Small, one-storied houses, such as the "shelter for the keepers...of Cattell" at Montauk, ordered built in 1663, developed into what are referred to today as "Cape Cod cottages."[17] Story-and-a-half Capes and two-storied-at-the-front lean-tos differ considerably in appearance yet have a remarkable organic similarity. The sequence of front door, entry or porch with stairway, and chimney on axis, the parlor with fireplace in the near wall and twin doors in the rear wall, and the placing of large kitchen and smaller rooms behind are common to both types. The plan variation occurs on the second floor where the principal bedrooms have to be at the center rather than at the front in the story-and-a-half house.

The only early Cape cottage in East Hampton remaining in place and still in recognizable form is located at the corner of Apaquogue and Jones roads. It belonged to Asa Miller in the middle of the nineteenth century and probably had been built by a predecessor in the family (Plates 25, 26; I-24). It is three-bayed and its centered door opens out. The stairway follows the scheme of garret steps in several lean-tos, such as those in the enlarged Mulford house

Plate 26. Miller House.
Plan of the first floor, restored.
Drawn by Clay Lancaster from measurements by José Sanabria.

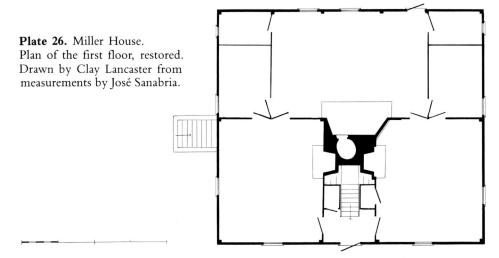

and the Osborne office. It is a straight flight ascending from opposite the front door and branching to upper chambers left and right with the point of emergence in front of the chimney under the roof slope. Flanked by closets in the angles, only the stringers and first few risers of the Miller stairway protrude into the entrance hall. Posts, girts, and plates with beaded edges outline the corners of the rooms, and fireplaces and other openings are in their expected places. The wall back of the east room fireplace angles out for a wider front to the kitchen fireplace. After acquisition of the property by Professor Robert W. Wood of Johns Hopkins University in 1908, the first story of the rear section was opened into a single room, a former batten partition was moved against the former outer wall at the east end, and an L-shaped extension was added to this side of the house. There was formerly a back stairs, ten feet from the west flank of the building, which probably was not original. The cellar is under this end of the house.

A dwelling (I-25) similar to the Miller house stood at the northwest corner of North Main Street and Cedar Street, across from the site of the Dominy house. In the 1860s, it was moved by builder George Eldredge to the south corner of Egypt and Hither lanes. Its first-floor arrangement is basically the same as that of the Miller cottage, and only the east end of the kitchen has been opened up. The stairway repeats the other's layout, but it is not closed in by closets. The stringers are exposed and are shaped like those in "Home, Sweet Home" and the Isaac W. Miller house. As in the latter, there are square newel

Plate 27. Gardiner House, 48 James Lane, mid-to-late-eighteenth century. Photograph by Harvey A. Weber.

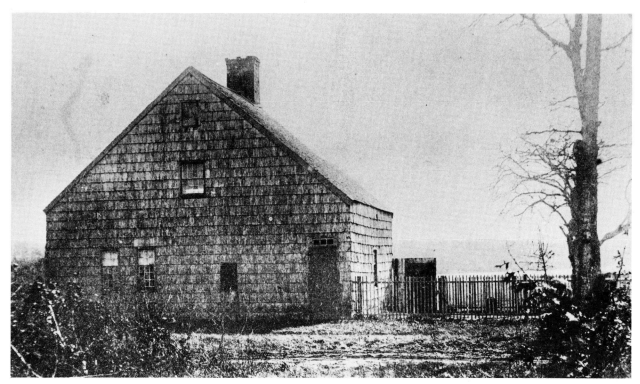

Plate 28. John Dayton House, Montauk Highway, eighteenth century. Photograph by H.K. Averill, Jr., 1880. Courtesy of C. Frank Dayton.

posts supporting handrails minus banisters. Dutch dormers were added on the front slope of the roof some time ago, and an ell was attached to the rear of the house.[18]

Like the T-shaped stairway in double Capes, the minimal or single Cape also presented a stairway innovation. The little house at 48 James Lane (Plate 27; I-26), standing on land originally belonging to the Reverend Thomas James and acquired by John Gardiner in 1696, has first-floor fireplaces only on one side and at the back. The interval between the chimney and outer wall provides space for a straight stairway. The Gardiner house is said to have been moved to James Lane from Three Mile Harbor. The rear portion has been altered and several additions are attached, but the original plan seems to have been that of a standard Cape.

The John Dayton house (Plate 28; I-27), although not strictly a Cape because its eaves are slightly above first-story ceiling level, stands on the stretch of Montauk Highway west of town near Georgica Pond. The building was altered and enlarged to serve as a gatehouse for the Albert Herter estate around the turn of the century. It has been moved back from the road. It is a single type but of unorthodox plan. First-floor framing, seen from the cellar, indicates that corner fireplaces backed up under the chimney. One of the fireplaces was rebuilt in the present layout. An old photograph shows a door near the right corner of the gabled end farther from the chimney. It opened into a passage with the stairway rising on the left, but this has been changed. An early, one-room extension lay beyond the adjoining kitchen, still in place.

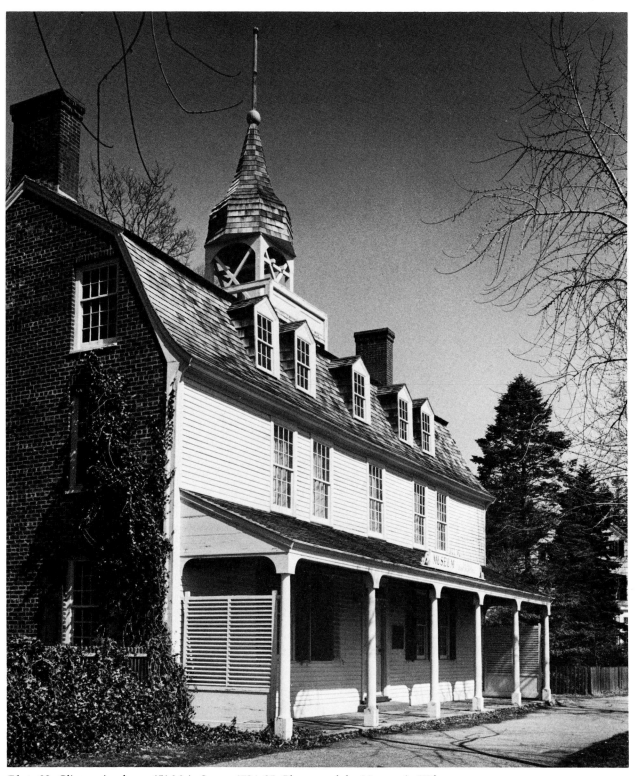

Plate 29. Clinton Academy, 151 Main Street, 1784–85. Photograph by Harvey A. Weber.

The Later Eighteenth Century

The great political upheaval of the later eighteenth century was, of course, the American Revolution. The Boston Port Bill was passed in March of 1774, and on June 17 the inhabitants of East Hampton met and voted, first to "defend the liberties and immunities of British America…from the principles adopted by the British Parliament"; second, to uphold the "non-importation agreement" as the most likely means of saving themselves from "present and future troubles"; and third, they appointed a standing committee to maintain a correspondence with the towns of New York and the other colonies. A local militia was organized and men from this group fought under Colonel Josiah Smith in the Battle of Long Island, in the Flatbush-Brooklyn area on 27 August 1775. After this disaster for the colonials, the British occupation of New York included the appearance of troops in and around East Hampton. Many families became refugees and fled to Connecticut. Those that remained suffered loss of property through appropriation and destruction.

The Revolution, like any war, wasted lives, energies, and resources, but it welded a unified nation. The success of the colonial cause gave the citizens a greater awareness of self accomplishment and the incentive to attain higher cultural achievements. It was this viewpoint that prompted the founding of Clinton Academy during the 1780s (Plate 29; I-219). Its purpose was to prepare students for the colleges established along the East Coast. Coeducational from the beginning, it averaged eighty students a year throughout the first decades of its existence. The academy was named after the incumbent governor of New York State, George Clinton.

The chief protagonist of Clinton Academy was the Reverend Samuel Buell. Dr. Buell personally acted as fundraiser and directed the construction of the building. He may have conceived its design as well. Like early educational buildings at Harvard and Yale Universities, Clinton Academy is gambrel-roofed; it has brick ends incorporating fireplaces in the chimneys and two-storied clapboarded walls front and rear. The gambrel roof, however, makes it virtually a three-storied building. It measures fifty by twenty-one and one-half feet in plan and had a seven-foot transverse hall containing the staircase, with classrooms to either side. The garret was not finished, though amply provided with fenestration. Built directly opposite the Presbyterian Church, the architectural dress of Clinton Academy attempted to complement that of the religious building. It had what Buell called "a beautiful piaeser," or open porch running across the first story, and a "neat Belcony [belfry] with a Walk round it."[19] The latter is an openwork, square-timber structure crowned by an octagonal campaniform roof capped by a metal ball and pole.

Opening exercises took place on 1 January 1785. Clinton Academy was chartered by the State Board of Regents on 20 December 1787, becoming the first accredited high school in New York. The Academy operated until 1881. The East Hampton Historical Society has used the building for many years as a museum.

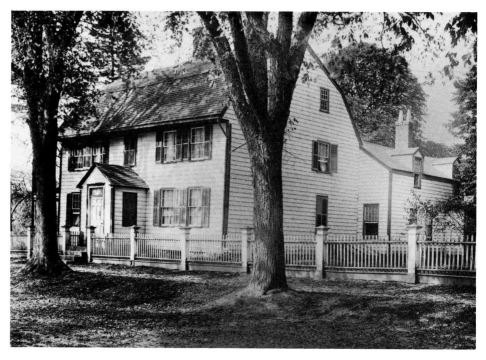

Plate 30. David Gardiner House, 95 Main Street, 1740. Courtesy of the East Hampton Free Library.

The gambrel roof had been in existence in America since the seventeenth century, not only on academic and other public buildings but on residences as well. The gambrel-roofed house of David Gardiner was built on the west side of Main Street in 1740 (Plate 30; I-28). It was five-bayed, two-storied, and two rooms deep with a center chimney. It had an early enclosed entrance pent added before the front door, which was retained when the house was moved back from the street in 1924. The building subsequently suffered extensive interior changes, was partly burned out by a fire, and has had additions on three faces. The bedroom in the northeast corner of the second story has reused paneling in the style of that in the parlor of "Home, Sweet Home." It may have come from the room below, which was enlarged, the floor dropped, and the walls given new paneling. The framework of the early house remains mostly intact up through the lower pitch of the roof, but the top has been rebuilt. The chimney was completely removed.

The other gambrel-roofed residence in East Hampton (Plate 31; I-29), built around 1800, belonged to General Jeremiah Miller and is three doors south of the David Gardiner residence. General Miller was East Hampton's first postmaster and he added a room on the north flank of his home in which to discharge his duties. Like the neighboring house, the building at 117 Main Street was relocated farther from the road and altered when it became a summer residence in 1885. The former front hall and adjoining rooms are combined into a single interior; fireplaces remain in place but are fronted with imported mantels. A passageway crosses the rear of the north chimney, which still has a period mantel for the room that probably served as a bedroom in this

corner of the house. The southwest room keeps its original proportions and its mantel has fluted pilasters, breakfront shelf, and carved pineapples and foliage in the frieze. Its style accords with the construction date of the house. The former stairway in the front hall having been removed, the house was given a late-nineteenth-century winding staircase rising from a central position in the back half of the house. Railings of the garret steps may be original. When the house stood on Main Street, the entrance was sheltered by a distyle classic portico with slender colonnettes on pedestals. A broader version appeared after the site change, along with a new eyebrow-type pediment centered on the front of the roof, and dormer windows on an added gambrel capping the post office. Still later, similar dormers appeared on either side of the pediment on the main pavilion. Other additions have enlarged the capacity of the house.

The developing double house, which had been two-storied and one room deep in the seventeenth-century "English" domicile, had increased the lower story to twice its former size in lean-to houses of the early eighteenth century. It then took another step forward in becoming two full stories at the rear in the later eighteenth century. The form became symmetrical on the flanks, contained as much space upstairs as the lean-to had below, and it gained a larger garret. It also usually was built over a full cellar. The earliest example using this design in East Hampton was the David Gardiner residence, which had acquired even more volume at the top by its gambrel roof shape. The Jonathan Dayton house (Plate 32; I-31), built in the late eighteenth century at what is now 143 Main Street, just north of Clinton Academy, belongs in the same category and has a normal, single-pitched roof. Like the Gardiner house, it has

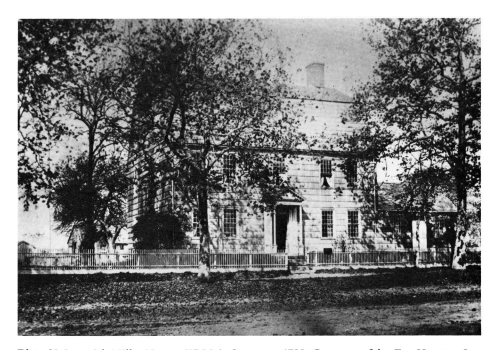

Plate 31. Jeremiah Miller House, 117 Main Street, ca. 1799. Courtesy of the *East Hampton Star.*

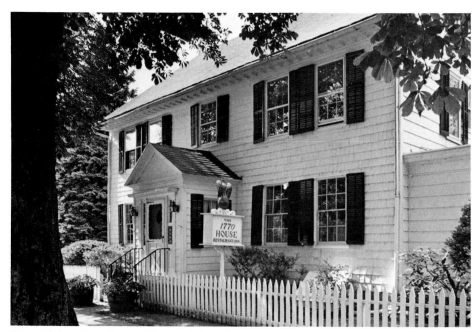

Plate 32. Jonathan Dayton House, 143 Main Street, late eighteenth century. Photograph by Harvey A. Weber.

an enclosed entrance pent. Its stairway is composed of straight flights that revolve around a square well. They have an open stringer, slender, tapered newel post, and square banisters carrying a handrail on top. Woodwork in the parlor, in the northeast corner of the house, is remarkably like that in the Gardiner house or in "Home, Sweet Home," making use of arched panel heads and fluted pilasters. The northwest corner of the lower floor retains the usual small divisions and service stairs, whereas the rear center and southwest corner have been changed; the kitchen fireplace was enclosed and the space

Plate 33. Front elevation of the Miller Dayton House, restored (1830s), 19 Toilsome Lane, 1799. Drawn by Clay Lancaster.

combined. A large kitchen has been affixed to the rear. The building now functions as an inn called the 1770 House.

One of the later, center-chimney, double houses, two full stories both front and back, is that of Miller Dayton at 19 Toilsome Lane (Plate 33; I-33). Dayton was something of an entrepreneur in his day. His ventures included building a wind-powered sawmill and a wharf at Northwest. His residence was the work of Samuel Schellinger, an Amagansett carpenter, descendent of William Schellinx (the Dutch spelling), who built the town prison in 1698. Schellinger's account book discloses that the timbers for the house were cut in 1793, and they were assembled six years later.[20] Except for the staircase, whose features are like those in the Jonathan Dayton house, and the use of thicker, plastered (as opposed to batten or paneled) walls, with posts no longer protruding into rooms, the first-floor layout is that of an early eighteenth-century lean-to. The upper floor arrangement is similar, with a passage across the rear of the chimney. An interesting feature is that the bearing walls between front and back rooms in the cellar are composed of several layers of bricks alternating with sections of old posts and summer beams, some having chamfers and lamb's-tongue stops cut into them.[21]

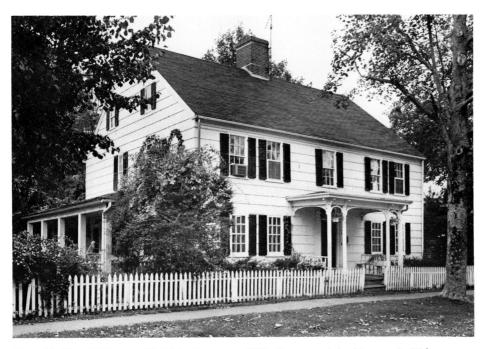

Plate 34. Sherrill House, 128 Main Street, ca. 1780. Photograph by Harvey A. Weber.

Other center chimney examples are the Sherrill house at 128 Main Street (Plate 34; I-30), said to date from 1780, the David Huntting house at 102 Main Street (I-35), and the Daniel Osborne house at 109 Main Street (I-34), all of about 1800. The last had a three-bayed facade. The lower windows have been widened to twice their original size, and a bay window on the south end and an ell at the back were added during the late nineteenth century. A front porch of that era was removed, and a modern entrance pent replaces it at the center.

The Nineteenth Century

The eighteen hundreds saw the United States come of age. Growth was rapid, and it was accelerated by mechanical means. The steam engine was applied successfully to water travel and to rail service. The continent was crossed by the first railroad line in 1869. These technical advances were not to affect Eastern Long Island for many years, but gradually the region began to adopt those which could be applicable to its way of life at the time.

The town's three surviving windmills were built during the early years of the century. The first was Pantigo Mill (Plates 35, 36; I-220).[22] Samuel Schellinger, who recently had constructed the Miller Dayton house, was the millwright. He began construction in March of 1804, aided by several assistants. Pantigo Mill stood atop the man-made mound called Mill Hill on the west side of the common at the north end of Town Pond (Plate 38). It was the third to occupy the site and although its predecessors, built in 1729 and 1771 were probably both post mills, in which the entire body of the mill was elevated and could be rotated to face the wind, Pantigo Mill represented the newer smock type. It had a fixed body with revolving cap, and it could accommodate heavier and more complex mechanisms than the old-style mills. The tower is octagonal. Eight cant posts at the corners sustain a circular

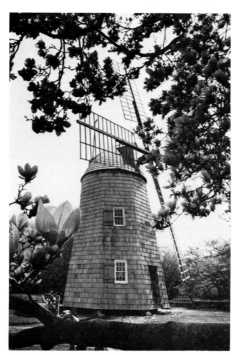

Plate 35. Pantigo Windmill, James Lane, 1804. Photograph by Harvey A. Weber.

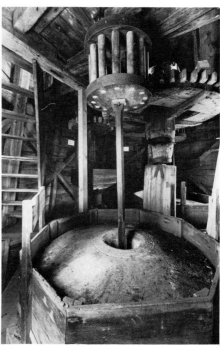

Plate 36. Pantigo Windmill. Second floor. Photograph by Harvey A. Weber.

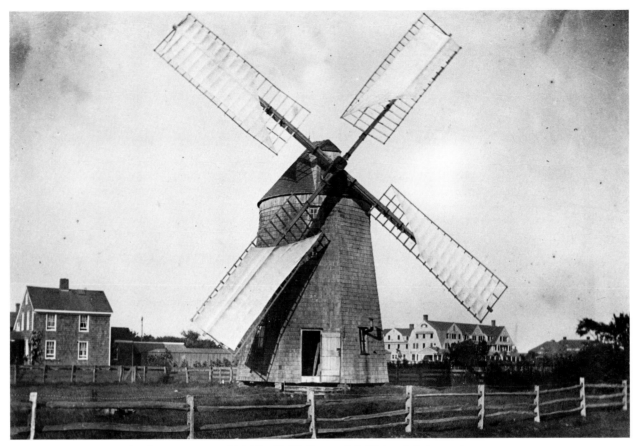

Plate 37. Gardiner Windmill, James Lane, 1804. The "Mill Cottage" (I-18) is at left, beyond are the Maidstone Inn and Maidstone Club. Photograph by Mary Buell Hedges, courtesy of Adele Hedges Townsend.

ring or *curb*, on which revolves the bonnet holding the shaft that is turned by the sails. A system of gears and shafts transmits the power to the millstones that do the actual work of grinding. In 1845 the mill was sold to David A. Hedges, who had it moved to his property on Pantigo Road, allegedly because the moving sails frightened horses passing by it. The mill changed position again to a site at the corner of Pantigo Road and Egypt Lane, and then in 1917 it was purchased by Gustav Buek and taken to the yard behind his residence, the present Home, Sweet Home Museum. Now owned by the Village of East Hampton, extensive repairs were made to the structure during 1978–79.

A few months after Pantigo Mill was begun, a second mill (Plate 37; I-221) was commenced on the east side of Town Pond. It was similar in form and was built by Nathaniel Dominy V, who had constructed one on Gardiner's Island. John Lyon Gardiner, one of several sponsors, was also the proprietor of Gardiner's Island, where the timbers for the mill were cut during January of 1804. Framing began on June 11, and the mill was completed on September 28. Gardiner noted that it cost 528 pounds, 6 shillings, and 11 pence, or about $1320, which was more than any residence in East Hampton was worth at that time. The mill continued to operate up to about 1900.

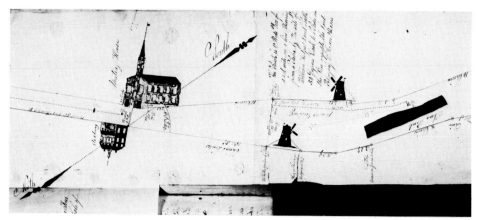

Plate 38. Survey of Main Street, 1833. This survey depicts Clinton Academy, the Presbyterian Meeting House, the Pantigo Windmill on its original site, and the Gardiner Windmill. From Book "G" of the East Hampton Town Records, East Hampton Town Clerk's Office.

Hook Mill (Plate 39; I-222) was Nathaniel Dominy V's second mill at East Hampton and was located in the triangular green at the fork of North Main Street and Pantigo Road. A mill had been located at this site as early as 1736. The post of the earlier mill, twenty-four inches square, proved to be sound, and ten or twelve feet of it were reused to receive the foot bearing of the upright shaft. Dominy's accounts testify to his looking for timbers on Gardiner's Island in April of 1806. The millwright was given one of eight shares in the mill as part payment for his work. He kept it in repair, and his descendants continued to care for it until 1908. Hook Mill was purchased by the village in 1922. It was again put in working order in 1939 and it continued to be operated into the 1950s.

Changes in domestic architecture came slowly to Eastern Long Island, where—as we have seen earlier—the conservative, center-chimney plan was adhered to in double houses to the end of the eighteenth century. Elsewhere,

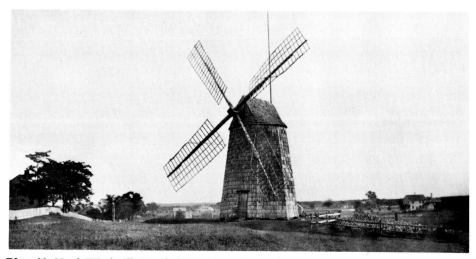

Plate 39. Hook Windmill, North Main Street, 1806. Photograph by George Bradford Brainard, ca. 1879. Courtesy of the Brooklyn Public Library, Brooklyn Collection.

as in much of New England, and the South, the twin-chimney arrangement had become popular long before the American Revolution. It appeared in East Hampton only on the eve of or during the early years of the nineteenth century. Although it was not greater in size than the single-chimney, double house and could not offer more or larger rooms, the two-chimney plan provided better circulation from room to room. One no longer had to walk around the solid masonry core to get from one room to another; one entered each and all from the common connector. Chimneys are placed between the front and rear rooms to either side of the hall, with fireplaces back to back. Their chimneybreasts protrude into the rooms, and recesses to the side may be filled with cupboards or closets. In East Hampton they may or may not be centered on their respective walls. Staircases consisting of a single straight flight with open stringers and handrail on top of its supports, curved upward at the summit in a ramp, resulted in the simplest and safest mode of ascent or descent to date. The basic, two-chimney-type plan was to be employed for a half century.

The Edward Mulford house (Plate 40; I–36) at 124 Pantigo Road was built during the early years of the nineteenth century. Mulford was a shipowner, and the house showed refinements suggestive of a well-traveled owner. The doorway is enframed by fluted pilasters set on pedestals, supporting an entablature with impost blocks at each end. The handrail of the staircase in the main hall is of mahogany, and it is of similar mold to that in the Miller Dayton house. It rises from an open stringer, with cutout consoles decorating the spaces beneath the steps. Window frames rise from the floor and have paneled aprons beneath the openings. The dining room and parlor in front (perhaps

Plate 40. Edward Mulford House, 124 Pantigo Road, 1802–5. Photograph by Harvey A. Weber.

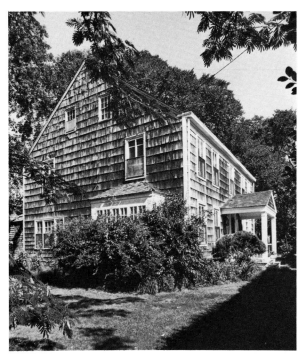

Plate 41. Josiah Dayton House, 35 Toilsome Lane, 1829. Photograph by Harvey A. Weber.

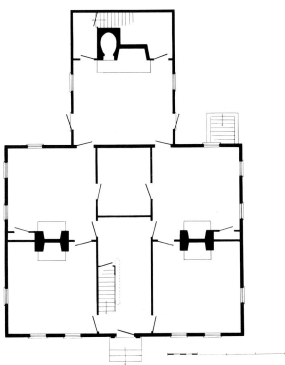

Plate 42. Josiah Dayton House. Plan of the first floor, restored. Drawn by Clay Lancaster.

Plate 43. Josiah Dayton House. Corner block in northeast parlor. Photograph by Harvey A. Weber.

the latter was the master's office) balance one another across the stairhall. In the southwest corner is a larger drawing room. Probably this area included a back stairway directly under the stairwell in the garret floor. The present flight from the second level up has been reversed from its original direction. The outside cellar hatch is on the east flank, behind which a modern extension to the house has been built. Following Mulford's death the residence was sold in 1827 to Captain Sylvanus Parsons, who resold it in 1841 to Captain Mulford Baker, a nephew of the builder.

The Josiah Dayton house (Plates 41, 42; I-38), at 35 Toilsome Lane, south of the Miller Dayton dwelling, was built where an older house had stood on land that had belonged to the Dayton family since the seventeenth century. Its timbers were cut in 1837, and housewright Benjamin Glover of Sag Harbor constructed the super-structure two years later on foundations laid by Charles Payne.[23] The plan of the house is remarkably regular, indicating a prior layout on paper. Each floor contains four fifteen-foot-square rooms, with chimneys between each pair, separated by a transverse hall with staircase in the front, and a storage space behind. The kitchen, which seems to have been a later addition to the older house that stood here and was retained as part of this one, is in the rear wing. It has old-fashioned doors that open out, twelve-paned sashes (as opposed to six-paned sashes in the new block), an oven to one side of the cooking fireplace, and pantry spaces left and right beyond, with a back service stairs adjoining the rear of the chimney structure. One notes that this kind of oven has a deeper throat than one at the back of a chimney, as it must have its own flue (see floor plan). The period of the house being within the

second quarter of the nineteenth century, interior woodwork is more sculpturesque than any we have encountered so far. Supports of the stair railing are gracefully turned shapes, the cap of the newel post flows into the rounded handrail, and consoles resemble those in the Edward Mulford house. Mantels display a bolder treatment, with higher profiles to running moldings. Door and window frames come together at square corner blocks, which are embellished with high-relief floral carvings (Plate 43). Later alterations to the building include a bay window added on the south flank and a pent on the north side. Small elliptical windows pierce the front wall of the hall to either side of the door, which is sheltered by a modern front porch.

The Captain Sylvanus Parsons house at 21 North Main Street is a building of comparable age and a floor plan similar to the Dayton house. Its contemporary neighbor, the Abraham Huntting house (I-39) at 15 North Main Street, exhibits a slight variation. Its two chimneys are pushed far apart, and whereas that to the south is between rooms (nearer to the outside wall), that to the north now serves a corner fireplace in the front room. Its masonry has been rebuilt, but the framing indicates that it follows the old form. There is no trace of a fireplace in the modern kitchen behind, and a ceiling in the laundry room beneath precludes examination of the first-floor joists. The James Parsons Mulford house (I-37) (*ca.* 1815), which stood on Main Street opposite the General Jeremiah Miller house and post office, was another two-chimney type. It was moved to 24 Jeffery Lane in 1923 and rebuilt after designs by Aymar Embury II. Patches in the garret floor mark the location of the early chimneys.

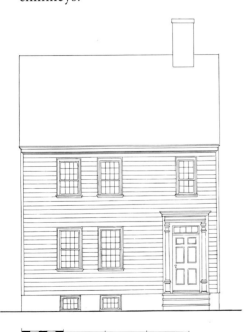

Plate 44. Front elevation of the Jacob Hedges House, restored, 73 Pantigo Road, early nineteenth century. Drawn by Clay Lancaster.

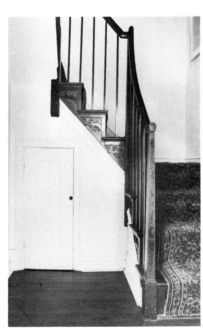

Plate 45. Jacob Hedges House. Stairway. Photograph by Harvey A. Weber.

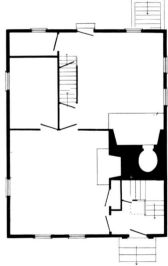

Plate 46. Jacob Hedges House. Plan of the first floor, restored. Drawn by Clay Lancaster from measurements by José Sanabria.

Baldwin Cook Talmage moved an early house from Northwest to his farm on the promontory between Georgica Pond and Georgica Cove in 1837, and then he built a new dwelling about three years later (I-40). It was two-storied and five-bayed and had a story-and-three-quarters, shed-roofed kitchen ell on the right flank. The approach to mid-century is indicated by the plainness of the woodwork (including the front doorway), which would have been cut out by steam-powered machinery. Newel post and banisters of the main staircase are heavier and more shapely than those previously examined. The chimney on the service-ell side of the building has been placed against the wall to serve the kitchen as well as the dining room. The latter's chimneybreast abuts the partition that separates it from the room behind.

A group of two-and-a-half-storied single houses is characteristic of the East Hampton vicinity. The first-story capacity of any of them is about equal to that of a single lean-to. In the Jacob Hedges house at 73 Pantigo Road (Plates 44, 45, 46; I-41) the chimney is placed behind the front stairway, which rises in several flights as in an early-eighteenth-century house. The parlor fireplace faces into the room from the near wall, and there is a closet between it and the hall door. The kitchen is in the expected place in the northeast corner, and straight flights of steps originally ascended and descended from this room against the wall separating the bedroom in the northwest corner. Its layout is remarkably like that of the first stage of the Dominy house, which was at least three-quarters of a century older. In contrast to the archaic positioning of

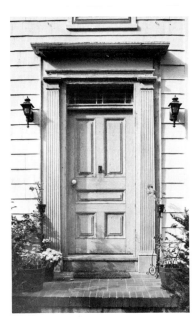

Plate 47. Ezekiel Jones House. Doorway. Photograph by Harvey A. Weber.

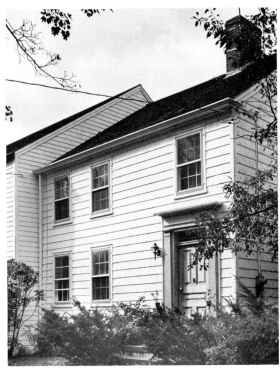

Plate 48. Ezekiel Jones House, Montauk Highway, early-to-mid-eighteenth century. Photograph by Harvey A. Weber.

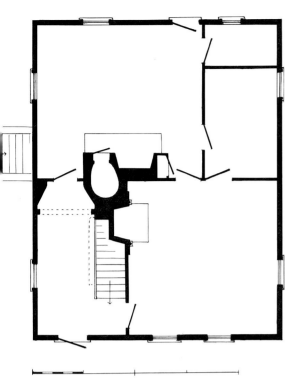

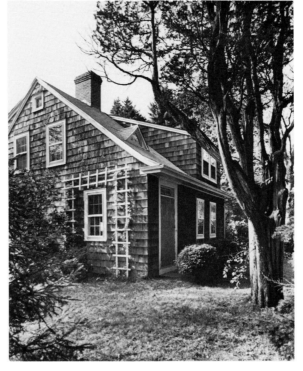

Plate 49. Jones House. Plan of the first floor, restored. Drawn by Clay Lancaster.

Plate 50. Jones House, Montauk Highway, early nineteenth century. Photograph by Harvey A. Weber.

these elements, trim in the Hedges house is up to date, with decorative consoles on the open stringer of the staircase, and window frames rising from the floor. Mantels are similar to those in the Josiah Dayton house. A two-storied ell was added to the rear of the house by builder George Eldredge in 1879, and the present front porch dates from 1902.

The similar Stafford Hedges house (I-42) stood farther from town (about halfway to Amys Lane) on the same side of Pantigo Road. It was moved to an inner lot off Cross Highway, between Hither and Middle lane, during the mid-1950s.

A comparable pair of houses (Plates 47, 48; I-45, I-46) are said to have been built by two brothers, Talmage and Ezekiel Jones, on the Montauk Highway across from Jerico Road. They seem a bit later than the Hedges houses: rather than having eight- or twelve-paned sashes, the fenestration has consistent, six-paned double sashes. The staircases are the more modern, straight-flight type with round newel posts and banisters. The posts have flaring shapes but the banisters are plain. Halls in both houses open at the back into the kitchens. The Jones houses have undergone changes in the rear halves, undoubtedly when later service wings were added. The Ezekial Jones house has an addendum on the west end considerably greater than itself. Its pilastered doorway is particularly fine.

The cottage (Plates 49, 50; I-55) directly across the highway from the two houses just discussed may have been built by another member of the Jones

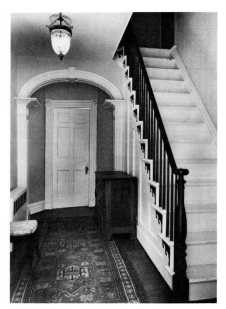

Plate 51. Jones House. Hall. Photograph by Harvey A. Weber.

family. It is quite different from them in form, being a story-and-a-half, single type, outwardly classifiable as a Cape. Even its front door opens out. But the interior reserves several surprises. In the hall a straight staircase ascends against the right wall, the space between it and the outside wall is spanned by an elliptical arch carried on square antae, and beyond a doorway opens into the kitchen (Plate 51). To the left of the door from the hall into the parlor is a classic mantel with semicircular Tuscan colonnettes. The fireplace itself is inserted in the space under the adjoining stairs; the flue follows their soffit and passes under the upstairs hall and into the chimney behind. It is reported that the fireplace draws superbly. Trim includes corner blocks, and centered over twin doors in the rear wall of the parlor is a wood plaque bearing a carved pineapple flanked by willow trees with radial motifs (quarter sunbursts) in the upper corners (Plate 52). Panels underscore the windows. A cupboard is in the west side of the kitchen chimneybreast, and the oven with a fuel storage compartment below is in the front plane opposite. A cellar under the southeast corner of the house is entered from outside. The little dwelling is a gem in the way its traditional plan has been manipulated to achieve the utmost in visual and spatial effects, enhanced by finely executed and attractive ornamentation. Later additions have been attached at the rear.

Plate 52. Jones House. Plaque over doors in parlor. Photograph by Harvey A. Weber.

The cottage (Plate 53; I-57) in the triangular lot on the west side of North Main Street, across from and beyond Hook Mill, cannot be designated a Cape because its front and rear eaves are at second-story windowsill level, and because the chimney is close to the opposite end of the roof ridge from that nearer the front door. It was built in 1849 for William Bennett by carpenter Lewis Jones to replace a former lean-to on the site. The delicacy of the pilastered doorway and smallness of the windows make the building seem earlier than it is. The room arrangement is determined by a transverse wall dividing the space into unequal parts. A small chamber is behind the stairhall on the south side. Handrail members are round. Doors throughout are five-paneled, consisting of a horizontal shape across the top and two pairs of verticals below. Two square rooms with interlaying fireplaces form the north two-thirds of the first story. A back stairs adjoining the transverse wall in the west room descends to the kitchen, which is a finished room at the front of the basement. Its cooking fireplace has an oven at the side.

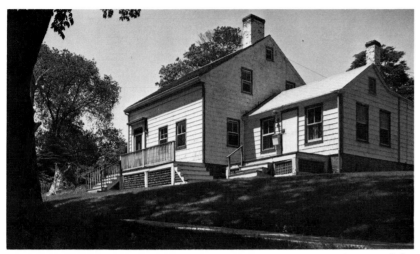

Plate 54. Presbyterian Manse, James Lane, 1836. Moved to David's Lane and altered in 1916. Reprinted, by permission, from Rattray, *Up and Down Main Street*.

Plate 53. William Bennett House, 43 North Main Street, 1849. Photograph by Harvey A. Weber.

The final divorce from the limiting chimney core of the house, which, as we have seen in the double dwelling, was split in two in East Hampton at the debut of the nineteenth century, was fully realized several decades later by the placing of fireplaces against outside walls. Rather than focusing in, house-holders now sat before the chimneypiece and looked out through windows to either side. In special instances there would be a garden vista provided. Early-seventeenth-century, catted chimneys were on outside walls. When flank chimneys first occurred in modern times is hard to say. Old houses were moved and rebuilt, and new ones were constructed of reused materials. Thus buildings became a medley of ancient and contemporary elements. One house that can be pointed to as having acquired chimneys against the outer walls in 1836 is the Presbyterian parsonage. A new location of the minister's residence was first proposed on 1 May, when the Town Trustees appointed a committee to purchase "Horace Isaacs' house & Lot for a parsonage if he will sell for $1700." On 8 May the purchase was confirmed. On 22 May the committee was to examine the house "relative to repairing the same." A week later they reported "in favor of a thorough repairing which with an additional room built on will cost about nine hundred dollars." On 6 June the Trustees agreed to overhaul it "in the most economical way" but a week later this committee reversed its decision and recommended "selling the old one [parsonage] and building a new one which was agreed to by the Trustees." This resolution apparently was final. On 21 June it was reported that the old building had been resold to Horace Isaacs for $650, that the parish had engaged John C. King to move it to Isaacs' lot on the west side of the street for $140, and that King had contracted to build a new house "above the stone work for eleven hundred and twenty dollars, the parish to do the carting."[24]

An 1854 drawing of the Presbyterian manse shows it to have had a principal pavilion three-bays wide, two-and-a-half stories tall, and two-rooms deep (Plate 54). Facing west, the entrance was at the north end of the facade, and the chimneys rose from the south flank. A one-room extension expanded from the north flank, level with the front, squared off by a parapet that came up

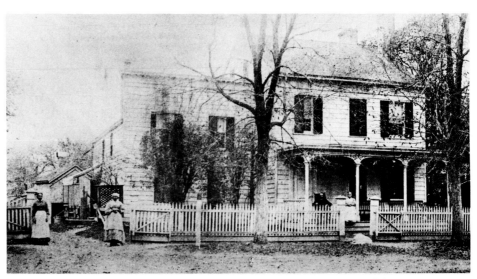

Plate 55. Thomas S. Isaacs House, 120 Main Street, ca. 1836. Courtesy of the East Hampton Free Library.

above the shed roof, and a chimney was just inside the outer wall. A one-storied kitchen was at the back. The plan would have been like a town house, with a stairhall running back from the front door, and a parlor and dining room to the side. Probably the addendum opposite was the minister's study. The building stood on the site of present St. Luke's church.

The manse became something of an archetype for the next phase of East Hampton building. The old house that King moved to Horace Isaacs' lot on the west side of Town Pond and put on preexisting foundations adjusted to it was altered to become a single house following the scheme of the main block of the manse, only its plan was reversed. Having performed the moving, perhaps John C. King rebuilt the house for Horace Isaacs as well. It is now at 199 Main Street. (I-47)

Another residence that must have been built about this time is that of Thomas S. Isaacs, Horace's son (Plate 55; I-48). It was located thirteen doors up from the manse, at present 120 Main Street. In its early state it was closer to the massing of the rectory than the father's converted house, having the annex on the right flank. It too was squared by a screen wall, but it was two storied. The parapet came up to about the same height as the main block and had a matching cornice. The interior trim is proper to the period. Windows have single-panel aprons, frames have corner blocks, and doors are six-paneled, consisting of a horizontal shape over two verticals in two superimposed sets. A cellar is under the southeast corner of the house. Thomas had a shop next south of the house where he made and sold shoes. In 1860 a new Presbyterian church was built on the lot to the north of the house, and after Isaacs died in 1875 his residence was acquired for a parsonage. Early in the present century, the old Presbyterian manse, farther down the row, was moved to 56 Davids Lane and altered into a summer house. The later parsonage at 120 Main Street also lost its close resemblance to that earlier form when it was doubled, the main pavilion being rounded out on the north end by a mass greater than that of the old wing.

The much-altered house at 84 Main Street (I-22), in which the Reverend Lyman Beecher lived during his tenure at East Hampton from 1799 to 1810, said to have been originally a lean-to (and like one it faces south), was rebuilt into an end-chimney type, probably a bit over a quarter of a century after the well-known minister and his family had moved elsewhere.

Sarah Diodati Gardiner married David G. Thompson, and their home at 217 Main Street (I-49) follows the pattern of the manse and Isaacs' houses. It must have come into being about the same time. Its three-bayed pavilion has a later addition on the north flank and doors have six equisized panels, like New York City residences of the 1830s. Its interior trim corresponds with that in the Josiah C. Dayton house, having deep undercutting in the corner blocks.

The William Lewis Huntting Osborn house (Plate 56; I-51), neighboring on the north (207 Main Street), is similar to the Thompson house in form but displays fully developed Greek Revival trim. The Greek Revival style of architecture, using Hellenic rather than Roman motifs (as had Georgian and Federal-period buildings), had been introduced into the United States by Benjamin Henry Latrobe's Bank of Pennsylvania at the turn of the century. It was publicized in builders' guides by Asher Benjamin, John Haviland, Edward Shaw and especially Minard Lafever. By the 1840s the Greek Revival had become the national American style. Its appearance in the Osborn house, therefore, is not so unexpected as is its infrequency elsewhere in East Hampton. The frontispiece is high style. Transom and slidelights around the front door are leaded (a local archaism, as in other places there would have been wood muntins), and they are enframed by heavy pilasters supporting an entabulature elaborated with dentils. The stairway has a baluster-shaped newel and banisters with tapering shafts. The balance of the woodwork represents the other facet of the Greek Rivival. Fireplaces and doors in the Osborn house are treated severely. Mantels consist of flat pilasters relieved only by a capital, and with only a few moldings on the fascia and a bed mold under the shelf. Doors are four-paneled and face boards surrounding them step out at the top, with reentrant angles at the corners. As mentioned in connection with the Baldwin Cook Talmage house, trim at midcentury was produced in mills by steam-powered machinery. The method—diametrically opposite to hand craftsmanship—encouraged its plainness, and sometimes facings came out little better than unregenerated lumber. The Osborn house is now the main part of the Maidstone Arms Inn.

The antagonist to the classic Greek Revival style and foremost protagonist of the Romantic mode in America was Andrew Jackson Downing, horticulturist and advocate of rural living, and resident of the picturesque Hudson River Valley. His books having to do with buildings were *Cottage Residences* (1842) and *The Architecture of Country Houses* (1850). These popularized the newer styles of architecture: the Gothic Revival (castellated and cottage or "pointed"), the Romanesque (round-arched), Italianate (including the Tuscan or symmetrical, and irregular or asymmetrical villa), and his own original "bracketed" style. Unlike the Greek Revival builders' guides, the Downing essays were plan books. Instead of showing elevations and scaled drawings of classic details, they presented vignettes or perspective drawings of entire house designs, complete with natural setting, and their floor plans. The

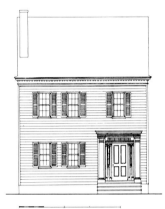

Plate 56. Front elevation of the William Lewis Huntting House, restored, 207 Main Street, ca. 1840. Drawn by Clay Lancaster.

presentation suited East Hampton, which was conservative and considerably more plan-conscious than eager to keep up with the latest architectural dress of whatever persuasion. The one element offered by Downing that was useful to these Eastern Long Islanders was the decorative bracket. It appears, modestly, on the Thomas S. Isaacs house. If the building dates from the 1830s, which seems likely, then the brackets would be a later addition. They soon came to appear as integral ornaments on East Hampton houses.

When Captain Jeremiah Mulford retired from whaling soon after midcentury, he built a boardinghouse (Plate 57; I-58) at what is now 140 Main Street by way of launching a new and more stationary enterprise. It is said to have replaced a former building on the site. The new structure was a traditional type, compact and equally balanced, with a square-piered entrance portico, and with regularly spaced brackets supporting deep roof eaves on all sides. It embraced a center-stairhall, two-chimney plan, with similar parlors at the front, and a large dining room spanning the width of the south parlor, hall, and part of the north parlor. The north parlor has two doors in the wall section to the side of the chimneybreast: one leading to the dining room and the other to a guest bedroom at the northeast corner of the house. The dining room has always been heated by a stove rather than by a fireplace. The kitchen is in a rear ell, in which there is a service stairway. The main staircase has the expected baluster-form elements, but trim in the house resorts to new but simple motifs. Doors and mantel pilaster shafts have long, flush panels divided into square sections by narrow trenches. Architraves have flat escutcheon-shaped dentils beneath the cornice, and the north parlor fireplace has an additional row of disks across the frieze. Here are the plain beginnings of what was to develop into late-nineteenth-century Eclecticism.

A house that breaks away from the facade formality of the captain's boardinghouse was built in 1864 for Stephen Hedges (Plate 58; I-59) beyond the old sheep pound at 28 Accabonac Highway. It was sited in front of an older dwelling, which was converted into a barn, recently destroyed by a hurricane.

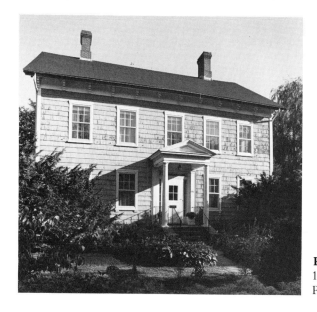

Plate 57. Jeremiah Mulford House, 140 Main Street, ca. 1860. Photograph by Harvey A. Weber.

The Hedges house had restrained trim inside. The exterior elaboration is limited to modest cornice brackets and slightly more complex equivalents attached to the porch posts. The present standardized banisters do not accord. The front of the house is the short, gabled end, and this may be the first time one appeared in East Hampton since the 1715 meeting house was reoriented with its entrance tower centered on the extension of its former gabled flank. The Stephen Hedges house was followed by others of similar design such as the Stafford Tillinghast house (I-72) and the J. E. Gay house built about 1891 (I-87).

Builder George Eldredge, who had moved a Cape from North Main Street to the corner of Egypt and Hither lane for his own use during the 1860s (I-71), built in 1876 a new house next door for his own occupancy (Plate 59; I-71). This second Eldredge house also had its shorter side turned toward the street, only here the gables were on the flanks, and instead of having a stairhall alongside the parlor, the room across the front was the up-to-date and more general-in-purpose living room. Stairhall and dining room are behind, the latter expanding out into a wing to the south, with the kitchen extension beyond. Such casual planning anticipated or reflected that of the rising second home or summer resort house. The type of woodwork seen in the Captain Jeremiah Mulford house at midcentury here has reached full maturity. The living-room mantel displays an assortment of geometric shapes, including low pyramids, and a shelf of undulating outline. Just as the newel post of stairways, fifty years earlier, had divorced itself from the column shape by taking on a baluster form, so at this time the mantel has been liberated from looking like a miniature classic doorway through use of the innovative motifs.

One of East Hampton's most exotic architectural designs was used in the Presbyterian Church (Plate 60; I-225), the one public building produced in the town shortly after the middle of the nineteenth century. The Reverend Stephen L. Mershon was minister in 1861 when construction was undertaken. It was built in the Romanesque Revival style, which had been introduced in

Plate 58. Stephen Hedges House, 28 Accabonac Highway, 1864. Photograph by Harvey A. Weber.

Plate 59. George Eldredge House, 84 Egypt Lane, 1876. Photograph by Harvey A. Weber.

America by Richard Upjohn in the Church of the Pilgrims at Henry and Remsen streets in Brooklyn in 1844. This style did not become popular until Henry Hobson Richardson's Trinity Church (1872) in Boston prompted its use in numerous public and commercial buildings and other churches throughout the nation. That East Hampton should have manifested an oddity may have been due to the taste of the Reverend Mr. Mershon, who in 1871, was to build the first of the ministers' seaside cottages on Ocean Avenue (I-61).

The auditorium of the Civil-War-period Presbyterian church was barnlike and five bays long; its windows were divided into tall, narrow, twin lights with a circular oculus set between their heads under a semicircular arch, and topped with hooded dripmolds. The front advanced and had twin doorways between two unequal square towers, each consisting of three levels. The smaller tower on the north had a steep, four-sided steeple. The larger, on the south, above tall louvered belfry openings on each side, had a clock arched over by the cornice, pushed up into the octagonal Mansard roof, which ended in a decorative railing at the truncated top. Old photographs show that the church was painted white, which was not an appropriate color for a mood-provoking, medieval-style building.

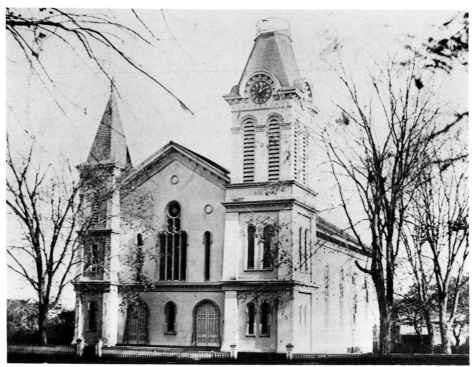

Plate 60. Presbyterian Church, Main Street, 1861. Courtesy of the East Hampton Free Library.

In 1960 the Presbyterian Church was remodeled by Arthur Newman, architect. The western towers were removed, the flanks of the auditorium extended forward another bay, and a square tower and octagonal steeple were centered on the facade, which was preceded by a tetrastyle Tuscan pedimented portico. All was in Colonial Revival style. The bar tracery in the former windows was exchanged for small-paned sashes. The clapboarded walls were retained, and the clocks were reinstalled in the new tower.

The conservatism that generally characterized East Hampton from earliest times persevered for three centuries. Change came reluctantly. In the spring of 1868, forty years after American railroads had been instituted and a year before the first transcontinental run, the Southside Railroad had been brought as far as Southampton, and it was proposed to issue bonds to raise $20,000 for financing its extension through to Sag Harbor. A ballot proved the East Hampton natives negative, and they were "opposed to calling any more meetings to test...[the] railroad question." They stated that they were "desirous of attending to...[their] own business and allowing other people to attend to theirs."[25] The steam line did not materialize over the East Hampton stretch until twenty-seven years later. In the following spring (1869), when it was proposed to separate parts of Suffolk and Queens to make a new county, the East Hampton residents announced that they "unanimously oppose[d] all and every act...in any way calculated to dismember any of our old and ancient Town or any of...[its] Territory."[26] At the beginning of 1887, when the Amagansett Telegraph and Telephone Company sought to erect utility poles along the road in this area, permission was reluctantly granted, and on condition that they not be "placed in front of any inhabited dwelling upon the same side of the highway."[27] This awareness of how public utilities can spoil the environment resulted in the eventual installation of wires underground. The burial of the unsightly continues to be one of the appealing and unique amenities of the community today. The influx of summer people to this quaint old town near the seashore was inevitable. With their arrival, architecture underwent considerable change.

Notes

The Seventeenth Century

[1] *Records of the Town of East-Hampton,* Vol. I (1639–1679/80). (Sag Harbor: 1887), pp. 2–3. This is the first of a five-volume work reprinting minutes of meetings, allotments of land, transfers, identifying marks on livestock, ordinances, officers elected, and other information. Subsequent data in this chapter are taken from this and Volume II, which covers the period 1679/80 to 1701/2.

[2] The term *meeting house* appeared in John Winthrop's journal in 1632, alluding to a religious-secular building newly erected at Dorchester, Massachusetts. This was a Puritan term. Anglican religious houses were always *churches.*

[3] Abbott Lowell Cummings, *The Framed Houses of Massachusetts Bay, 1625–1725,* (Cambridge: 1979), pp. 105–6.

[4] Daniel M. C. Hopping, *The Mulford House, an Historic Structure Report,* privately sponsored, 1981, I, 1, 4–6; I, 2, 1–3. Mr. Hopping's study includes twenty-five sheets of measured drawings, executed by Anne E. Weber, on file in the Historic American Buildings Survey, Washington, D.C.

[5] Cummings, *op. cit.,* Fig. 24, p. 23.

The Early Eighteenth Century

[6] *Records of the Town of East-Hampton,* Vol. III (1701–31), (Sag Harbor: 1889), pp. 5–6; Henry P. Hedges, *A History of the Town of East-Hampton, N.Y.,* (Sag Harbor: 1897), p. 28.

[7] At least those showing in old photographs were of this pattern. These are presumably the new sash windows that Jonathan Hedges installed by agreement with the Trustees on 19 February

1789, for which he was paid forty pounds. (*Journal of the Trustees . . . of East Hampton Town, 1772–1807,* (East Hampton: 1927), p. 118)

[8] *Records,* Vol. III, pp. 387, 392.

[9] *Ibid.,* pp. 143, 147, 153; *East Hampton Trustees Journal,* 1725–1772, (East Hampton: 1925), p. 66.

[10] This might refer to ornamental parts of missing side pieces of the older pulpit, but those of the existing portion are complete, making it unlikely.

[11] *East Hampton Trustees Journal, 1826–1845,* (East Hampton: 1926), pp. 140, 173, 181, 189, 208, 220, 263.

[12] Cummings, *op. cit.,* pp. 31–33.

[13] On 7 April 1713 the Trustees of East Hampton "in regard of the scarcity for timber at Montauk" (formerly a source of ample supply) ordered "that whosoever shall presume to fell or cut down tree or trees" would be fined "the sum of ten shillings" for each tree cut or forty shillings "for each and every load of timber any way carried off." (*Records,* Vol. III, p. 300)

[14] Perhaps there was a transitional form. Most of the rear rafters in the Isaac Hedges house, 61 North Main Street, reused from a steeper roof, have trenches three inches across and one inch deep, a foot apart on center, for connecting boards. The William Barnes house, 48 Egypt Lane, has these trenches front and rear, and a few in the latter plane contain the old connecting boards. Continuous sheathing boards superimposed in both examples run left to right rather than up and down (as with legitimate purlins), perhaps indicating they were a later supplement to the roof structure.

[15] A set of fourteen sheets of measured drawings was made of the building by Daniel M. C. Hopping for the Historic American Buildings Survey in 1940. Included are plans, elevations, structural details, hardware, and even some of the Dominys' tools. A reproduction of the shop has been created in the H. F. DuPont Winterthur Museum in Delaware.

[16] Interview with C. Frank Dayton, East Hampton, 13 July 1981. The existence of the fireplace was reported to Mr. Dayton by one of the workmen, the late William Conrad.

[17] *Records of the Town of East-Hampton,* Vol. I, p. 205.

[18] Parallels can be drawn between these houses and the Jacob Schellinger house (ca. 1725) at Amagansett, now the Amelia Cottage Museum. This building has the same sort of stairway, only it is entirely enclosed, that is, it is entered by a door opening from the porch. The building has retained or restored small rooms flanking the kitchen. It also has an added straight back stairway in the kitchen adjoining the west partition; the cellar is under the east end of the rear section.

The Later Eighteenth Century

[19] Letter to Elisha Pitkin from Samuel Buell, 6 October 1784. Long Island Collection, East Hampton Free Library, Document Book # 11.

[20] Samuel Schellinger Account Book, private collection.

[21] The William Hedges house (the Purple House), formerly next south of Clinton Academy on Main Street, had similarly constructed basement walls. Timbers incorporated in the brick-work consisted of a full post and half summer beams, all chamfered and having a crude scoop for stop. They and the house were moved outside of the village limits on Further Lane.

The Nineteenth Century

[22] Information about the three East Hampton mills is taken from a manuscript by Robert J. Hefner, which is slated for publication as a book, entitled *Long Island Windmills,* by the Society for the Preservation of Long Island Antiquities.

[23] Josiah Dayton Account Book and Receipt Book, collection of C. Frank Dayton, East Hampton.

[24] *Records of the Trustees of East Hampton Town, 1826–1845,* (East Hampton), pp. 201-4.

[25] *Records of the Town of East-Hampton, 1850–1900,* Vol. V, (Sag Harbor), p. 134.

[26] *Ibid.,* p. 144.

[27] *Ibid.,* 330–1.

One Hundred Years
of Resort Architecture
in East Hampton:
The Power of the Provincial
Robert A.M. Stern

One Hundred Years
of Resort Architecture
in East Hampton:
The Power of the Provincial
Robert A.M. Stern

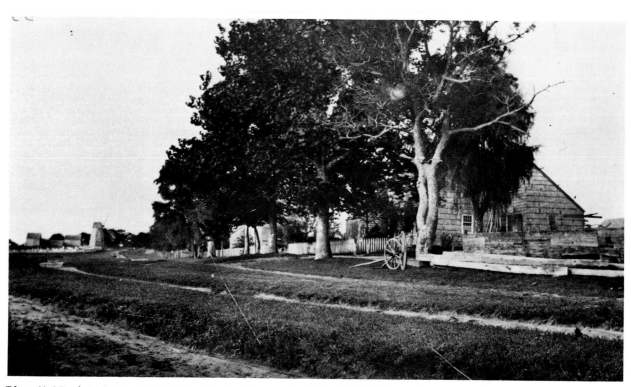

Plate 61. North Main Street, 1879. The Dominy House, demolished in 1940, is on the right. The North End burying ground and the Hook Windmill are in the distance. Photograph by George Bradford Brainard, 1879. Courtesy of the Brooklyn Public Library, Brooklyn Collection.

Through most of its history as a summer resort East Hampton has attracted many architects of distinction. They have come to the South Shore to build in accord with their own temperaments, the temper of their times, and the temper of the place. As Charles deKay observed in 1903:

> "It is rare to find city folk building with so much feeling for the landscape as one observes in East Hampton. . . . The simplicity and sobriety of the scenery appear to have influenced the architecture."[1]

This respect for the place was in part the product of happy accident—East Hampton became popular as a resort at the time of the Shingle Style's greatest popularity—as well as a combination of other factors including reverse social snobbery, which valued old things over new, and the vigilance of an informed community which continues to share a real appreciation of those natural and man-made features that make East Hampton special to this very day.[2]

East Hampton is uncommonly graced by nature, with lovely wide beaches, ponds, dunes, woods, and gentle hills, but it is the act of men building in relationship to that landscape which has forged the special sense of place already apparent to the summer visitors who began to colonize it after the Civil War. East Hampton is one of the few summer resorts which has been fortunate enough to avoid serious natural disasters (Bar Harbor was virtually destroyed by fire in 1947 and the dune development at Westhampton was leveled by the hurricane of 1938); the suburbanization of our cities (Lake Forest and the North Shore of Boston are no longer resorts); mass tourism; and, most of all, the changing waves of fashion which have rendered much of Newport and the Jersey shore visually chaotic.

East Hampton's architecture provides a useful mirror in which to see the relationships between architecture, landscape, and culture which can foster rather than diminish a sense of place. The one hundred-year-long tradition of resort architecture in East Hampton illustrates a simple thesis: a sense of place and a sense of style need not be mutually exclusive in American architecture.

Never a playground for the conspicuously wealthy such as Long Branch and Newport were, East Hampton nonetheless managed to sustain its modest prosperity even through the Great Depression and the Second World War. True, some of the large houses were torn down in the 1930s and 1940s when economic depression, a severe hurricane in 1938, gasoline rationing during World War II, and the disappearance of cheap domestic help, made the village seem very remote and the larger cottages hopelessly overscaled. But by the middle 1950s people began to develop a new style of living in these houses without household staffs, while cheap fuel and expressways brought the village within easy striking distance from New York and encouraged year-round weekend use of the houses. More importantly, the community prospered and new, smaller houses were built, often to designs prepared by exceptionally gifted architects.

The development of East Hampton's summer colony (with the infusion of wealth that the idea of a summer colony implies) brought changes to the old village. To a considerable extent, mutual distrust and mutual amazement colored the relationship between the natives and the summer people. Nevertheless, East Hampton, more than perhaps any other summer resort of the late

nineteenth century represents a successful attempt to build a new community in a way that is sympathetic to the vernacular architecture of the place. This ideal of cultural continuity expressed through architecture influenced the actions of architects and patrons. It also touched the architecture of the village with that sense of inevitability that marks great works of art. This sense of architectural continuity perhaps as much as any other single factor accounts for East Hampton's continued success as a resort.

To a certain extent, East Hampton has been a summer resort since its founding in 1649. In colonial days titled representatives of the crown came "for the waters."[3] Nevertheless, its development in the eighteenth century and in the first three-quarters of the nineteenth century was almost exclusively that of a quiet agricultural community whose picturesque character derived from the inherent beauty of its landscape, from its shingled, seventeenth- and eighteenth-century saltbox cottages, and from its windmills.

In the early days of the nineteenth century, the only architectural accommodations made for the influx of tourists was the moving back of eighteenth-century houses from the Main Street and the addition of front porches or *piazzas*. Many of the porches were removed in the 1920s under the twin impact of the automobile and the "restoration" movement inspired by the example of Colonial Williamsburg.

The first significant wave of summer visitors discovered East Hampton in the 1870s, finding a charming village spread out along an exceptionally broad, grassy, main street with windmills used to grind grain at each end. In an account of Long Island, a reporter for a New York newspaper of 1871 observed that:

> Of all the original places in that old-style land, and of all the places that date back to the seventeenth century, none so now retain the customs and relics of the past in their perfectness as East Hampton. Here, within one hundred miles of New York City, is a place as dissimilar as if the great city were not; and within the quiet limits of this village, but for the telegraph wires, one might easily imagine himself in an old Puritan village of the last century.
>
> From the belfry of the church, the view is very fine; the eye sweeps far out oceanward, and counts the white sails and dingy smokestacks as they pass, while east, west and north perfectly cultivated fields, richly clad in green greet the eye.

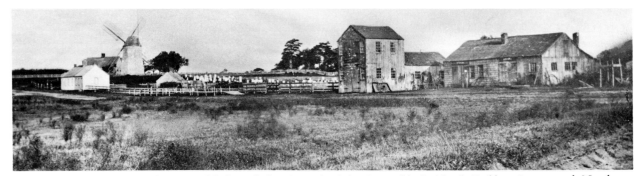

Plate 62. The Hook, 1879. The Strong blacksmith shop is on the right. Beyond is the North End burying ground, North End schoolhouse, and the Hook Windmill. Photograph by George Bradford Brainard, ca. 1879. Courtesy of the Brooklyn Public Library, Brooklyn Collection.

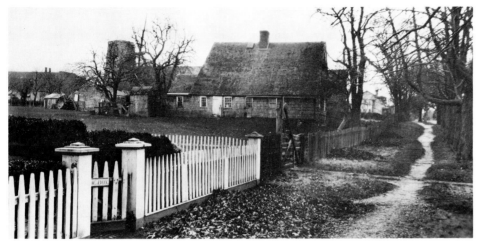

Plate 63. Mulford House and Pantigo Windmill, James Lane. Photograph by Eugene L. Armbruster, ca. 1923. Courtesy of the Queens Borough Public Library.

The long, wide street stretches out east and west with its magnificent growth of elms, westward, lost in its various branches to other towns, amid woods—or traced as a thread-like line near the beach, between the green pastures and the yellow sands which hold the waves in check.[4]

The first summer visitors to come in significant numbers after the Civil War were ministers from New York and Brooklyn who then stayed at boarding houses or cottages rented from the enterprising Talmage family firm (Plate 64). Many of these cottages—built in the area then called Ocean Terrace (soon renamed Divinity Hill, where Lily Pond Lane and Lee and Cottage avenues were later cut through)—still stand, though in extensively renovated form.

Plate 64. Three of the cottages built by the Talmage family firm in the 1870s. This photograph, taken about 1892, shows the view looking south along a dirt road that became Cottage Avenue. On the far left is the T. DeWitt Talmage House (I-65), and the second house on Cottage Avenue is the James B. McLeod House (I-69). Courtesy of Elizabeth Kelley.

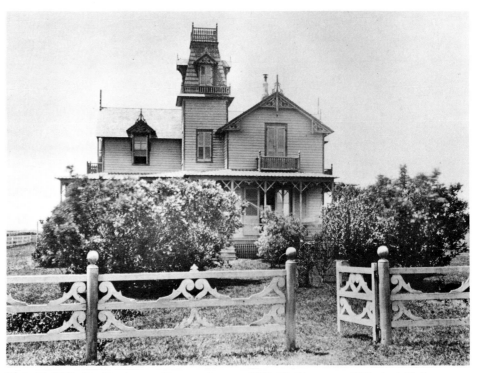

Plate 65. W.R. MacKay house, Cottage Avenue, 1873–74. Courtesy of Elizabeth Kelley.

An old photo of the residence of Reverend MacKay (Plate 65; I-67) on Cottage Avenue shows a High Victorian Gothic cottage replete with mansarded roofs, a turret, and cast iron fretwork.

The house of the most widely known of the original ministers, the Reverend T. DeWitt Talmage of Brooklyn (I-65), whose fiery sermons attracted 3,000 parishoners each Sunday and whose articles were frequently printed in the press, was described in 1874: "North of the road is the Rev. T. DeWitt Talmage's new cottage, Gothic in architecture, and neatly painted in light drab, trimmed with red. Near his house are three others built after the same pattern, two of which are just receiving finishing touches from carpenters and painters."[5]

The first of the minister's cottages, Sea Side Cottage, (I-61) was on Ocean Avenue. It was built about 1871 for summer use by the Reverend Stephen L. Mershon, who had been the Presbyterian minister in the village. One of the early cottages built on Cottage Avenue about 1874 and purchased in 1897 by the Reverend James B. MacLeod (Plate 66; I-69) appears closer to its original state than any of the others. Its almost perfectly cubic volume is surmounted by a low, hipped roof that is interrupted at its front by a gabled pediment trimmed with a scrollwork arch. The rather closed volume of the house is surrounded by a covered porch on the south and west sides to take advantage of the prevailing summer breezes.

The MacLeod cottage seems less Gothic than some of the other Talmage cottages. As such it more closely resembles the four original summer villas built by affluent businessmen for their own use on the south side of Ocean

Avenue in the 1870s. These were: Henry Terbell's of 1869–70 (I-60); C. P. B. Jefferys's Sommariva of 1873 (I-63); Dr. J. S. Satterthwaite's of 1874 (I-70); and Frederic Gallatin's of 1878–80. These four houses fall into the category of *country seats* or *villas* as opposed to *cottages*, the name given to the Shingle-Style houses that characterize East Hampton's development in the late 1880s and 1890s. Three of the four villas were placed on relatively large plots although the Satterthwaite house occupied only three acres.

The four villas are typical examples of the Stick Style, a building mode of the 1860s and 1870s common in Newport and Long Branch, New Jersey, as well as in the various resort towns along the Hudson River. Typical of that style is an intricate interplay between wooden elements which were expressive of, but not the actual elements of, the building's construction. Stick-Style villas were most often set on generous lots, treated as though they were estates or parks, and were oblivious to the architectural style of the community as a whole.[6]

The most distinguished of the four Stick-Style villas was surely the Gallatin house (Plate 67) designed by James Renwick, Jr., the first of a long succession of well-known New York architects to build in East Hampton. Renwick, best known as the architect of St. Patrick's Cathedral on Fifth Avenue, also designed Gallatin's townhouse in New York. The Gallatin villa was torn down in the 1930s. The only photograph of it reveals a two-story, gabled design with implied structural articulations characteristic of the Stick Style. It is a particularly rich example of this style, which by 1878 was beginning to wane. The Gallatin house was described by the Sag Harbor *Express* as: "one of the finest houses in Suffolk County, it being finished with inlaid hardwood floors and stained glass windows, tiled hearths, fireplaces, etc."[7]

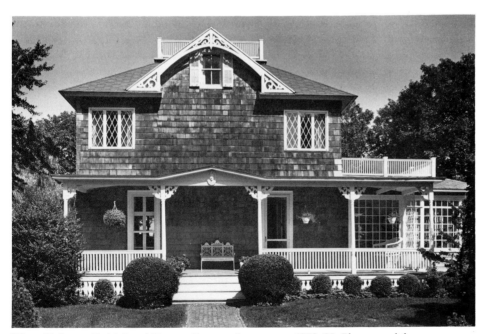

Plate 66. James B. McLeod House, Cottage Avenue, ca. 1873–85. Photograph by Harvey A. Weber.

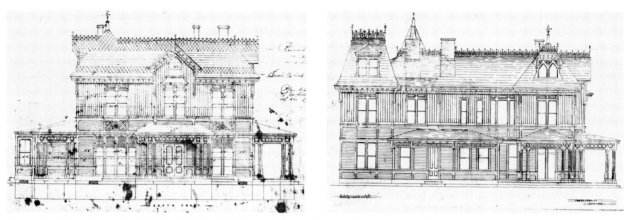

Plate 67. Elevations of the Frederick Gallatin House, Ocean Avenue, James Renwick, Jr., 1878–80. Demolished 1930s. Courtesy of the East Hampton Free Library.

Sherrill Foster has uncovered various versions of the Gallatin house drawn by the Renwick office between 1877 and 1890 which supply a reasonably complete view of the house, supplemented by a distant, postcard view from the early 1900s. The house was completed in 1878, significantly enlarged in 1880 and again in 1889–90. In 1887–88 it was moved two hundred feet closer to Hook Pond to a "more delectable site."[8]

The Satterthwaite villa (Plate 68; I-70) was only slightly less grand. It was designed by Briggs and Corman of Newark, New Jersey, and built by R. V. Breece of Long Branch, New Jersey. The house, which was extensively renovated by its second owner, Charles G. Thompson, between 1893 and 1895, was described by the *Sag Harbor Corrector* as:

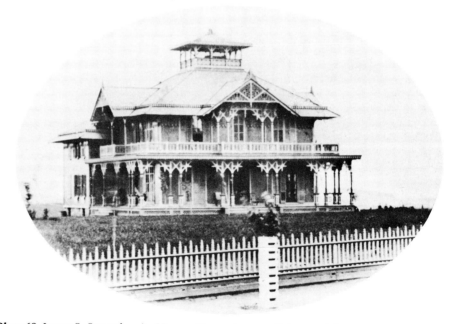

Plate 68. James S. Satterthwaite House, Ocean Avenue, Briggs and Corman, 1874. Courtesy of the *East Hampton Star*.

...a large and handsome summer residence, the first one here, if not the first in Long Island, of the Long Branch pattern...two storied, with a mingling of the Gothic, Grecian and Italian styles of architecture. Single boards form the partitions, lath and plaster being entirely tabooed. Different paints serve in place of a variety of woods in the finish of the rooms. A wide piazza surrounds the house. There are seventeen rooms besides a high ceiling and handsome finish. The grounds are being graded with close regard for the general effect, several kinds of trees set out, and the appropriate fences built.[9]

As Foster has pointed out, a contemporary photograph reveals "a Stick-Style cottage with romantic Swiss Chalet elements," the pyramid of the roof "softened by the delicate, airy Stick-Style screening over the facade."[10]

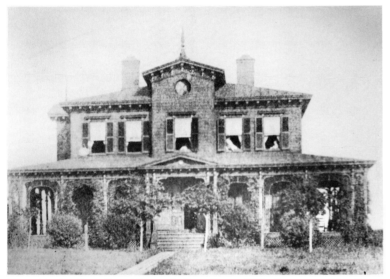

Plate 69. C.P.B. Jefferys House, Jefferys Lane, 1873. Courtesy of the *East Hampton Star.*

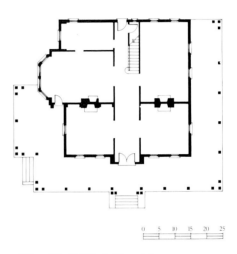

Plate 70. C.P.B. Jeffreys House. Plan of the first floor, conjectural restoration. Drawn by José Sanabria and Oscar Shamamian.

Henry Terbell's house (I-60) is less well known. It was extensively renovated in 1901 and again in 1915, and no picture of its original state remains. C. P. B. Jefferys's villa, Sommariva (Plates 69, 70; I-63) remains in something approaching its original state. Foster suggests that Jefferys, a "civil engineer whose outstanding achievement was the Sand Patch Tunnel on the Baltimore and Ohio Railway, then one of the longest tunnels in the world" may well have designed the house for his own use.[11] It is, in any case, a far less exuberant example of the Stick Style than either the Gallatin or Satterthwaite villas. It faces Hook Pond but seems rather removed from its context—a bland, generalized composition, comfortable but not artistically challenging.

Of these earliest summer cottages, neither the Stick-Style houses of the wealthy businessmen nor the Gothic cottages of the clergymen were built with a feeling for the local landscape, development patterns (the first clergymen's cottages were not even related to a street system), or the architectural traditions of East Hampton.

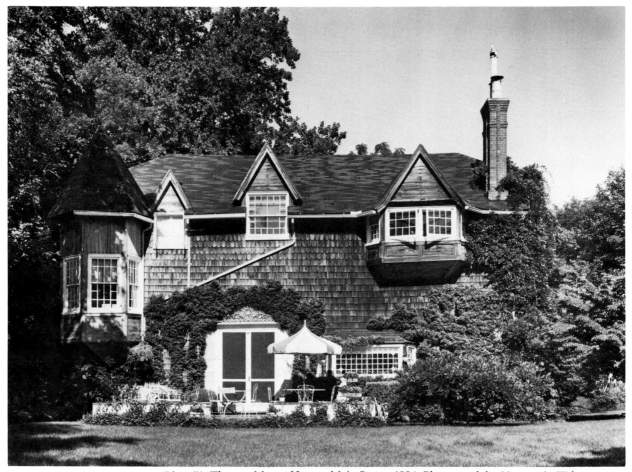

Plate 71. Thomas Moran House, Main Street, 1884. Photograph by Harvey A. Weber.

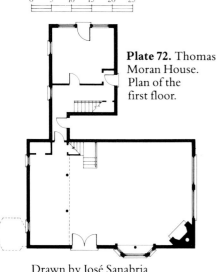

Plate 72. Thomas Moran House. Plan of the first floor.

Drawn by José Sanabria and Oscar Shamamian.

The character of East Hampton was to change noticeably after the Centennial when the village began to become established as a regular summer resort in the contemporary sense. In the late 1870s the malaise of the post-Civil-War period waned. There was a spurt of interest in the nation's pre-Revolutionary past triggered by the Centennial celebration in Philadelphia. Many Americans, liberated from cities by the railway system, set out into the countryside to experience the simpler life of the preindustrial villages. Until after 1896 East Hampton was not even connected to New York City by the railroad which had been extended only to Bridgehampton six miles to the west before heading north to Sag Harbor. Therefore, it was more a backwater than any other colonial village on the south shore of Long Island. Nevertheless, East Hampton was "discovered" in 1877 when *Scribner's* magazine commissioned a group of writers and artists from New York to report on the villages of Long Island. Many of these artists and writers belonged to the Tile Club (so called because each member was obliged to decorate a tile for the Club's weekly meetings). The following is an account of the local scene which the young artists encountered on their first visit:

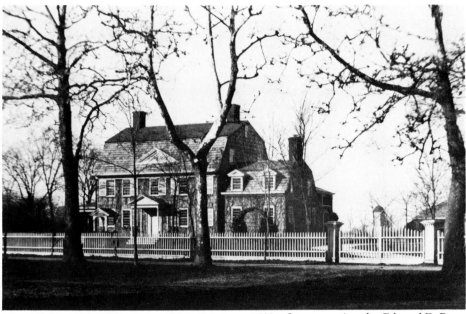

Plate 73. Jeremiah Miller House, Main Street, ca. 1799, after renovations by Edward DeRose in 1885. The windmill replica built by DeRose in 1885 is in the background (I-76). Photograph by H.K. Averill, Jr., Courtesy of C. Frank Dayton.

[The village] consisted of a single street, and the street was a lawn. An immense *tapis vert* of rich grass, green with June, and set with tapering poplar trees, was bordered on either side of its broad expanse by ancestral cottages, shingled to the ground with mossy squares of old gray 'shakes'—the primitive split shingles of antiquity. The sides of these ancient buildings, sweeping to the earth from their gabled eaves in the curves of old age, and tapestried with their faded lichens, were more tentlike than houselike. The illimitable grassy lawn stretched east and west to infinity. Not the Warwickshire landscape, not that enchanted stretch from Stratford to Shottery which was Shakespeare's lovers' walk, is more pastorally lovely.

Every house in these secluded villages is more than two hundred years old. They last like granite—weather-beaten, torn to pieces, and indestructible. They alternate with smart cottages covered with the intensest paint. 'Pretty as a painted boat' is the beach-dwellers' ideal of elegance, and the garish freshness that appropriately constitutes the comeliness and the salvation of a boat is naturally the artistic standard in land-architecture too.[12]

Some of the Tile Club artists were so taken with East Hampton that they decided to make it their summer home, boarding at various houses along Main Street. Winslow Homer stayed only a short time, but Childe Hassam, Thomas Moran, and Mary Nimmo Moran became life-long summer residents.

Other visitors were not only impressed with the special character of the village but with the natives as well. The Reverend Dr. Todd, on vacation from his home in Tarrytown, New York, observed that "a peculiar charm of antiquity and quaintness seems to hang over the whole place, and its impression on the visitor is deepened by the manifest pride which its inhabitants feel

in their ancestry, and by the care they take to preserve every souvenir that keeps alive the memory of the past."[13]

The fifteen-year period that followed the Tile Club's visit has been classified as the Boarding House Era. Though an oversimplification, this term does accurately reflect the fact that the artists and clergymen, as well as most of the other summer colonists, either boarded with local families or lived in houses rented from them, during which time many of "the natives [lived] on their back lots in summer in rudely constructed huts."[14]

The summer colony did not become firmly established until around 1890. Many of the summer visitors then began to build "cottages" for their own use or purchased cottages built on speculation either by enterprising businessmen of the village or occasionally by other summer people. All through the nineties the prominent summer people focused attention on East Hampton and its summer colony through their own appearances in the popular press. Jeanette Edwards Rattray quotes a journalist for the New York *World* who noted that

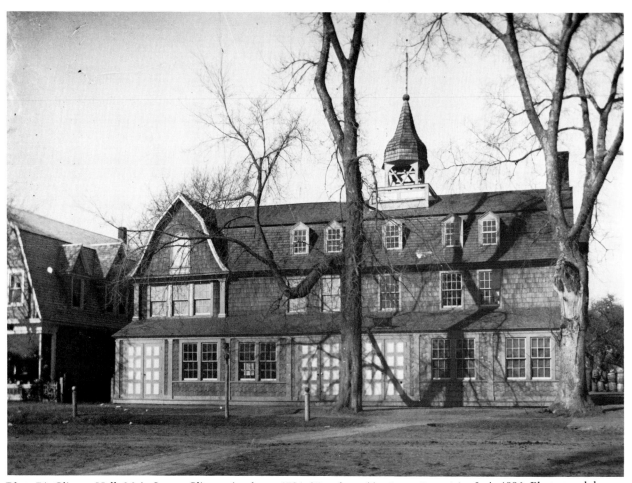

Plate 74. Clinton Hall, Main Street. Clinton Academy, 1784–85, enlarged by James Renwick, Jr. in 1886. Photograph by Mary Buell Hedges. Courtesy of Adele Hedges Townsend.

...like Bar Harbor, East Hampton was discovered, as far as the summer colony goes, by artists. I don't say East Hampton will ever become a second Bar Harbor, but it was begun on the same lines and has the advantage of being very much nearer New York. Neither the natives nor the summer residents want either a railroad or a hotel...they fear that improvements would make East Hampton...fashionable."[15]

The railroad did come to East Hampton in 1896, however, as did a hotel, the Maidstone Inn, in 1901. But the hordes of unwashed urban poor that many no doubt feared never materialized nor did the more likely enemy, the "lesser ranks" of the nouveaux riches who, unable to survive at Newport, might well have chosen to test the waters at East Hampton.[16] From the 1870s until well into this century the artists, clergymen, and old-line families set the tone.[17]

Nothing of significance was built during the so-called Boarding House Era. By the 1880s three developments occurred that anticipated the direction the development the summer colony was to take after 1887: the construction of the Moran studio; the renovation of the Jeremiah Miller house for summer use; and the conversion of the former home of the Clinton Academy into a social hall.

The first important summer house to be built in a vernacular or provincial style was that of Thomas and Mary Nimmo Moran, two of the Tile Club artists who had decided to make East Hampton their permanent summer home. In 1884 they built a combined studio and house (Plates 71, 72; I-75) on a site set back from Main Street across from the village green. In many important ways, the Moran studio can be said to have set the tone for the summer cottages built in the 1890's; shingled and gabled, it resembles a traditional East Hampton barn modified in an original, even quirky, style with a number of delightful bays and oriels. The effect is wonderfully free and inventive. Its plan is open and loosely organized, shockingly so for its time. In 1890 a writer for the New York *Herald* caught the spirit of the house:

> Moran spends his summer here in a weather-beaten shingled house of novel interior. The first floor is devoted to a studio, with an immense plate glass window looking out toward the north, and a winding stair leading to regions above. Great screens form partitions when necessary and I hear that when meal time comes the table is set behind one of these.[18]

A year later, in 1885 Edward De Rose of New York bought the Jeremiah Miller house (Plate 73; I-29), one of the old houses on Main Street, moved it back from the street, and remodeled it. This renovation marked the beginning of a second important and enduring trend which not only served to obscure the "boundaries" between summer colony and village, but which, because De Rose significantly chose to keep the character of the original house, further reinforced the plain shingled architecture of the village as a paradigm for new summer houses. The local press was astonished by De Rose's decision to keep the original character of the old house. A writer in the *Star* pointed out that though the interior of the house has been completely reconstructed, "the old time style of finish has been retained and any one would think, from a cursory glance at the inside, that he was gazing upon a house in construction many years ago."[19]

By the late 1880's, East Hampton's summer colonists, like those at Newport and Narragansett, began to feel the need of a meeting hall at which to hold dances and other social events. Characteristically, instead of building a new structure, the summer colonists led by Frederic Gallatin undertook to finance a number of improvements to the eighteenth century Clinton Academy building on Main Street (Plate 74; I-219), in order to make it suitable for summertime parties and for the use of local residents in the off-season. Gallatin contributed Renwick's services as architect for the renovation; and the project added, at the rear, a ballroom with a gallery. Renwick's renovation is notable, like that undertaken by De Rose, for its sympathetic treatment of the building's original style.

Given the conservative nature of the summer residents, the popularity of the local, shingled vernacular, and the example set by Moran and De Rose, it is not surprising that the first significant wave of summer-house development closely followed the traditional architectural culture of the area.

In 1887 a large tract of land across from the Gallatin and Satterthwaite houses was made available for development and the first boom in summer cottage construction began. The solidly entrenched businessmen and professionals with access to "old" money took advantage of the availability of land at the edge of the village. Within ten years, or so, a second major tract would be auctioned in the area, covering much of what is now the summer colony.

The four original villas had been sited along what was to become Ocean Avenue, a natural extension of the village's Main Street leading toward its principal geographical asset, the beach. Thus a development pattern was established which resulted in the close physical continuity between the summer colony and the village. This accident of town planning, perhaps no more than a by-product of real estate development, has made the summer colony seem more a part of the village than an imposition on it.

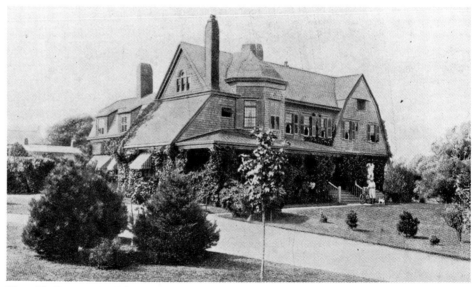

Plate 75. Everett Herrick House, Ocean Avenue, I.H. Green, Jr., 1887. Courtesy of the East Hampton Free Library.

In 1887 a large tract of land was opened up across Ocean Avenue from the four original villas. The first house to be built on the new tract was Pudding Hill (Plate 75; I-77), designed by I. H. Green for Dr. and Mrs. Everett Herrick in 1887. Green was an architect with offices in Sayville, some forty miles west on Long Island. Working within the Shingle Style of his day, Green was able to relate Pudding Hill to the eighteenth century architecture of the village. The Herrick's house was not only "inspirited" by what Scully has described as "the plasticity and warm surface texture [of] the plastic, gambrel-roofed types of the early eighteenth century, "but also possessed some of the eccentric charm of the Moran cottage.[20]

Because Green's design for Pudding Hill was based on his earlier scheme for the W. N. Terry summer house at Sayville (Plate 76), it is unlikely that he had any particular sense of the East Hampton vernacular.[21] Rather, he was simply adept at the fashionable Shingle-Style mode of the day. In fact, the plan of Pudding Hill is a simple reversal of that drawn for the Terry house. Pudding Hill is a fully developed example of the Shingle Style with a generous stair leading up from a living hall to second-story bedrooms. Broad verandas originally gave most of the downstairs rooms direct access to the out-of-doors, though the extension of the house by Green in 1906 closed many of these and cut the interiors off from nature. Pudding Hill is dominated by Green's favorite gambrel roof, against which a shed roof is leaned at one end and a bell-topped tower is massed just off the center. It resembles the roof-scape of Clinton Academy and the numerous windmills found in the village.

Plate 76. Summer Residence for Mr. W.N. Terry at Sayville, L.I., I.H. Green, Jr., Sayville, Long Island. From *Architecture and Building,* 23 April 1887.

Pudding Hill appears to have been well received among the members of the nascent summer colony. In 1888, Green was commissioned to design a house for Dr. and Mrs. George Munroe (Plates 81, 82; I-78) on the adjacent parcel. The Munroe house with its long gable roof sheltering a piazza that stretches across two elevations is one of Green's most accomplished works in East Hampton. A service wing at right angles is tucked away in the rear. The house is only one room deep, with generous openings to provide for ventilation and view. The interior is very simply detailed with "mouldings, doors, mantels and other details following closely the correspondingly colonial work in the old East Hampton houses."[22]

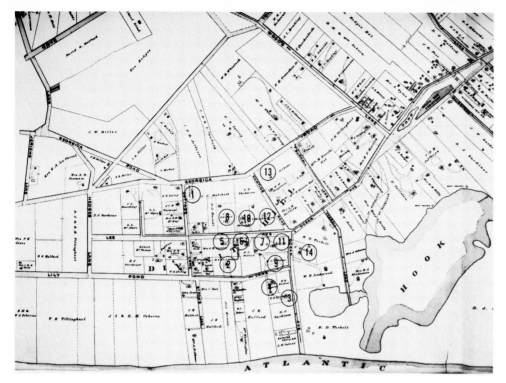

1. Thomas Nash House (I-127)
2. Ireland House (burned ca. 1960)
3. The Lanterns (burned 1935)
4. W. Tyson Dominy House (I-125)
5. William M. Carson House (I-122)
6. Mrs. E.J. Vaughan House (I-88)
7. First Frederick G. Potter House (I-11
8. Charles H. Adams House (I-85)
9. E. Clifford Potter House (I-117)
10. Mrs. C.L. Hackstaff House (I-115)
11. Warren G. Smith House (I-81)
12. First Schuyler Quackenbush House (
13. Fourth S. Fisher Johnson House (I-14
14. Stephen Mershon House (I-61)

Plate 77. Map of the Summer Colony in 1902. From *Atlas of Suffolk County, Long Island*, E. Belcher Hyde, Brooklyn, 1902. Courtesy of the Suffolk County Historical Society.

Plate 78. The Summer Colony in 1904. This view is from the dunes to the east of the main beach pavilion. Photograph by Fullerton, 1904. Courtesy of the Suffolk County Historical Society.

Plate 79. Lee Avenue looking east. The Arthur T. Dunbar House (I-140) is in the foreground. Photograph by Professor Robert Wood, ca. 1908, using a camera attached to a kite. Courtesy of Elizabeth Bogert.

te 80. The view from the dunes to the summer colony in 1904. The Sea Spray Inn, moved from Main Street to the dunes in 1902 (burned in 1978) the foreground. The only buildings on the broad treeless plain from the dunes to Lily Pond Lane are the stable and carriage house of Mrs. Louise :hington (I-119). Photograph by Fullerton, 1904. Courtesy of the Suffolk County Historical Society.

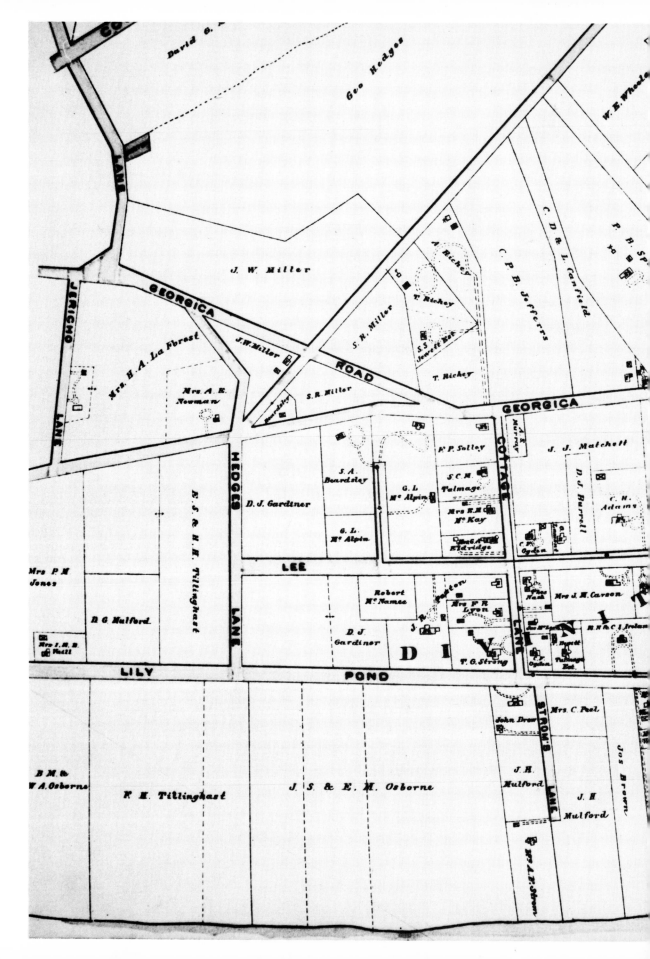

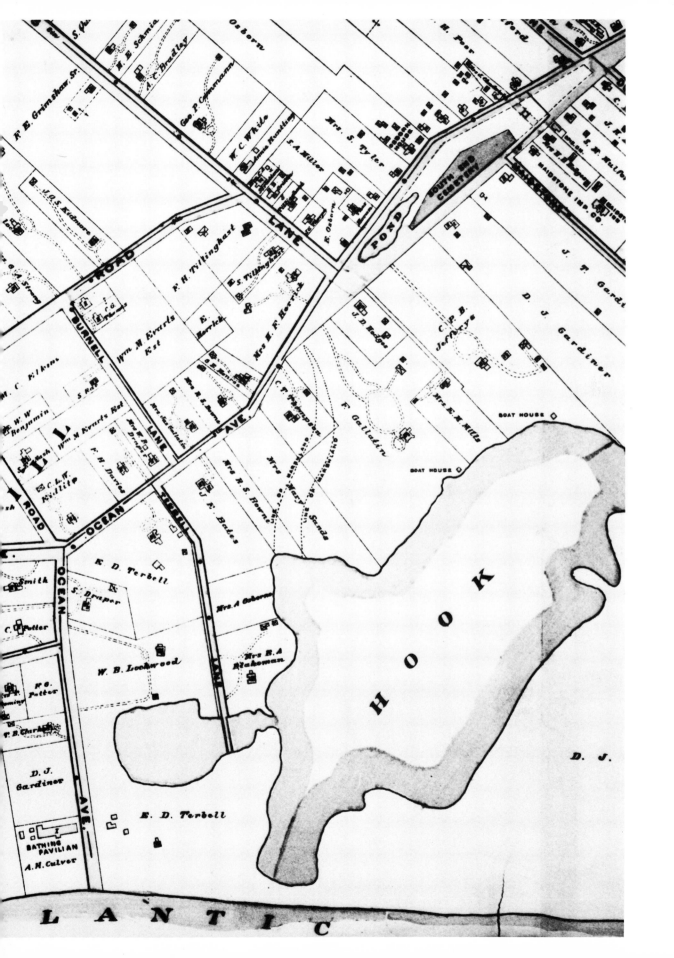

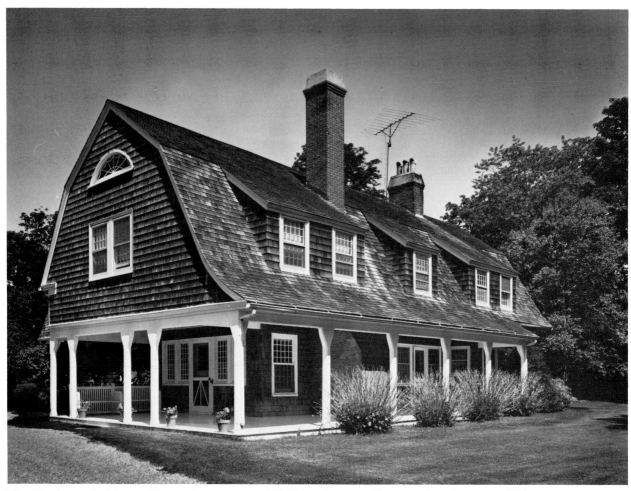

Plate 81. George E. Munroe House, Ocean Avenue, I.H. Green, Jr., 1888. Photograph by Harvey A. Weber.

Plate 82. George E. Munroe House. Plan of the first and second floors. Redrawn from *American Architect and Building News,* 7 December 1907.

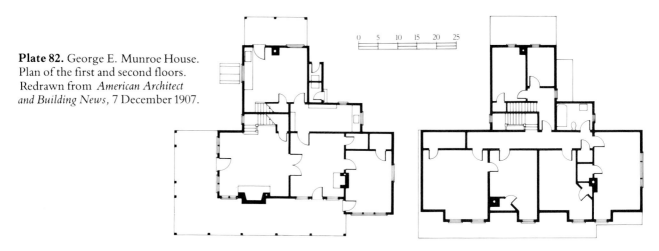

The virtues of the Herrick and Munroe houses were quickly perceived: in 1890 W. S. Boughton, the new owner of the East Hampton's recently founded newspaper, the *Star,* wrote that the Herrick cottage "combined a bit of seaside-resort architecture with the style of the native old-fashioned houses."[23] Even as late as 1907, when the Shingle Style was long out of fashion, the editors of the *American Architect* saw fit to publish the Munroe house and to comment upon its "sympathy of design and economy of construction. With these objectives in view the general character and simple lines of the houses built more than a century ago by the early settlers of East Hampton were followed so far as modern requirements would permit."[24]

Green's practice in East Hampton flourished in the 1890s. In 1889–90 he built a house for the Misses Ireland on Lily Pond Lane employing specific references to the characteristic saltbox cottages of the village. The Ireland cottage was destroyed in a fire in the early 1960s and no photographs have been found except for a distant glimpse taken in 1902 (Plate 83).

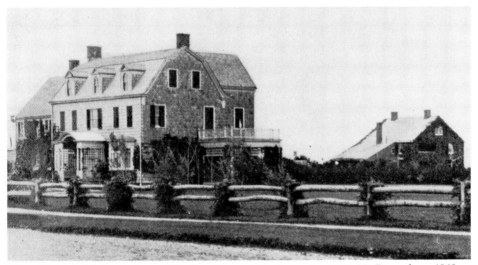

Plate 83. (right) Ireland House, Lily Pond Lane, I.H. Green, Jr., 1889–90. Burned, ca. 1960. (left) William M. Carson House (I-122). From *Architectural Record,* January 1903.

In 1890–91 Green was very busy in East Hampton with houses for the Wheelock family as well as the clubhouse for the newly founded Maidstone Club. It is difficult to know exactly what Almy Wheelock's house (I-83) originally looked like. Extensive renovations undertaken by Aymar Embury II in 1929–30 transformed it into an Adamesque-colonial mansion, but the house Green built for Almy Wheelock's son, William Efner Wheelock (I-84) at the back of the property on the socalled *inner dune* remained pretty much intact until renovations were undertaken by the author in 1979–80. The Efner Wheelock house is a simple, horizontal gambrel-roofed cottage on two floors with two subsumed porches at the ground floor, one facing the ocean. Its interior (and no doubt that of the Almy Wheelock house as well) is justly noted for its lovely chestnut paneling and for the pioneering collection of locally crafted eighteenth- and early-nineteenth-century furniture which was assembled by the owners. The Wheelocks not only appreciated and collected

the work of such distinguished local craftsmen as the Dominy family but they were also the first in East Hampton to demand historical authenticity in the execution of some of the details of their house design. The hardware for their doors, for example, was fashioned after those on the "little old Town House"[25] which stood in Main Street across from the Presbyterian Church.

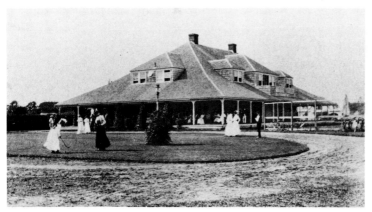

Plate 84. First Maidstone Clubhouse, Maidstone Lane, I.H. Green, Jr., 1891. Burned, 1901. Courtesy of the East Hampton Free Library.

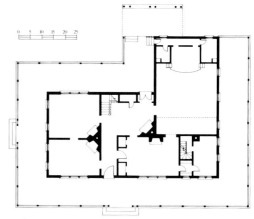

Plate 85. First Maidstone Clubhouse. Plan. Redrawn from *Architecture and Building,* 13 February 1892.

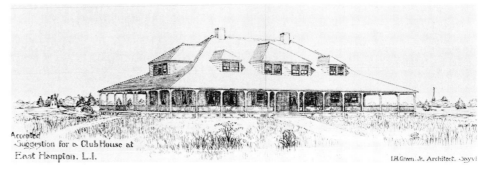

Plate 86. First Maidstone Clubhouse. Drawn by I.H. Green, Jr. From *Architecture and Building,* 13 February 1892.

The first Maidstone Clubhouse (Plates 84, 85, 86) which Green designed in 1890–91, was located just east of the village green approximately where the Club's tennis house is now located. It burned in 1901 and Green was called in to design a larger replacement (Plate 87). This in turn burned in 1921 and Roger Bullard designed the new clubhouse on the dunes. Green's two designs were low, shingled structures with ample roofs sheltering piazzas. In each, Green skillfully adjusted a relatively large-scale public program to the residential architectural character of the neighborhood.

In 1899–1901 East Hampton's first hotel, the Maidstone Inn (Plate 88) was built adjacent to the clubhouse. For this, Green provided a gambrel roof that sheltered a relatively large building, again within the context of the neighborhood's buildings.

Green was busy in East Hampton throughout the 1890s and early 1900s. Greycroft (I-91), the large house he designed for Mr. and Mrs. Lorenzo G.

Woodhouse on the south side of Huntting Lane in 1893–94, is nearly comparable in quality to the Munroe cottage. Its plan is cross-axial with a lovely stairway rising at the center, illuminated by an intricately designed fan window above. Delicate fanlights also light the gable ends and attic dormers striking a notable balance between the informality of the local vernacular and the tendency toward abstract order apparent in the plan and the execution of the Adamesque-colonial details.

In the same year, 1894, Green completed John D. Skidmore's house (Plate 89; I-92) on Georgica Road. Though a less characteristic design, perhaps because Green was only the supervising architect (the *Star* reported that

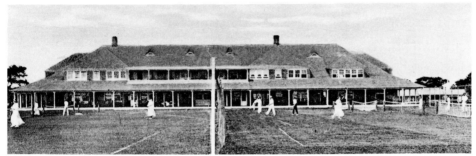

Plate 87. Second Maidstone Culbhouse, Maidstone Lane, I.H. Green, Jr., 1910. Burned, 1921. Courtesy of Averill D. Geus.

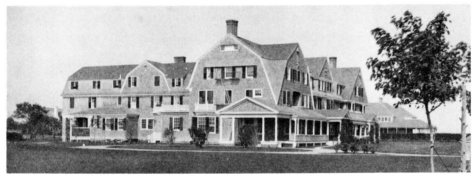

Plate 88. Maidstone Inn, Maidstone Lane, I.H. Green, Jr., 1899–1901. Burned, 1935. The second Maidstone Clubhouse is in the background. Courtesy of the East Hampton Free Library.

Skidmore's son, Samuel, was the original designer)[26] it nevertheless utilizes Green's favorite flared gambrel roof sheltering a broad piazza. Pedimented and shed dormers are combined to create a continuous band of evenly spaced windows that give an uncharacteristic monumentality to the facade.

In 1895 Green designed a modestly sized house for Annie Huntting (I-94) who used it to take in boarders. After that he only built four more times in East Hampton. Younger, locally based architects and builders absorbed his style and were able to do almost as well with it. In 1901 as we have seen, Green designed the second Maidstone Clubhouse. In 1902 he designed a generously proportioned, gambrel-roofed cottage for Max E. Schmidt (I-137) which brings to a conclusion the cycle of gambrel-roofed cottages Green had initiated fifteen years earlier. In 1915 he built for a final time in the Village, but this

house for Mr. F. Stanhope Phillips (I-164) on Dunemere Lane, with its massive proportions, seems unrelated to the earlier Shingle-Style architecture.

Although Green did not introduce the gambrel roof to East Hampton, his frequent use of this form led other architects and builders to adopt it. By the 1890s it came to seem every bit as indigenous an expression of the local character as the lean-to profile of "Home Sweet Home" (I-5). It can be seen in

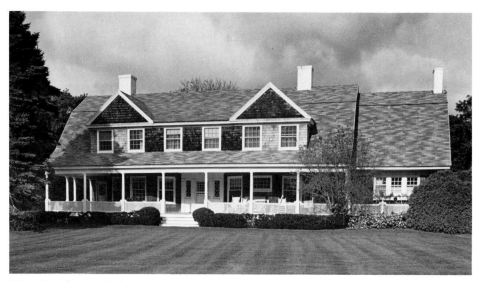

Plate 89. John D. Skidmore House, Georgica Road, I.H. Green, Jr., 1894. Photograph by Harvey A. Weber.

the Bowne house (I-79) and in Mrs. E. J. Vaughn's cottage on the south side of Lee Avenue. The Vaughn house (I-88), built in 1892 by George A. Eldredge, a self-taught architect and builder responsible for a considerable number of houses in East Hampton in the 1890s and 1900s, not only demonstrates the adaptability of the more intellectually conceived Shingle-Style formula to less well-trained talents but also shows that the gambrel-roof could be adapted quite successfully to more modest houses. Eldredge's house for Clara Ogden (Plate 90; I-112) in 1899 is perhaps his most skillful. The use of a cross-axial plan and an exaggerated gambrel establish a scale appropriate to its location at the end of Drew Lane.

In 1901 Eldridge, assisted by John Custis Lawrence, a young architect, used the gambrel roof again at modest scale in designing the E. J. Edwards Drug Store (I-231) which was built next door to Clinton Hall on Main Street. The *Star* commented that "the exterior of the store...with the exception of the lower half of the front, more nearly resembles a Colonial cottage than a business building." Lawrence was responsible for the design of the drug store's interior, including a ceiling of green opal glass panels, white tile floors, and fine, wood cabinet-work, which the *Star* found to be "entirely different from anything ever seen here before."[27] Eldredge and Lawrence's finest moment is the H. A. Wessell house on Middle Lane (Plates 91, 92), an ample, gambrel-roofed cottage, one end of which is a tower treated as a faithfully detailed replica of a local windmill.

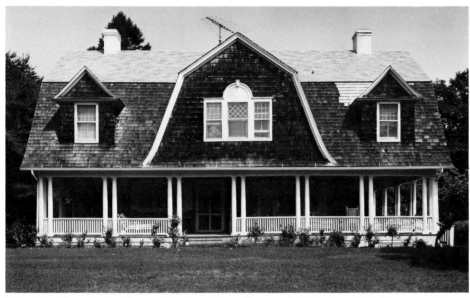

Plate 90. Clara Ogden House, Lily Pond Lane, George A. Eldredge, 1899. Photograph by Harvey A. Weber.

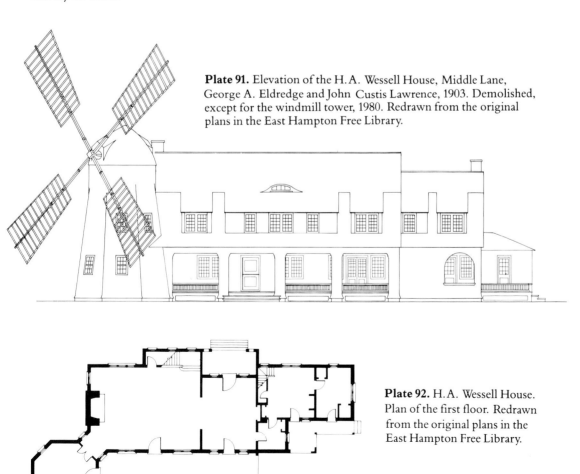

Plate 91. Elevation of the H.A. Wessell House, Middle Lane, George A. Eldredge and John Custis Lawrence, 1903. Demolished, except for the windmill tower, 1980. Redrawn from the original plans in the East Hampton Free Library.

Plate 92. H.A. Wessell House. Plan of the first floor. Redrawn from the original plans in the East Hampton Free Library.

0 5 10 15 20 25

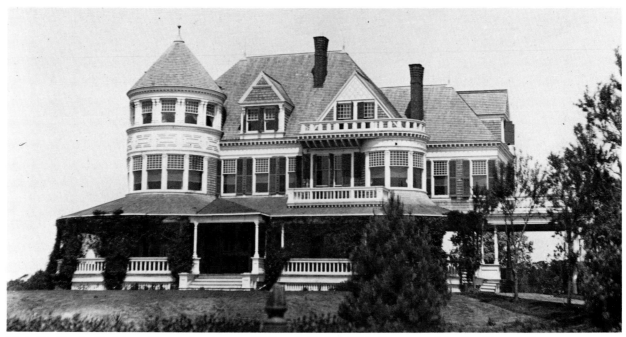

Plate 93. Charles H. Adams House , Lee Avenue, William B. Tuthill, 1891. Courtesy of the *East Hampton Star.*

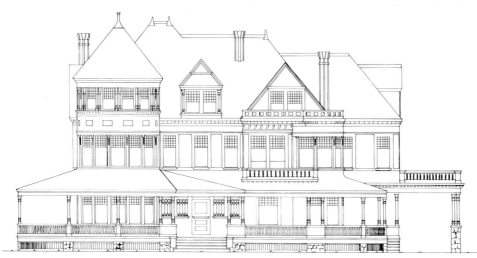

Plate 94. Elevation of the Charles H. Adams House. Redrawn from the original plans.

Plate 95. Charles H. Adams House. Plan of the first floor. Redrawn from the original plans.

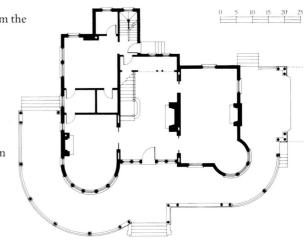

Eldredge could also emulate the style of J. G. Thorp, a leading architect with offices in New York and East Hampton (see below). In 1901 the *Star* reported that

> some people have discovered that it is possible to have a handsome cottage erected after designs made right here in East Hampton. Our local builders are competent to design and erect cottages that will compare favorably with houses fashioned by New York architects.[28]

One such house designed by Eldredge and assisted by J. C. Lawrence is the W. W. Benjamin house (I-136) on Crossways, which when completed in 1902, was described by the *Star* as

> suggestive of colonial days. . . . Entering from the front porch you find yourself in a large hall finished in Old English walnut with a well-designed stairway at the opposite side. On the left is a large. . . dining room with woodwork of colonial design. . . on the right of the hall is the living room finished and furnished in sixteenth century style.[29]

Although Green established the stylistic tone for the first generation of summer cottages in East Hampton, not all the early summer colonists and their architects were willing to build as modestly nor exhibit as much sensitivity to the local vernacular.[30]

The house of New York State Senator Charles Adams (Plates 93, 94, 95; I-85), built in 1891 on the Ocean Terrace (later Lee Avenue), is probably the biggest cottage ever built in East Hampton, and surely far bigger than the typical cottage of the eighties and nineties. Designed by William B. Tuthill,

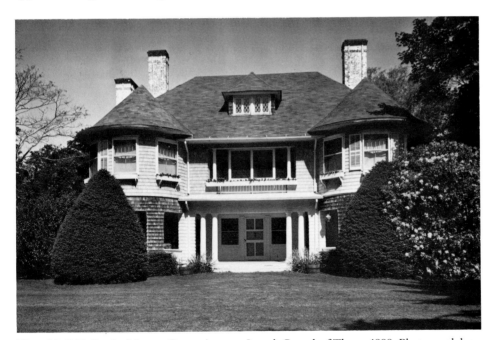

Plate 96. F. H. Davies House, Ocean Avenue, Joseph Greenleaf Thorp, 1899. Photograph by Harvey A. Weber.

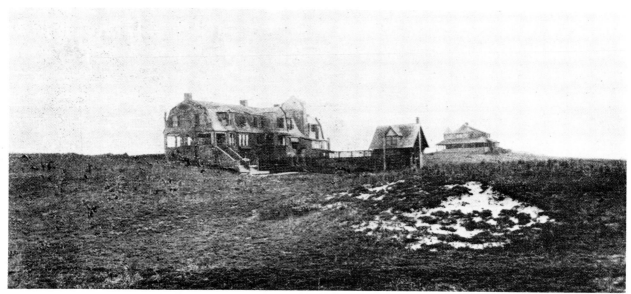

the architect of Carnegie Hall in New York, its magnitude prompted a contemporary observer to remark (and probably not with the kindest of intentions) that "it looks more as if it belonged in Newport than in East Hampton, and is grandly proportioned and equipped."[31] Despite the use of shingles and white-painted wood trim, its broad piazza and four-square placement on the site as well as the rigid symmetry and verticality of the composition prevent it from establishing close links with either the local colonial style or the Shingle Style. It is stuffy and pompous. Eleven years later

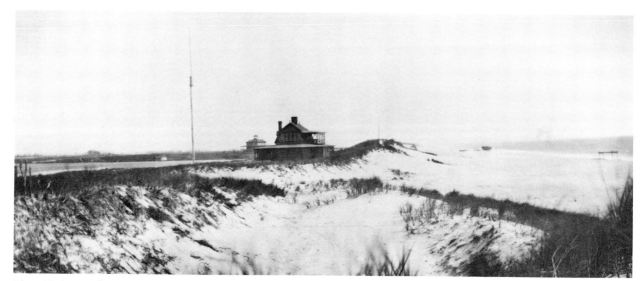

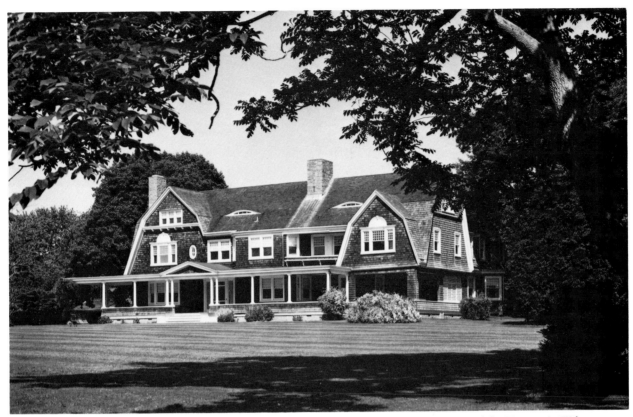

Plate 99. Schuyler Quackenbush House, Lee Avenue, Cyrus L. W. Eidlitz, 1898–99. Photograph by Harvey A. Weber.

Plate 100. Schuyler Quackenbush House. Plan of the first floor. Drawn by José Sanabria and Oscar Shamamian.

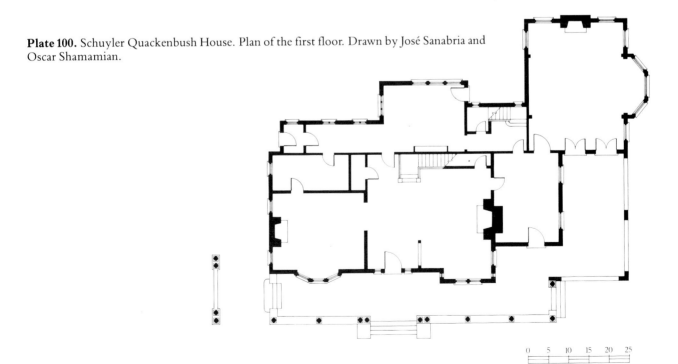

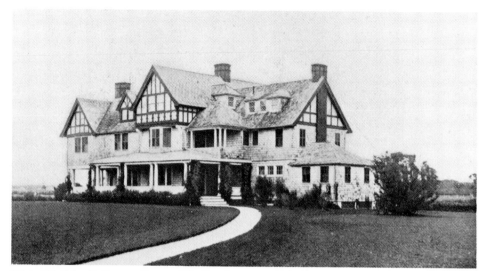

Plate 101. John R. Paxton House, Lily Pond Lane, Joseph Greenleaf Thorp, 1901. From *Architectural Record*, January 1903.

J. Greenleaf Thorp would demonstrate in the Davies house (Plate 96; I-114) on Ocean Avenue that similar compositional strategies could be handled in a more relaxed manner.

At the same time that the summer colony was beginning to develop at a suburban scale along the land stretching between the village and the beach and a more rural kind of development along the so called inner dune was being initiated by the Wheelocks, the ocean front was very slowly beginning to be colonized. Although five houses already had been built along the dunes just to the west of the lake in Wainscott, the first house built on the dunes of East Hampton was that of Reverend Heber Newton who in 1888 erected a cottage

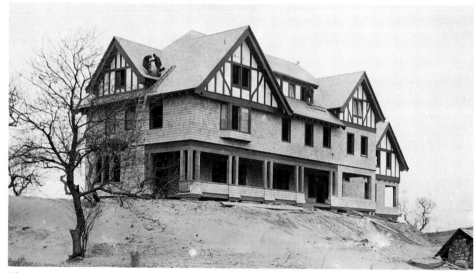

Plate 102. S. Fisher Johnson House, Georgica Road, John Custis Lawrence. 1903–4. Courtesy of the East Hampton Star.

on the spit of land which separated the ocean from Georgica Lake. At the Newton house a low-hipped roof sheltered a ten-foot-wide piazza on all four sides. Three years later, Newton's house was followed by a more elaborate beach cottage built for Laura Sedgwick. The Sedgwick cottage (Plate 97; I-86), like Heber Newton's, may well have been the work of the young architect from New York, Joseph Greenleaf Thorp, who began summering in East Hampton in 1889. Thorp was in any case responsible for the additions which were made to it in 1894 and again in 1896.

In 1893, a third house was built on the dunes by Howard Russell Butler (Plate 98; I-90). The architect is unknown. The house is unusual in its combination of the enveloping gambrel-roofed type, well established in the village by the early 1890s, with appended porches whose elaborate basketry of braces and supports recalls the earliest Stick-Style cottages.

The economic collapse of 1893 interrupted building but by the end of the 90s, when the economy improved and a number of new houses were under construction, the attitude of the summer colonists and their architects toward style had changed somewhat from that of the late 1880s and early 1890s. The Shingle Style continued to dominate the local production with Green as its leading exponent, J. G. Thorp producing excellent, if somewhat dry, designs and Cyrus L. W. Eidlitz designing a modest Shingle-Style house for himself (I-103) and a far more ambitious one for his sister and brother-in-law, Mr. and Mrs. Schuyler Quackenbush (Plates 99, 100; I-107). Eidlitz, who is not known for his work as a domestic architect, outdid himself at the Quackenbush house which deKay characterized as a "handsome villa, something more than cottage, less than manse."[32] The principal section of the house (which may once have been U-shaped with a courtyard at the rear) consists of a long gambrel roof interrupted by two asymmetrically placed, cross-gambrel dormers, each a different size. Eyelid windows and eccentrically placed chimneys further enliven the roof while a continuous veranda outside the main volume of the house as well as a syncopated rhythm of windows give an exceptionally lively effect.

Two other late, Shingle-Style cottages command our attention: the Reverend John Paxton cottage on Lily Pond Lane, designed by Thorp in 1901, and the S. Fisher Johnson cottage on the inner dune, designed in 1903–4 by J. Custis Lawrence. The Paxton cottage (Plate 101; I-131) exhibits none of the compositional calm of Green's typical, gambrel-roofed cottages. Its restless combination of half-timbered gables, numerous dormers, and diagonally latticed, as well as plain, double-hung windows, are effectively tied together along the front by a broad, covered piazza. Better preserved and less busy is the S. Fisher Johnson cottage, Onadune (Plates 102, 103, 104; I-143), which upon its completion was described as "one of the most pleasantly located and costly residences in town, situated on a high terrace on the dunes."[33] It has expansive views in all directions including south across the summer colony to the sea. Although the overall composition of the house, with its many-gabled roof, subsumed piazzas, and broad stair rising from a living hall should be seen as representative of the Shingle Style, the extensive use of half-timbering led a writer in the *Star* to describe it as "Elizabethan in style."[34]

The Quackenbush, Paxton, and S. Fisher Johnson houses mark a late, exuberant flowering of the Shingle Style in East Hampton.[35] More typical of

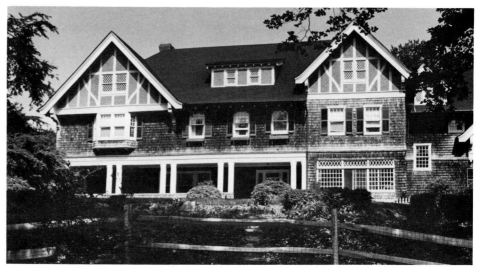

Plate 103. S. Fisher Johnson House, Georgica Road, John Custis Lawrence, 1903–4. Photograph by Harvey A. Weber.

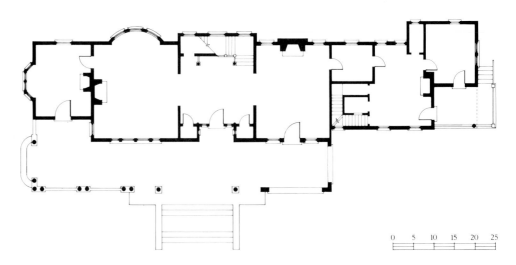

0 5 10 15 20 25

Plate 104. S. Fisher Johnson House. Plan of the first floor. Redrawn from the original plans.

the period were the relatively bland, almost banal, but nonetheless satisfying houses that J. G. Thorp produced in seemingly endless succession, houses so similar as to constitute what deKay described as a type. These houses, which cost from $8,000 to $12,000, are, as deKay put it,

> almost without exception simple developments, not from the colonial manse, but from the colonial dwelling of wood, only the dwelling is generally more liberal in porches and loggias than the early settler's house, as befits the home that is for summer only.[36]

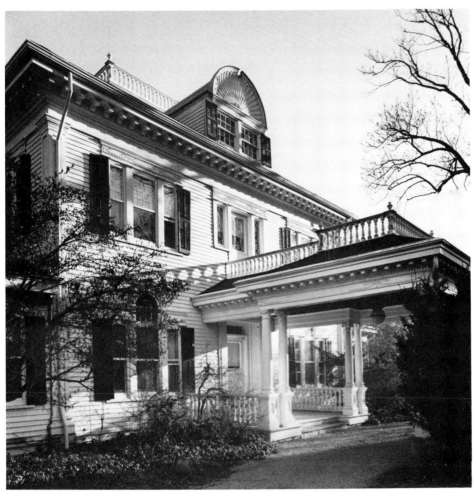

Plate 105. Satterthwaite–Thompson House, Ocean Avenue, after renovations attributed to McKim, Mead, and White in 1893–95. Photograph by Harvey A. Weber.

Plate 106. Satterthwaite–Thompson House. Detail of shell. Photograph by Harvey A. Weber.

It is Thorp's somewhat bland hand that has stamped the architecture of the summer colony more than any other; deKay observed, "the character of East Hampton's unpretentious architecture owes a good deal to [his] taste."[37] Thorp's three houses for the Potter family (I-116, 117, 148), his Hackstaff house (I-115), as well as his more elaborate Paxton house, seem as a group to define the typical summer colony cottage.

> These houses and a dozen more which it would be tedious to enumerate have the great merit of being as much the creation of the owner as the architect, the two working together within narrow limits and producing something that fits the family exactly. The margin of decorative features is small, so that these villas are less like works of the fine than of the useful or industrial arts....Here we have...something almost severe, softened to be sure by the rapid growth of rose vines, ampelopsis, clematis and honey suckle, to all of which and to their congeners the smooth moist air of Eastern Long Island is benignant.[38]

The turn of the century in America was a restless era, full of imperialistic swagger yet almost self-destructively intimidated by the example of the European past. Thus the free compositional techniques of the Shingle Style, with its specifically American vernacular references, gave way in East Hampton as elsewhere to more academic styles such as the Adamesque colonial or to work based on English vernacular cottages. Neither of these stylistic trends marked a complete break with the Shingle Style for that style had aspects of each of the other two within it.

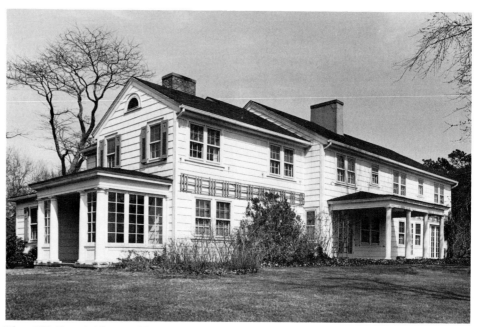

Plate 107. Francis Newton House, Georgica Road, William Welles Bosworth, 1907–10. Photograph by Harvey A. Weber.

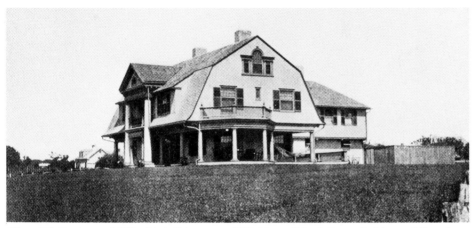

Plate 108. Lockwood Villa, Terbell Lane, ca. 1900. Demolished. From *Architectural Record,* January 1903.

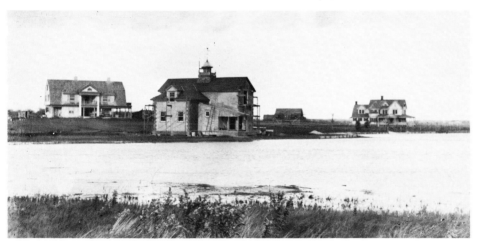

Plate 109. Lockwood Villa and carriage house and Mrs. E. A. Blakeman House (I-135). Courtesy of the *East Hampton Star.*

East Hampton never fully embraced the Adamesque-colonial style, though it was introduced in the very year of the World's Columbian Exposition when Charles Thompson, the new owner of the Satterthwaite villa hired McKim, Mead and White to renovate the house (Plates 105, 106; I-70). While it is clear that the McKim firm's work was not supervised by their office, and although there is some doubt as to whether their plans were followed at all, the house was nevertheless transformed into a small, finely-proportioned, Adamesque-colonial mansion. The square plan of the original was well suited to the demands of the new style. Its perimeter porches were closed in by a new clapboarded skin with appropriately proportioned and detailed windows, a porte cochere and new porches were added, and the interiors were rendered, as the *Star* put it, "pure colonial throughout."[39]

Probably as much on practical as on aesthetic grounds, the Thompson house was not widely emulated in East Hampton. Compared with the natural-colored cedar cladding of the Shingle-Style work, the white-painted surfaces of the Adamesque colonial create a perpetual maintenance problem in the salt air. The four-square proportions of the volume creates a deep plan and with it ventilation problems. The character is inevitably far more formal than most of the typical Shingle-Style cottages of the day. Furthermore, there was no historical antecedent to the Adamesque-colonial style in East Hampton.

Henry Terbell's house (I-60) next to Thompson's is one of the four original villas. It was remodeled in the Adamesque-colonial style in 1901 by Walter E. Brady, an architect from Southampton. Unfortunately, Brady did not proceed with much flair and the cottage, which was remodeled again in 1915, remains an imposing but uninteresting landmark.

Only one new cottage of significance was erected in the Adamesque-colonial style. In 1907–10, William Welles Bosworth designed a new house at Fulling Mill Farm for Mr. and Mrs. Francis Newton (Plate 107; I-154). Far more a country house than the typical suburban villa of the summer colony, the Newton house sat in open land at the edge of the village on the shore of Georgica Pond. Bosworth's design, based on plans originally drawn by Grosvenor Atterbury, is notably elegant with a relaxed, informal quality in spite of the refinement of the detail and the large size of the overall house. Its interiors are particularly lovely, with fine paneling. It is much more a colonial-style farmhouse than a grand Adamesque country house.

Although the strict Adamesque-colonial mode did not take root in East Hampton, a number of interesting houses were built around 1900 that incorporated fairly explicit classical motifs into the shingle cottage type. Lockwood Villa (Plates 108, 109), about 1900, is a particularly good example of this hybrid approach, combining a gambrel roof with a fairly "correct" pediment supported on two colossally scaled Doric columns. Also notable, is the

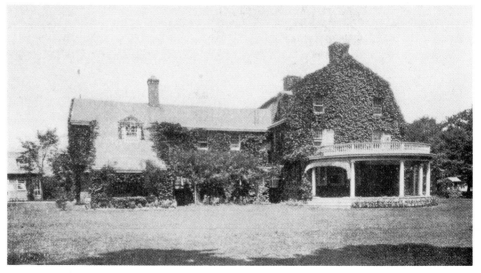

Plate 110. Jeremiah Miller House, 117 Main Street, ca. 1799, after renovations of 1885. Piazza added in 1889. From *Architectural Record,* January 1903.

90

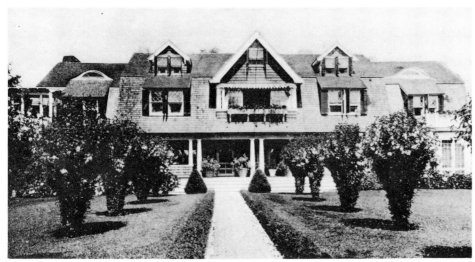

Plate 111. Lorenzo E. Woodhouse House, Huntting Lane, Joseph Greenleaf Thorp, 1903–4. Demolished 1949. Courtesy of the East Hampton Free Library.

projecting porch at one end, the roof of which is supported on Doric columns. Similarly, the west semicircular piazza, which Thomas Manson added to the DeRose house (Plate 110) in 1899, with its delicately scaled colonnade supporting an intricately turned cornice and parapet rail, brings what deKay described as the "colonial" of the "manse" to a house whose origins are strictly those of a vernacular country dwelling.

The gambrel-roofed cottage for Mrs. L. E. Woodhouse (Plate 111), designed by Thorp in 1903–4, with its nearly strict symmetry and its use of paired classical columns, also exemplifies the hybrid approach, as does the residence for Judge E. E. McCall (Plate 112) on the dunes at Georgica. Possibly the work

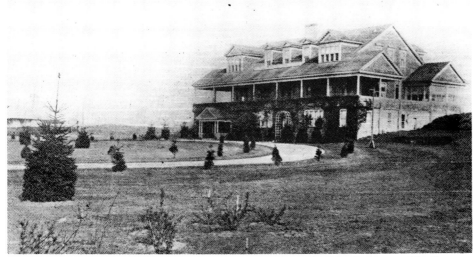

Plate 112. E. E. McCall House, West End Road, 1916. Burned 1920s. Courtesy of the East Hampton Free Library.

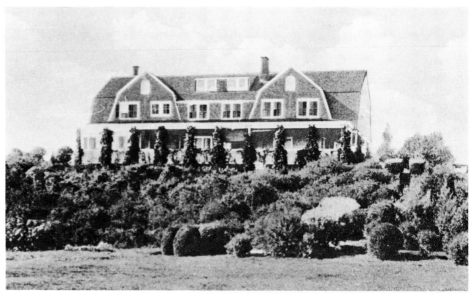

Plate 113. S. A. Beardsley House, Lee Avenue, William Strom, 1899. Demolished. Courtesy of the Nassau County Historical Museum.

of Thorp, the McCall house was an amply sized, grandly proportioned composition with its principal rooms and verandas raised to the second floor to provide a view of the ocean over the dunes at one side and of Georgica Pond on the other. The gable form is used repetitiously to define the overall volume of the house, to make porches at its ends, shelter the entrance at the ground floor, and form dormers to ventilate the third-floor bedrooms. Not only are the gables trimmed with dentilated cornices, but the roof of the grand piazza is supported by an evenly spaced classical colonnade. The McCall house burned in the 1920s.

Similarly classical in composition and vernacular in form is the S. A. Beardsley House (Plate 113), designed by William Strom, a New York architect. It majestically commanded the summer colony from atop the inner dune just west of Cottage Avenue.

Perhaps the most Adamesque in spirit of the hybrid houses, and certainly the most explicitly "fancy," was designed by James Brown Lord for John Drew, the actor. Completed in 1901, it was a simple rectangle surmounted by a boldly projecting hipped roof (Plates 114, 115). At the front, along Lily Pond Lane, the roof was interrupted on one side by twin gables as well as by two eyelid dormers. Projecting porches at each end were supported on columns. At the rear, three more dormers interrupted the roof; their roofs in turn were concealed behind scroll pediments. Even more unconventional are the carved wood panels, replete with swags of flowers, set above many of the windows.

The Thomas Nash and William Carson houses, on adjoining lots on Lee Avenue, are perhaps the loveliest of the hybrid compositions, combining the vernacular familiarity of the Shingle Style with a new sense of monumentality achieved through axial composition and explicitly classical detail. The Carson house (Plate 116; I-122) (1899) is based on a Long Island model, the eighteenth-

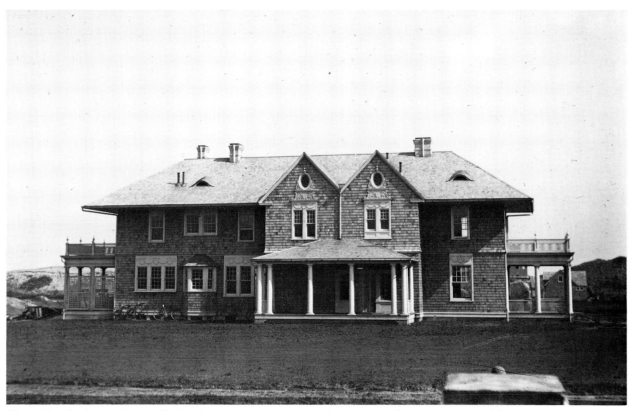

Plate 114. John Drew House, Lily Pond Lane, James Brown Lord, 1901. Demolished. Courtesy of the *East Hampton Star.*

Plate 115. John Drew House. Courtesy of the *East Hampton Star.*

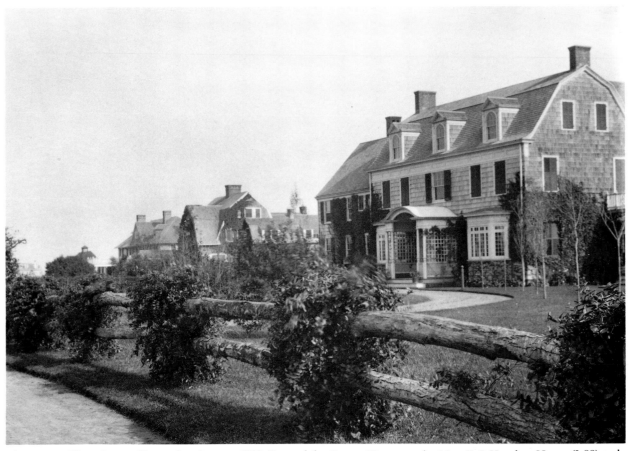

Plate 116. William Carson House, Lee Avenue, 1899. Beyond the Carson House are the Mrs. E. J. Vaughan House (I-88) and the Frederick G. Potter House (I-116). Photograph by Fullerton. Courtesy of the Suffolk County Historical Society.

century Rock Hall in Lawrence. The strictly symmetrical volume of the principal wing of the Carson house is crowned by a gambrel roof. The entrance is sheltered by a delicately curved porch roof resting on carefully proportioned pairs of vaguely classical columns. The strict axiality of the Nash House (Plates 117, 118, 119; I-127), with its slightly projecting attic pediment and gently curved entrance canopy supported by Ionic columns, is offset by a two-story, flat-roofed bay added by Nash in 1904. This addition, combined with the smaller semihexagonal bays supported on brackets all lit by casement windows, suggests an aspect of Elizabethan vernacular design unusual in a house otherwise so thoroughly classical. The Nash house contains some of the finest interior woodwork in the village.

As the reaction to the Shingle Style became popular in East Hampton, so did the neo-Elizabethan vernacular cottage. Both are to a considerable extent sides of the same coin. Each is a reaction to the formal excesses of the High Victorian Gothic and each attempts to re-establish architectural roots in the preindustrial past.

94

Plate 117. Thomas Nash House,
Lee Avenue, Thomas Nash, 1900.
From *American Homes and Gardens,*
September 1907.

Plate 118. Thomas Nash House. Stair hall. From *American Homes and Gardens,*
September 1907.

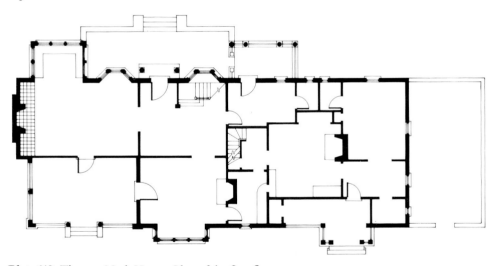

Plate 119. Thomas Nash House. Plan of the first floor.
Redrawn from *American Homes and Gardens,* September 1907.

The interest in English vernacular architecture was widespread in the 1890s
in the United States and Germany. Just as the interest in the eighteenth-
century American vernacular parallels the growth of the Shingle Style at the
time of the Centennial, so too does the interest in the English work parallel the
emergence of a new style, largely English in its origins, which has been
alternately characterized as the Arts and Crafts Style or the Free Style. In
England this new style was being explored by such architects as Edwin
Lutyens and M. H. Baillie Scott; in America, Wilson Eyre, Will Price, Harrie
T. Lindeberg, and Grosvenor Atterbury were its prominent proponents.

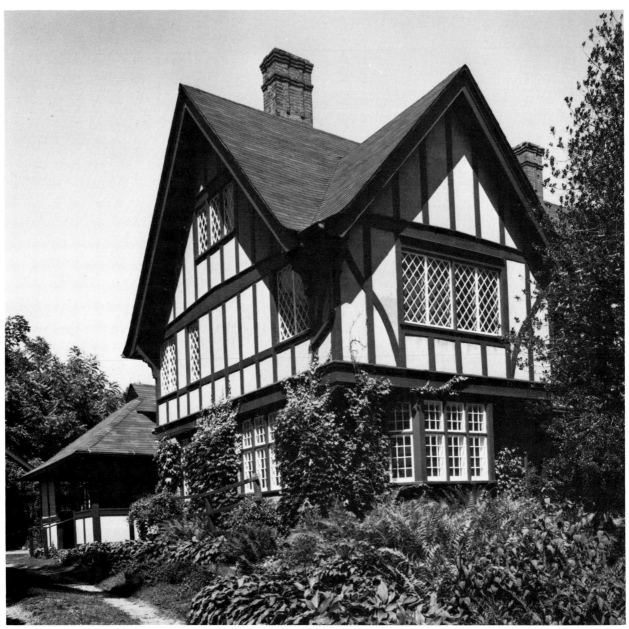

Plate 120. Joseph Greenleaf Thorp House, Woods Lane, Joseph Greenleaf Thorp, 1893. Photograph by Harvey A. Weber.

The neo–Elizabethan cottages that were built from the mid 1890s until the First World War differed significantly from the neo-Elizabethan work of the 1870's which had initially inspired the architects of the Shingle Style. Far more relaxed in composition and largely unornamented, these self-consciously modest designs were tied to the artistic and moral beliefs of the Arts and Crafts movement and mark a serious attempt to establish an alternative to the industrial civilization of the late Victorian era.

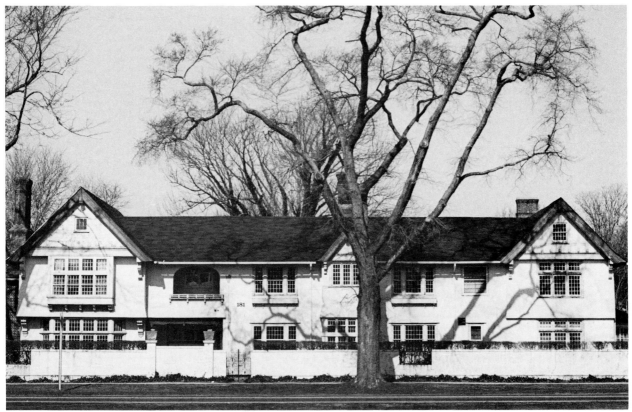

Plate 121. Miller–Papendieck–Poor House, 181 Main Street, after renovations by Joseph Greenleaf Thorp in 1911. Photograph by Harvey A. Weber.

The English "free-style" cottages well suited the anglophiliac social and cultural temper of the times. An increasingly vocal group of summer people wanted to rename the village Maidstone and transform its architectural character to that of a pre-seventeenth century Kentish village, presumably like the one the original settlers left behind in the seventeenth century. East Hampton's anglophilia was part of a broader cultural and sociological xenophobia which affected the upper middle classes as hordes of emigrants arrived from Southern and Eastern Europe between the 1890s and the First World War. It was reinforced by connections between the artists in East Hampton and their English counterparts. The Morans, in particular, had close English ties and were personally acquainted with Ruskin. The move to anglicize East Hampton reached a fever pitch in the 1920s. St. John Ervine, the English critic and essayist recently returned from a visit to the States, commented on the controversy in the London *Observer*:

> The present-day inhabitants of East Hampton are eager to change its name to Maidstone, and they have built a church in the street which is a reproduction of Maidstone parish church. . . . The singular fact about this lovely village, lying placidly under its elms and close to the Atlantic Ocean is that, although it was founded by Englishmen, and made beautiful by trees that were born in the Kentish Weald, it does not suggest England. It seemed to me to be intensely

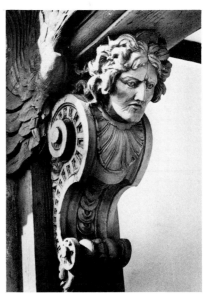

Plate 122. Miller–Papendieck–Poor House. Detail of entrance. Photograph by Harvey A. Weber.

American. East Hampton is native; New York is foreign. East Hampton is American; New York is cosmopolitan. East Hampton is a western village; New York increasingly becomes an Oriental town. I do not know how much of the founders' stock survives in East Hampton, but the founders themselves have left their mark on it; and that mark is lovely. The individualism of the English who will not submit to any authority but their own is apparent in this place, for though the founders of East Hampton came from Kent and brought live memorials of Maidstone with them, they were not content to repeat Maidstone. They made a new village and made it American. The sentiment which is expressed in the reproduction of Maidstone Parish Church and in the effort to alter the name of the village is entirely modern. The pioneers preferred to start afresh.[40]

In 1893 Thorp built East Hampton's first Elizabethan vernacular cottage for his own summertime use on a modest site on Woods Lane (Plate 120; I-89). Though notable for its fine detail in wood and its use of dark tan stucco in combination with half-timbering, the Thorp house is symmetrical and stiff in its composition. It is not clear why Thorp chose this style for his own house since during the nineties and well into the first decade of the new century, he adhered to the Shingle Style for his East Hampton clients. In fact, Thorp's only other Elizabethan cottage was the extensive renovation of the former Papendieck house (itself a renovation of the eighteenth-century Miller house) for its new owner, J. Harper Poor (Plates 121, 122; I-13). As redesigned it is a Shingle-Style cottage literally encased in a stucco skin in order to make it Elizabethan. Like Thorp's own house, it is notable for its wood detail; the carved beams at the entrance are particularly unusual.

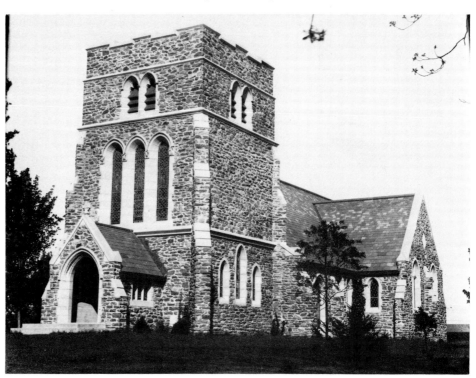

Plate 123. St. Luke's Episcopal Church, James Lane, Thomas Nash, 1910. Courtesy of the *East Hampton Star.*

Plate 124. Two designs submitted for a public library at East Hampton by Aymar Embury II. From *Architecture*, 15 April 1911.

Plate 125. East Hampton Free Library, 153 Main Street, Aymar Embury II, 1910–11. Photograph by Harvey A. Weber.

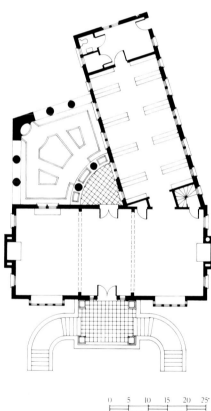

Plate 126. East Hampton Free Library. Plan. Redrawn from *The Brickbuilder,* February 1913.

The Poor cottage introduced the Elizabethan mode to the village green, where it was followed in rapid succession by Thomas Nash's St. Luke's Church (Plate 123; I-235) in 1910 and by the charming Free Library (I-236) designed by Aymar Embury II in 1910–11. The former, a well-crafted, though somewhat improbable, English perpendicular church of stone, replaced the informal Stick-Style wooden chapel that had served Episcopalians of the village since 1859. Nash, a summer resident, was consulting architect to Trinity Church Parish in New York with which St. Luke's was then affiliated.

Significantly, the Free Library was designed with three facade alternatives: one in a rather robust Beaux-Arts–Georgian style, a second in a more chaste Adamesque colonial, and the third, accepted by the client, in the Elizabethan vernacular (Plates 124, 125, 126; I-236). As built, the Free Library was a

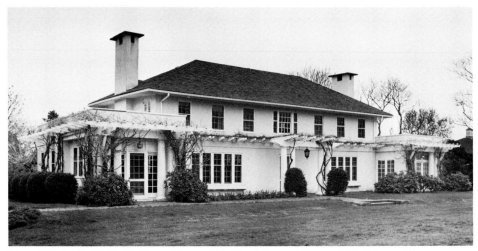

Plate 127. Frederick K. Hollister House, Lily Pond Lane, Albro and Lindeberg, 1910. Photograph by Harvey A. Weber.

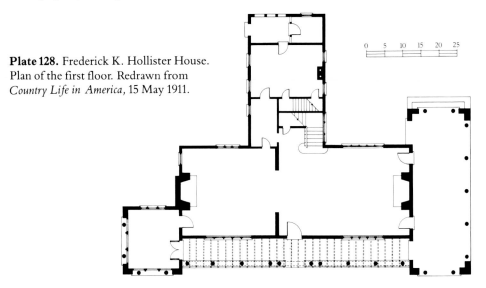

Plate 128. Frederick K. Hollister House. Plan of the first floor. Redrawn from *Country Life in America,* 15 May 1911.

charming L-shaped structure with the longer arm of the L closed against the shorter at an acute angle to shelter a quiet reading garden defined in part by a row of gently scaled columns supporting vines. Subsequent additions have compromised its informality and sacrificed its sense of crafted detail.

Although Thorp pioneered the English vernacular style in East Hampton, it was another architect, Harrie T. Lindeberg, who established its popularity. In a brief account of East Hampton's architectural history, Aymar Embury II cites Lindeberg as the herald of the "revival of good taste in the early 1900s."[41]

Lindeberg, in partnership with Lewis Colt Albro (who on his own later designed a house for Hamilton King (I-179) on Apaquogue Road) is responsible for four houses in East Hampton, all virtually within a stone's throw of each other along Lily Pond Lane. Of these, the house built in 1910 for Dr. F. K. Hollister (Plates 127, 128; I-153), though the least characteristic of Lindeberg's

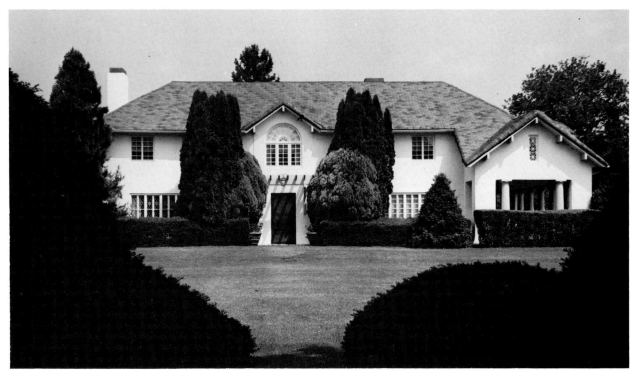

Plate 129. Edward T. Cockcroft House, Lily Pond Lane, Albro and Lindeberg, 1905.
Photograph by Harvey A. Weber.

Plate 130. Edward T. Cockcroft House. Plan of the first floor.

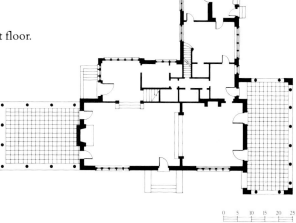

work, was influential locally, especially on the work of J. C. Lawrence whose
Voorhees house on Dunemere Lane (I-159) (1913) very closely follows it, as
does his Cody house (I-189) (1928). The low-pitched, hipped, shingled roof of
the Hollister house and the extensive use of vine-covered pergolas and covered
porches continue to give it the character of an Italo-American villa, of the kind
one normally associates with the work of Lindeberg's near contemporary,
Charles Platt. More characteristic of Lindeberg's style is his first house in East
Hampton, built in 1905 on Lily Pond Lane for Edward T. Cockcroft (Plates
129, 130; I-147), and its companion Coxwould (Plates 131, 132; I-156), built

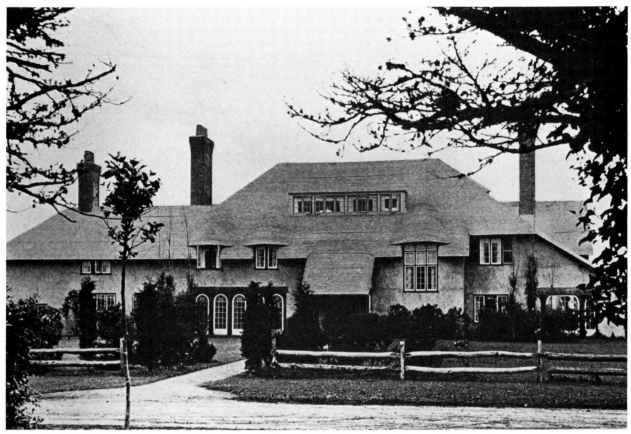

Plate 131. John E. Erdman House, Lily Pond Lane, Albro and Lindeberg, 1912. From *Architecture,* January 1915.

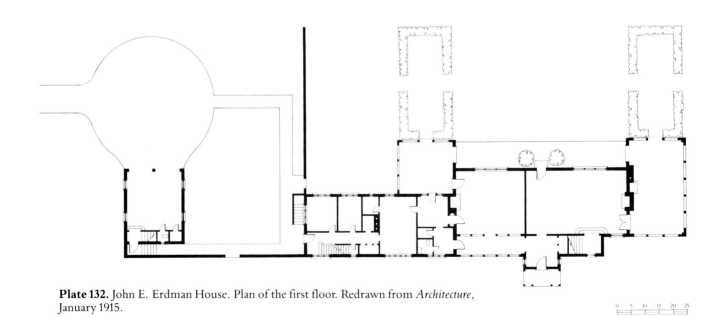

Plate 132. John E. Erdman House. Plan of the first floor. Redrawn from *Architecture,*
January 1915.

0 5 10 15 20 25

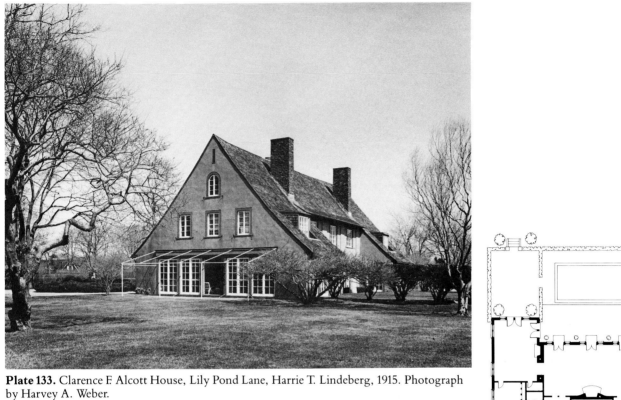

Plate 133. Clarence F. Alcott House, Lily Pond Lane, Harrie T. Lindeberg, 1915. Photograph by Harvey A. Weber.

Plate 134. Clarence F. Alcott House. Plan of the first floor.

across the street for Dr. John F. Erdman in 1912. Facing each other, the Cockcroft and Erdman houses constitute a uniquely satisfying ensemble. Each is crowned by what was considered their architect's trademark, the so-called Lindeberg roof, a technique by which shingles were laid up to suggest the voluptuous curves of roofing thatch.

The plans of the Cockcroft and Erdman houses have formally composed rooms informally related to each other. Inside and out the Cockcroft house is the more eclectic of the two. Its use of amply proportioned fluted columns to support the porch roof and pergolas, lends an ambiguous grandeur to the composition. The Erdman house, more wholly Elizabethan, is cozier; its sheltering entrance porch offering a particularly gracious note of welcome on an otherwise closed and somewhat forbidding north elevation. The Erdman house is one of Lindeberg's finest and his best in the village. Its complex balance of an asymmetrically composed principal wing with the service spaces set to one side, and its carefully callibrated relationship between the interior rooms and garden spaces is exceptional, particularly in East Hampton where houses are more typically placed on undifferentiated greenswards.

The Alcott house (Plates 133, 134; I-166) is Lindeberg's last commission in

Plate 135. William S. Jenney House, Egypt Lane, Polhemus and Coffin, 1917–21. From *Architecture,* October 1923.

Plate 136. William S. Jenney House. Plan of the first floor. Redrawn from *Architectural Record,* November 1923.

East Hampton. Like those for Cockcroft and Erdman, it is sheathed in warm, buff, beachsand stucco and seems marvelously suited to the landscape. Its composition is more symmetrical than in Lindeberg's other houses and its modified U-shaped plan and low-sweeping, flared roof, as well as the handling of the elevation of the central portion of the U suggest the influence of Edwin Lutyen's work.

A number of other architects followed Lindeberg's lead in East Hampton. They include Lewis Colt Albro, Lindeberg's partner until 1913, and Polhemus and Coffin who built the W. B. Jenny house (Plates 135, 136; I-180) on Egypt Lane in 1917–21. Roger Bullard's Maidstone Clubhouse of 1922, and later his house for Ellery James (Plates 137, 138, 139; I-184) on the dunes near Georgica, most convincingly manifest Lindeberg's strong and continuing influence.

Plate 137. Ellery S. James House, West End Road, Roger Bullard, 1926. From *Architectural Record,* November 1933.

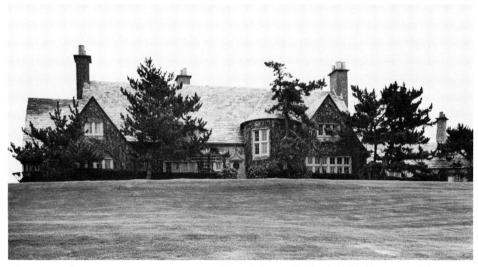

Plate 138. Ellery S. James House, West End Road, Roger Bullard, 1926. Photograph by Harvey A. Weber.

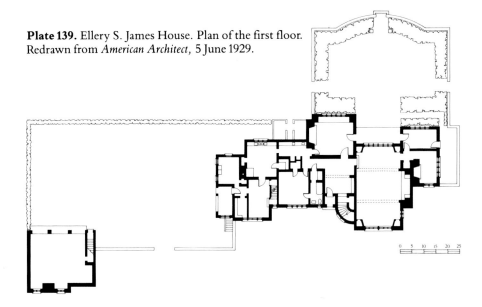

Plate 139. Ellery S. James House. Plan of the first floor. Redrawn from *American Architect,* 5 June 1929.

The second Maidstone Club building had burned in 1921 and Bullard was commissioned to design a new clubhouse (Plate 140; I-181) at the edge of the beach. He chose a style that was as much inspired by French farmhouses, then very much the rage, as it was by English vernacular cottages. Bullard wrote that the skyline of the building conforms to the undulation of the dunes, the wings at either end rising gradually to the main ridge, the general character and roof lines suggesting the farm houses of Normandy."[42]

Though a significant departure from the two previous Shingle-Style clubhouses that had been in the heart of the village, Bullard's scheme made sense not only in terms of its moorlike site between the golf course and the ocean, but also because it directly adjoins the site of Robert Appleton's recently completed, quite Elizabethan house, Nid de Papillon (I-175). Though somewhat stiff and abstract, with very little detail, the new clubhouse was an

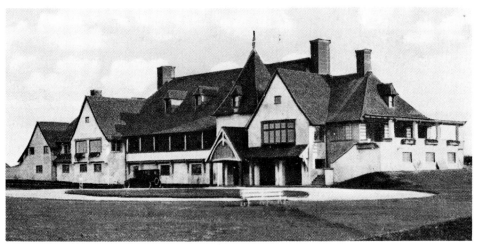

Plate 140. Third Maidstone Clubhouse, Old Beach Lane, Roger Bullard, 1922–24. Courtesy of Averill D. Geus.

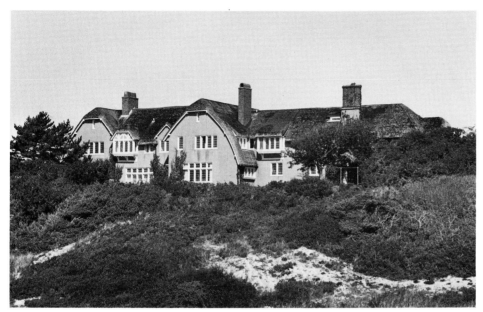

Plate 141. Robert Appleton House, Old Beach Lane, Frank E. Newman, 1918. Photograph by Harvey A. Weber.

Plate 142. Robert Appleton House. Plan of the first floor. Redrawn from the original plans.

appropriate companion to its much more scenographically explicit neighbor, a late example of the Elizabethan vernacular that succeeded in bringing together the vigor of the Shingle-Style compositions of the eighties and the atmospheric effects of the stuccoed villas. Designed by Frank E. Newman, a comparatively unknown architect from New York, the Appleton house (Plates 141, 142; I-175) is baronial in keeping with the owner's unusually extensive holdings along the dunes that included a polo field, paddock, and chicken coops. By contrast, Mrs. Lorenzo E. Woodhouse's Elizabethan theatre, designed by F. Burrall Hoffman in 1917, is more skillful and stylistically correct (Plate 143; I-171).

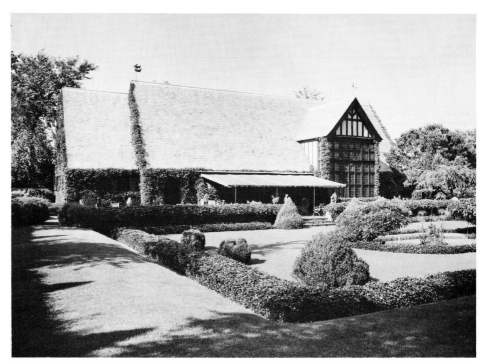

Plate 143. Mrs. Lorenzo E. Woodhouse Playhouse, Huntting Lane, F. Burrall Hoffman, 1917. Photograph by Samuel Gottscho. Courtesy of Gottscho–Schleisner.

Before the introduction of the Elizabethan vernacular mode associated with Lindeberg, an even less stylistically specific type of stucco cottage had been popularized in East Hampton by Grosvenor Atterbury. Unlike many of the architects from New York who built in East Hampton, Atterbury had close ties to the East End. His father was a pioneer summer colonist of the Shinnecock Hills west of Southampton Village where Atterbury spent his summers and built a number of houses. He also built in Water Mill and in Southampton where he was the architect for the Parrish Art Museum on Job's Lane.

Atterbury was more freely eclectic in his approach than his contemporaries. He searched for a character of design conforming very closely to the surroundings, rather than designing a building and shaping the ground to provide it with a proper setting. As the editors of *Architecture* observed in 1911,

> Mr. Atterbury does not stop at designing the mass of the building to work into the contours of the ground; he harmonizes his color scheme in the most exquisite possible manner with the color of the countryside in which the house is placed and so skillfully is this done that the house at once loses all the rawness of a new building and takes its place as part of the landscape. . . . Mr. Atterbury works out a subtle harmony in reds, browns, and buff suited primarily to the autumn landscape or the burnt-out foliage of the sea coast.[43]

Atterbury's first house in East Hampton, The Creeks (Plates 144, 145, 146; I-111), was built for the painter, Albert Herter in 1899. A free interpretation of

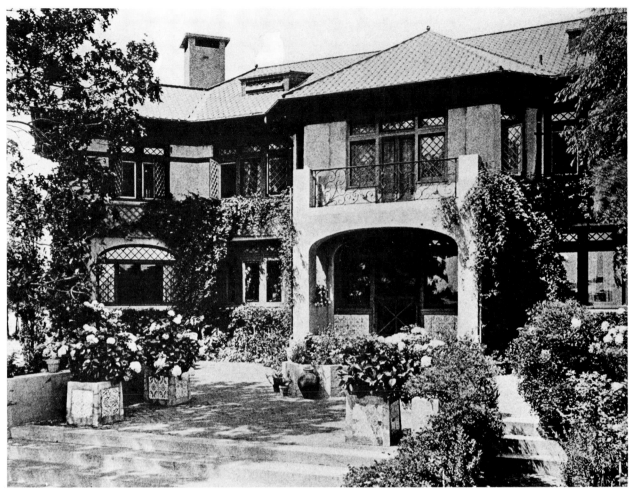

Plate 144. Albert Herter House, Montauk Highway, Grosvenor Atterbury, 1899. From *Architecture,* September 1919.

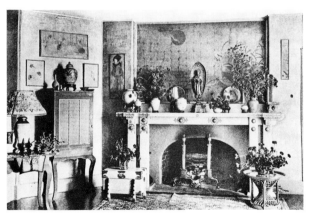

Plate 145. Albert Herter House. Interior. From *Architecture,*
September 1919.

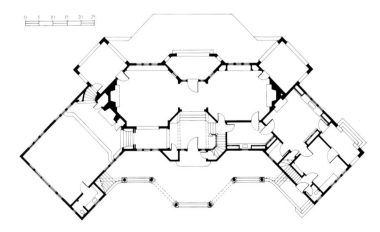

Plate 146. Albert Herter House. Plan of the first floor.
Redrawn from *American Architect and Building News,*
2 September 1908.

an Italian villa, it occupies one of the prize sites in the area, located at the extreme west end of the village on the edge of a low promontory between two of the creeks which feed Georgica Pond. It is on axis with the narrow spit of sand beach that divides the ocean from the pond. The Italian theme is carried into the design of house, boathouse, and studios, which are stuccoed and roofed in tile. It seems quite unrelated to local architecture though it is marvelously responsive to the potential of the site and to the requirements of its artist-owner for ideal light in all rooms. It is graced with an elaborate Italian garden, and the plan, an open U, allows ideal light in each important room of the house and unobstructed views of Georgica Pond and the ocean just beyond.

The C. C. Rice house (Plates 147, 148), Atterbury's next in East Hampton, was set on the Eastern Plain. It burned in the 1920s. The Rice house was, as the

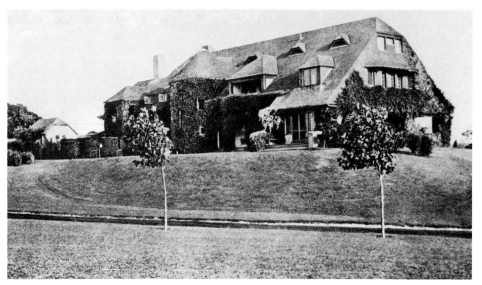

Plate 147. C. C. Rice House, Hither Lane, Grosvenor Atterbury, 1899. Burned 1920. Courtesy of Averill D. Geus.

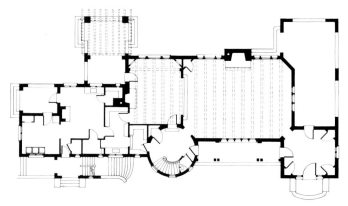

Plate 148. C. C. Rice House. Plan of the first floor. Redrawn from *American Architect and Building News,* 26 August 1908.

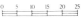

editors of *Architecture* described it, a

> complicated scheme where low towers, outside stairways, a multitude of dormer windows, and irregular, picturesque porches and grouped together...[with] thoughtful and intelligent workmanship [to become] a unified composition.[44]

When built, the site was not planted and the house commanded views of the ocean across Hook Pond. According to deKay, "the Rice and Herter villas have two of the finest views in Suffolk County."[45] The Rice house seems stylistically more appropriate to East Hampton than the Herter. Its mass and rich palette of materials not only complements the landscape but also the tradition of shingled cottages. One can imagine that its browns, russets, and creams and red-stained, shingled roof were very effective in the late summer and fall. Its vague evocations of Norman farmhouses and the draping of the shingles over the stucco base are reminiscent of H. H. Richardson and the early work of Wilson Eyre. Its shallow, stretched-out plan is distinctly similar to those used by Shingle-Style architects, though the continuous piazzas have given way to independent covered porches.

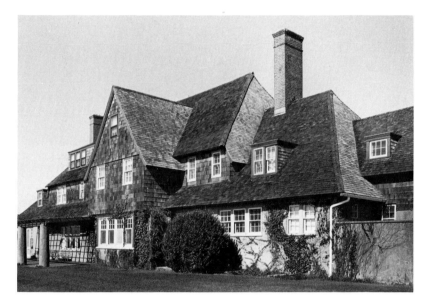

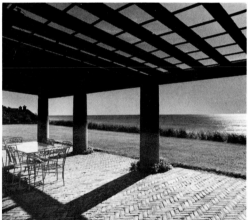

Plate 150. Paul Salembier House, Photograph by Harvey A. Weber.

Plate 149. Paul Salembier House, Lily Pond Lane, Roger Bullard, 1924, after renovations by Grosvenor Atterbury in 1927. Photograph by Harvey A. Weber.

Compared to the Rice house, Atterbury's cottage for Benjamin Richards (I-124) is very modest. It was to have been set in a walled garden never realized.

Atterbury worked one more time in East Hampton, remodeling in 1927 the house Roger Bullard had designed only three years earlier for Paul Salembier (Plates 149, 150; I-182), presumably introducing exterior details such as the columns, trellises, and half-timbering which are absent in Bullard's earlier Maidstone Clubhouse or in his later James house.

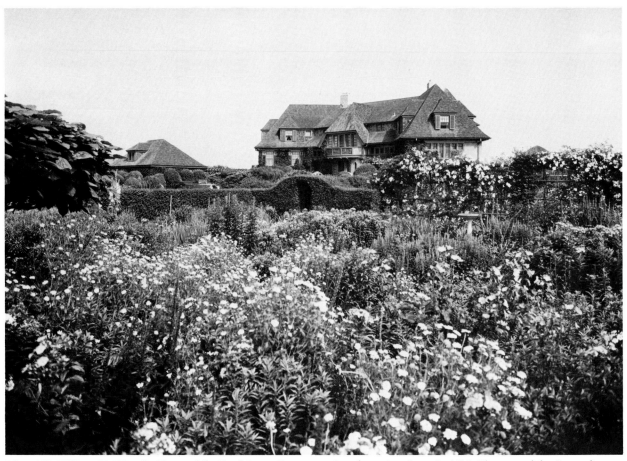

Plate 151. William H. Woodin House, Lily Pond Lane, Grosvenor Atterbury (attributed), 1916. Photograph by Samuel Gottscho. Courtesy of Gottscho–Schleisner.

Plate 152. William H. Woodin House. Plan of the first floor. Drawn by José Sanabria and Oscar Shamamian.

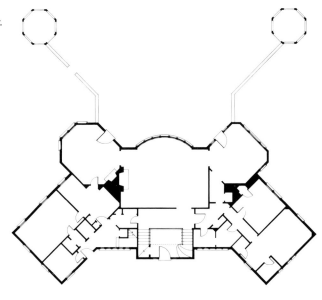

The William H. Woodin (Plates 152, 153; I-167) house of 1916 can be attributed to Atterbury because he designed its gardener's cottage in 1925, and it resembles in many ways the renovated Salembier cottage. Most importantly, however, its general character is similar to Atterbury's other work, particularly his contemporaneous Greenway development in Forest Hills Gardens and an unidentified house he designed at Cold Spring Harbor.

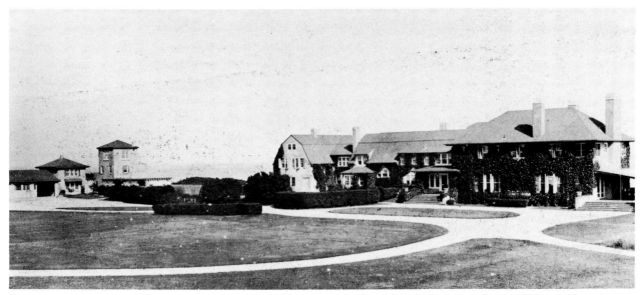

Plate 153. Frank B. Wiborg House, Highway Behind the Pond, 1895. Demolished. Courtesy of Mr. and Mrs. William M. Donnelly.

The century's teens were the years of estate building in East Hampton. The uncertain political conditions curtailed summer travel to Europe and stimulated local growth. The impact of the newly enacted graduated income tax had not yet begun to make a significant dent in personal wealth. Though Robert Appleton's Nid de Papillon was perhaps East Hampton's greatest estate, Frank B. Wiborg's estate (Plate 153) next door was more widely known, perhaps because of its elaborate gardens.

In the developing Eastern Plain, large houses were the order of the day, even on relatively small properties of five or ten acres (which, of course, were vast in comparison with the one- and two-acre parcels of the summer colony). The Eastern Plain was largely undeveloped before the teens. The Dr. Jacob Gould Schurman house, designed in 1901–2 by Thorp, sat on ten acres "commanding unobstructed views in all directions."[46] When completed, the large house appeared to loom up against the sky and could be seen from almost any portion of Main Street.[47] As late as 1911 C. C. Rice's house on Further Lane was the principal monument of the Eastern Plain, commanding views over Hook Pond and the ocean.

The most interesting of the Further Lane houses of this period is the one built in 1916–17 by George W. Schurman, designed by Arthur C. Jackson (I-172). A year later, on the adjoining site, Arthur Truscott designed a suitable

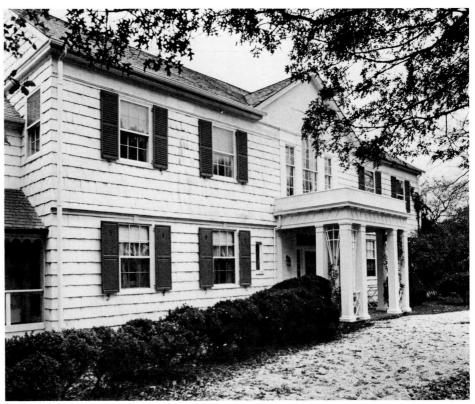

Plate 154. George Roberts House, Middle Lane, Aymar Embury II, 1930–31. Photograph by Harvey A. Weber.

companion, also in stucco, for Wallace Reid (I-174). Together these houses mark the furthest development of the merging of Shingle Style and the Elizabethan vernacular techniques of Atterbury and Lindeberg. But by the end of the 1920s, the interest in the Elizabethan vernacular had waned, with the exceptions of Bullard's James house and Atterbury's renovation of the Salembier cottages.

Spurred on by the reaction to the internationalism of World War I, the restoration of Colonial Williamsburg, and the celebration of the village's seventy-fifth birthday in 1924, there was a general shift toward what were generally regarded as "colonial" prototypes. Unfortunately, as can be seen in Guild Hall (I-239), designed by Aymar Embury II in 1930–31, the colonial forms that were imitated were often unrelated to East Hampton's own colonial traditions.[48] Not surprisingly, Embury did not see it that way. He found the Elizabethan work incongruous, and repudiated his own contributions to this genre. In 1935 he wrote that he "had always regretted its introduction (however excellent it may be in itself) on the Village Green." He also claimed that he had proposed that the third Maidstone Club be built "along the traditional lines of East Hampton."

Sometimes the interest in colonial precedent led back to local traditions. As early as 1910 houses were being built that set out to revive the lean-to houses of

Plate 155. Dune houses. Photograph by Harvey A. Weber.

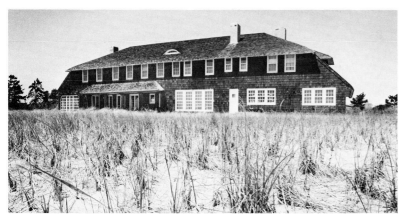

Plate 156. Fourth Frederick K. Hollister House, Drew Lane, John Custis Lawrence, 1920. Photograph by Harvey A. Weber.

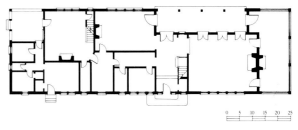

Plate 157. Fourth Frederick K. Hollister House. Plan of the first floor. Redrawn from the original plans.

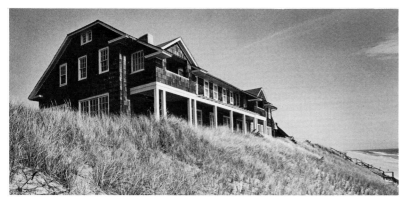

Plate 158. Lawrence Oakley House, Drew Lane, John Custis Lawrence, 1926. Photograph by Harvey A. Weber.

the eighteenth century. In this, Mary Talmage, the developer who acted as her own architect though she was not so trained or licensed, was no doubt inspired by the example of Mr. and Mrs. Gustave H. Buek of Brooklyn who purchased "Home Sweet Home" in 1908 and began to restore it, a procedure which they continued until Mr. Buek's death in 1927 when it was purchased by the village. Mrs. Talmage's first cottage of 1910 (I-155), built for rental, stands on Jones Road. It was described by the *Star* as "very old, yet entirely new among the modern houses of the town...being patterned after the houses built in this place one and two hundred years ago, with the short roof in front of the long sloping roof in back."[49]

By the late twenties, many of those building in the unspoiled greenery of Hither and Middle lanes (as opposed to the dune landscape off Further Lane) painted their shingled cottages white, instead of leaving them unpainted. This trend toward a "back country" aesthetic was emphasized in 1926 when Percy Hammond moved an "old white colonial cottage," the so called Aunt Phebe's Cottage (I-3), to a site on the north side of Hither Lane and commissioned Thorp to renovate it. Earlier Thorp had established his credentials as a restoration architect when, in collaboration with Lawrence, he prepared plans for the restoration of Clinton Academy in 1921. The trend toward a country look culminated in Aymar Embury's colonial design for the construction of a large house for George B. Roberts in 1930–31 on a site stretching between Further and Middle Lanes. Built in the colonial style, it was designed by Aymar Embury II for George Roberts in 1930–31 (Plate 154; I-193).

Remarkably, even the Shingle-Style traditions flourished again in the 1920s as the splendid string of dune cottages west of Main Beach that J. C. Lawrence designed clearly indicates. (Indeed, as the inventory at the end of this book shows, this time-honored way of building never really died out in East Hampton.) Among the dune cottages, those for B. Franklin Evans (I-160) (1913), Herbert Coppell (I-177) (1920), Frederick K. Hollister (Plates 156, 157; I-176) (1920), and Lawrence Oakley (Plate 158; I-185) (1926) are perhaps the most interesting. The Evans house was perhaps the first attempt to combat the blackness of cedar shingles by staining them a permanent light grey. According to the *Star,* the house was originally sheathed in old-fashioned twenty-four-inch shingles, laid twelve inches to the weather, and stained a cement grey, with the roof of a soft green—"a harmonious blending of the artificial with the natural."[50]

The Coppell house is similar to the Evans house in its planning. Although remodeled and made less English by Robert Tappan in 1928, drawings show a simply detailed composition crowned by a Lindeberg-style roof. The Hollister beach house is notable for its continuously blended hipped-and shed-roofs, and for eyelid dormers that give a streamlined effect of roof and wall reminiscent of the early work of Wilson Eyre. The Oakley house is distinquished by a long, sheltered piazza overlooking the sea, the second-story roof of which rests in a carefully syncopated colonnade.

East Hampton was not immune to the somewhat frivolous stylistic experimentation that can be said to characterize much of the domestic architecture of the 1920s. The most extreme example was Eltinge Warner's house (Plates 159, 160; I-186) on the dunes across from the Lily Pond. Designed by Robert Tappan, it emulated a Spanish farmhouse.

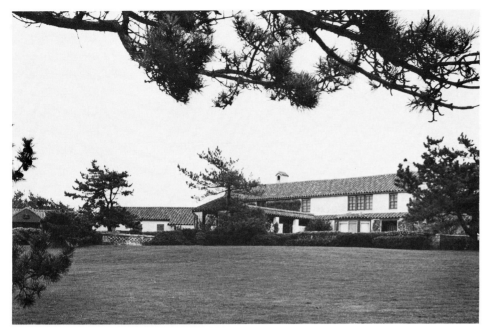

Plate 159. Eltinge F. Warner House, Lily Pond Lane, Robert Tappan, 1926. Photograph by Harvey A. Weber.

Plate 160. Eltinge F. Warner House. Plan of the first floor. Redrawn from *Arts and Decoration,* February 1928.

0 5 10 15 20 25

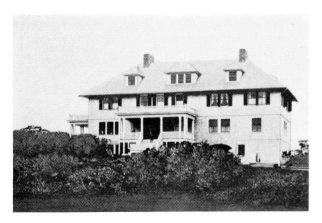

Plate 161. F. D. Solley House, Lee Avenue, Joseph Greenleaf Thorp, 1910. Demolished. From *Architectural Record,* January 1903.

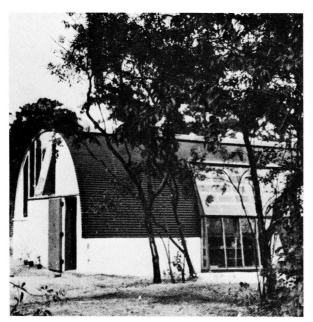

Plate 162. Robert Motherwell House, Georgica Road, Pierre Chareau, 1946. From Rene Herbst, *Pierre Chareau*.

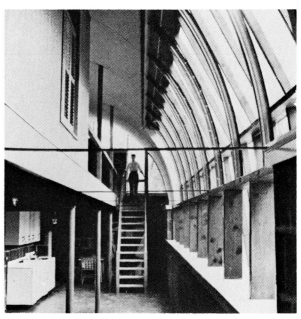

Plate 163. Robert Motherwell House. Interior. From Rene Herbst, *Pierre Chareau*.

The collapse of the economic system in 1929 and a series of harsh storms in 1930–31 and again in 1938 limited the development of the resort community. A few large houses were built, usually in colonial modes, and were sensibly set back from the water's edge. In addition to the Roberts house, Arthur Jackson's house for Shepherd Krech (I-194) and Aymar Embury II's house for A. W. Chauncey are notable examples of this genre—the former for its use of natural cedar shingles in an otherwise formal composition, the latter for its sensitive placement overlooking Georgica Pond. More often than not, however, during the twenty years following the stock market crash, big houses were lost to the wrecker's ball or to fire. The houses of Frederick Gallatin, Dr. Solley (Plate 161), and George L. McAlpin were torn down in this period and Jacob Schurman's was transformed into a ranch house in 1949. A number of smaller houses were built and a number of cottages of the summer colony renovated in response to the diminished lifestyle of the era. By and large, East Hampton retreated to its former self as a quiet backwater, cut off from the life of the city, especially in the 1940s when gas shortages confined travel to the railroad.

At the end of the Second World War East Hampton was rediscovered by artists, this time by Europeans who had emigrated to the United States in search of asylum from the political and military upheavals. Among these European emigrés was an architect, Pierre Chareau, coarchitect with Bernard Byvoet of the epochal glass house for Dr. Dalsace built in Paris in 1930–31. Chareau designed a house in 1946 for Robert Motherwell (Plate 162, 163; I-197) at the corner of Georgica and Jericho Roads. In its attitudes toward the site and the local architectural traditions, the Motherwell house inaugurates the characteristic pattern of the most interesting work of the postwar period. Its

formality has less to do with a feeling for the place than with notions of advanced technological innovation and abstract geometrical composition. Though built at a time when building materials were in short supply, Chareau's use of a Quonset hut as the principal means of enclosure was related more to issues of style and ideology. A building freed from bourgeois con-

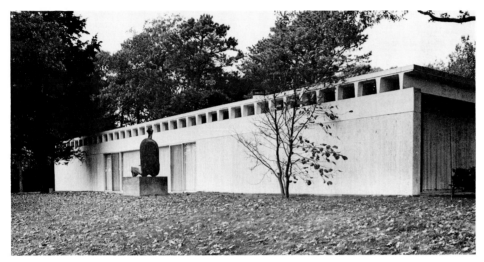

Plate 164. Gordon Bunshaft House, Georgica Close Road, Gordon Bunshaft, 1963–64. Photograph by Harvey A. Weber.

Plate 165. Gordon Bunshaft House. Plan. Redrawn from *Architectural Record,* Mid-May, 1966.

ventions, the very opposite of the provinciality that had hitherto characterized resort architecture as such, it announced East Hampton's transformation into a cosmopolitan resort.

On its own terms the Motherwell house was from the outset an impossible bit of work. James Tanner has observed that Chareau's and Motherwell's intention to "construct a revolutionary dwelling for under ten thousand dollars" resulted in an "astonishing" house, and an "astonishing miscalculation in the budget, since the design required doors, windows, balconies, and flooring to be entirely handmade."[51]

The relationship of Motherwell's house to its wooded corner lot is deliberately casual. The house is conceived of as an object in space with almost no connections to the out-of-doors. Though related to the traditional East Hampton summer house in its objectlike character, it ignores the lessons the traditional summer cottages had to offer, with their orientation to breezes, porches, and time-honored materials.

Motherwell's house was the first of a succession of modernist houses which sought to break away from that relationship of building to site and building to building so long characteristic of East Hampton's architecture. Because East Hampton was already largely built up and because the landscape was no longer open, the shift in attitudes away from general values of place to mere considerations of specific site has not had a chaotic effect on East Hampton's townscape as it has in more vulnerable neighboring landscapes such as the former potato fields of Bridgehampton or the broad sand of Amagansett where the results have been truly chaotic.

Nevertheless, the shift had a profound effect on post-World-War-II architecture. It has not simply been a change of styles, as the shift from the Shingle Style to the Elizabethan vernacular had been, but a profound revolution in attitude toward the relationship of program and site that has brought new and strange forms to the local architecture, with architects frequently using house commissions as proving grounds for ideas intended to be explored later at a public scale. Although some architects produced works of astonishing inventiveness, less fertile talents, who in previous times had been able to adapt the high-style modes to their more modest projects and budgets, floundered.

For many architects and owners, the alternative to the advanced work of the 1950s and 1960s was the bland colonial, mansard, or ranch house of anywhere suburbia that are scattered throughout Georgica and in Pondview. When the owner's tastes are more ambitious and his pocketbook more ample, a Ber-

Plate 166. Charles de Kay House, Georgica Road, Charles de Kay, 1907–8. Demolished. Interior. Courtesy of Ormand de Kay.

120

Plate 167. Marshall Cogan House, Terbell Lane, Gwathmey/Siegel, 1972. Photograph by Harvey A. Weber.

Plate 168. Marshall Cogan House. Plan of the second floor. Redrawn from *Architectural Record,* Mid-May 1973.

muda-type cottage such as those built opposite the Jenny house on Egypt Lane might result.

In contrast to the antitraditionalism of the so-called traditional houses built at Pondview and elsewhere stands the extreme expressionism of the resolutely experimental modernist houses of the 1950s through the 1970s. It is not that the architects of the modernist houses are against the vernacular traditions of the resort. Rather, they saw them as closed and finished. Modern architecture, they argued, is a universal language of form which is merely to be adapted to particular programs, building techniques, and sites. The orthodox modernism of the 1950s through 1970s represents a struggle to release design from issues of locale and taste and to create an architectural style universal in its applicability—a new classicism of the machine.

Gordon Bunshaft's own travertine-clad house at Georgica (Plates 164, 165; I-203) is characterized by its architect as being like an Italian villa.[52] Its coolly abstract interior spaces recall in modernist terms the interiors of Charles deKay's pioneering concrete house, Abrigada (Plate 166). Robert Rosenberg's glass house on the dunes (I-198), Paul Lester Weiner's Scull house (I-202), Richard Meier's Hoffman house (I-205) on Georgica Road, as well as Gwathmey/Siegel's Cogan house (Plates 167, 168; I-208) overlooking Hook

Plate 169. Renny Salzman House, Further Lane, Richard Meier, 1970. Photograph by Ezra Stoller, © ESTO.

Plate 170. Renny Salzman House. Plan. Redrawn from *Richard Meier, Architect*.

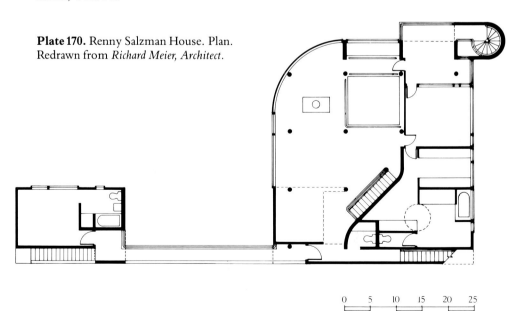

0 5 10 15 20 25

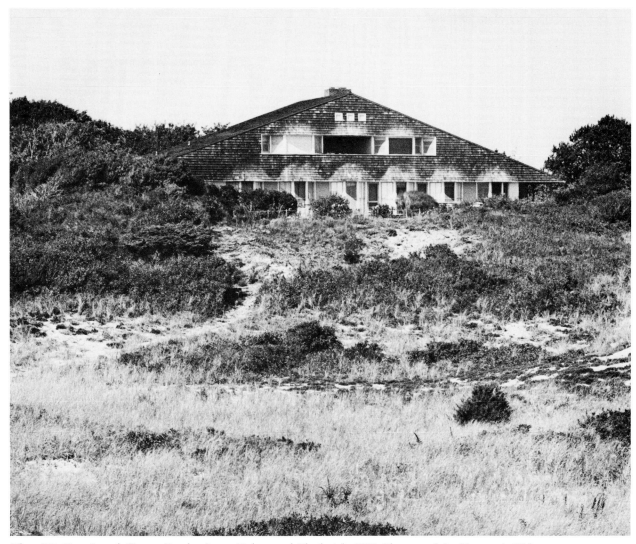

Plate 171. Otto Spaeth House, Further Lane, Nelson and Chadwick, 1955. Photograph by Harvey A. Weber.

Pond are all examples of this approach, though the Cogan house, with its broad terraces, porte cochere, and awnings is a serious attempt to restate the principles of the traditional resort houses in terms of a new reductive sensibility.

The Salzman house (Plates 169, 170; I-206), Meier's second house in East Hampton, is much more interesting and less abstract than his earlier effort. Its neighbor, Nelson and Chadwick's Otto Spaeth house (Plates 171, 172; I-199) of 1955, was the first house built in the post-war period in a new, invigorating style which combined the simplification and abstraction of modernism with the archetypal forms and techniques of traditional artithecture. In effect, the Spaeth house, by offering specific stylistic homage to McKim, Mead and White's Low house at Bristol, Rhode Island (1887), not only focused attention

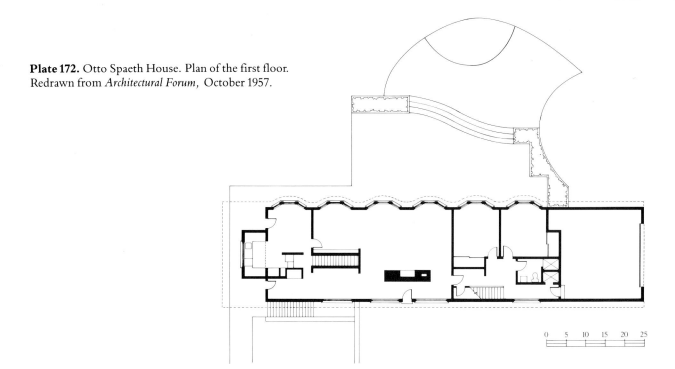

Plate 172. Otto Spaeth House. Plan of the first floor. Redrawn from *Architectural Forum,* October 1957.

on a neglected tradition but also demonstrated convincingly that the traditional styles deserved study and emulation.[53]

The impact of the Spaeth house was negligible at first, only gaining in critical esteem in the mid sixties as architects, influenced by the theories and the architecture of Robert Venturi, once again came to value localized traditions and regional styles. Venturi, ironically, is represented in East Hampton by a totally uncharacteristic work of his professional youth, a contrived Japanese house he designed in 1959 during his brief partnership with William Short (I-201).

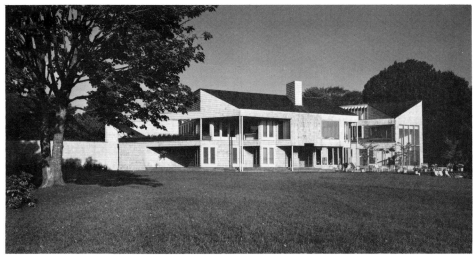

Plate 173. Norman Mercer House, Ocean Avenue, Robert A. M. Stern and John S. Hagman, 1972–74. Photograph by Edmund H. Stoecklein. Courtesy of Robert A. M. Stern, Architects.

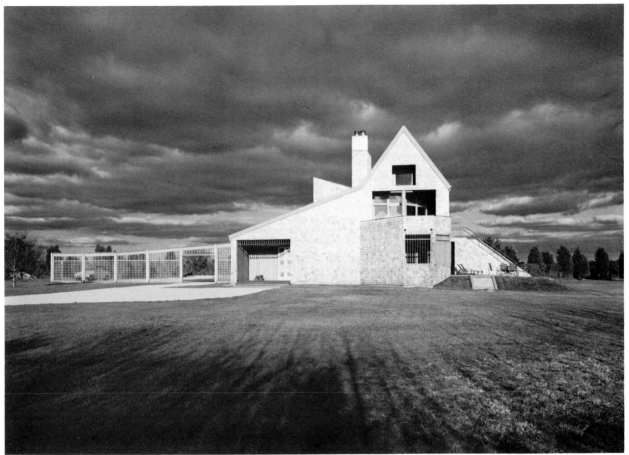

Plate 174. Lawrence Flinn House, Further Lane, Jaquelin T. Robertson, 1980. Photograph by Edmund H. Stoecklein. Courtesy of Eisenman/Robertson.

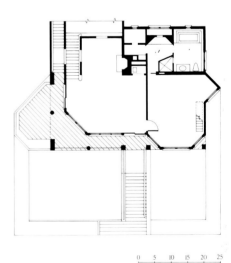

Plate 175. Lawrence Flinn House. Plan. Redrawn from *Architectural Record,* mid-May 1981.

The early attempts at reviving provincialism approached the local traditions cautiously, usually attempting to "modernize" it through geometrical distortion. In the Chalif house (I-204), Julian and Barbara Neski split a barnlike, gabled volume and set one half at right angles to the other. Alfredo DeVido, in his Bross house (I-210), exaggerated the vertical proportion as he twisted the internal geometry to make a composition that was strange and familiar at the same time. At the Mercer house (Plates 173; I-211), an elaborate reconstruction of the Patridge ranch house of 1955, the author, then in partnership with John Hagmann, split the line of the ridge at the midpoint and explored a diagonal geometric plan in an effort to establish a bridge between present and past modes. Similarly, Jaquelin T. Robertson's Flinn house (Plates 174, 175; I-213) overlooking both the Salzman and (first) Spaeth houses, attempts a synthesis between modernist abstraction and the lean-to house vernacular.

Since the 1970s, the search for a free vernacular appropriate to and rooted in the place seems to be earnest. It has been triggered in part by circumstances similar to those which prevailed one hundred years earlier: a disastrous and divisive war, a corrupt political situation, and milestone in the nation's history

which began to lift the spirits. As in the 1880s, strategies were devised—or perhaps rediscovered—by architects and their clients to make peace with the environment. Many old houses (this time resort cottages and not eighteenth-century village houses) were restored and remodeled sympathetically. Occasionally new cottages that echo the old are also being built in the various traditional resort neighborhoods where a few sites remain, and in such new subdivisions as Cove Hollow Farm.

Enough has been built to suggest that although some architects will continue to explore the universal forms of modernism, many others will approach the problem with a more sympathetic view of the past. One thing is clearer now than it has been since the 1920s: that some architects at least have the willingness and the capacity to make positive use of the local vernacular in the creation of new, innovative work.

Notes

1. Charles deKay, "Summer Homes at East Hampton," *Architectural Record* (January 1903) pp. 19–33, see also deKay, "East Hampton the Restful," *New York Times Illustrated Magazine* (30 October 1898). I wish to thank Ms. Dorothy King, librarian in charge of the Long Island Collection, East Hampton Free Library, for her invaluable assistance and many courtesies during the formative stages of this project. N. Sherrill Foster supplied many helpful observations. My appreciation also goes to Jenny Moncayo who has lent her invaluable assistance to this project in many ways, not the least of which by patiently typing the inevitably endless versions of the manuscript leading to the final text.

2. See Vincent J. Scully, Jr., *The Shingle Style and the Stick Style: Architectural Theory and Design from Richardson to the Origins of Wright,* revised edition (New Haven: Yale, 1971); also Scully, *The Shingle Style Today or the Historian's Revenge* (New York: Braziller, 1974).

3. Jeannette Edwards Rattray, *Fifty Years of the Maidstone Club* (East Hampton: privately printed, 1941) p. 13.

4. Henry E. Colton, "East Hampton and its Old Church," *Appleton's Journal* (25 March 1871) pp. 346, 347.

5. "Breathing Spots on the South Shore," *Sag Harbor Corrector* (30 May 1874).

6. The Stick Style developed a formal language based on an intricate interplay between wooden elements which were expressive of, but not the actual, elements of the building's construction. See Vincent J. Scully, "Romantic Rationalism and the Expression of Structure in Wood. Downing, Wheeler, Gardner, and the 'Stick Style,' 1840–1876," *Art Bulletin* 35 (1953) pp. 121–42; also Scully, "The Stick Style" in Antoinette Downing and Vincent J. Scully, Jr., *The Architectural Heritage of Newport, Rhode Island,* 2nd edition (New York: Clarkson Potter, 1967) plates 157–85.

7. *Sag Harbor Express* (11 July 1878).

8. *East Hampton Star* (24 December 1887).

9. "Breathing Spots on the South Shore," *op. cit.*

10. N. Sherrill Foster, "Boarders to Builders. The beginnings of Resort Architecture in East Hampton, 1870–1894," *East Hampton Star,* Part II, (15 March 1979).

11. *Ibid.*

12. *"The Tile Club at Play,"* *op. cit.* Louise Clarkson, in her *The Shadow of John Wallace* (New York: White, Stokes and Allen, 1884) pp. 5–6 confirms the Tile Club's impressions. Clarkson changes East Hampton's name to "Rest Hampton" which she characterizes as a quaint and lovely town of one long street; a grassy avenue so broad, that over its green expanse meandered two or three unpremeditated roadways, worn at different periods to suit the...varying convenience of the inhabitants. On either side is a walk bordered by huge elms and sycamores and horse chestnuts, and these same great trees shelter the picturesque little houses that stand in their uncalculated simplicity close upon the road. They are two centuries and more old, some of them shingled cottages, whose roofs take so steep a slant and whose color is so delicious a gray, that it is no wonder the artists have settled upon the place and claimed it their own. See also, *The New Long Island. A Hand Book of Summer Travel* (New York: Rogers and Sherwood, 1879) pp. 7–8,29; for a brief discussion of the Tile Club's visit to East Hampton see, Jason Epstein and Elizabeth Barlow, *East Hampton. A History and Guide* (Wainscott and Sag Harbor, New York: Medway Press, 1975) p. 68.

13. Letter from the Reverend Dr. Todd, dated 19 September 1892 in Tarrytown (New York). *Argus* (24 September 1892).

14. According to a New York report, quoted in Rattray, *Fifty Years of the Maidstone Club, op. cit.,* p. 124, as late as 1894 East Hampton was "distinctly a village of cottages. No hotel, no band, no merry-go-round, no Vanity Fair....The natives of East Hampton live in their back lots in summer, in rudely constructed huts. Their houses are, almost without exception, leased to wealthy city people, who will pay very extravagant prices to occupy during the summer months these queer old homesteads."

15. *East Hampton Star* (21 August 1891).

16. That fear is alluded to by deKay in his "East Hampton the Restful," *op. cit.:* "How long will East Hampton retain this sensible and wholesome attitude? It is hard to say. The railway now gives access to thousands whereas in former years only hundreds cared to brave the tiresome six miles of dust to and from Bridgehampton station."

17. DeKay remarks: "Two elements in the summer guests work conservatively; the artists and the clergy, neither class usually burdened with money and neither anxious to be saddled in summer with the round of party, dinner, and visit give-and-take which is a time devourer in the city." *Ibid.*

18. *East Hampton Star* (30 August 1890).

19. *East Hampton Star* (26 December 1885).

20. Antoinette F. Downing and Vincent Scully, Jr., *The Architectural Heritage of Newport, Rhode Island, op. cit.* Green built extensively on the South Shore of Long Island as well as in Maine. See "View in Hall, House for W. L. Suydam," *Building* (7 July 1888) plate; "House for Mr. J.C. Tappin, Islip, L.I." *Architecture and Building* (18 January 1890) plate; "The Anchorage" Residence of Mr. W. T. Hayward, Sayville, L.I.," *Architecture and Building* (24 June 1893) plate; "Twin Oaks, Residence of Charles L. Tappin, Babylon, L.I.," *Architecture and Building* (9 December 1883) plate; "House for Mr. Ernest Dodd, Babylon, L.I.,". *Architecture and Building* (10 February 1894) plate; "Glengariff, for Mr. George B. Cooksey, Seal Harbor, Maine," *Architecture and Building* (5 August 1893) plate.

21. "Summer Residence for Mr. W. N. Terry at Sayville, L.I., *Architecture and Building* (23 April 1887) plate 17.

22. *American Architect and Building News* (7 December 1907); 192, plates.

23. "Our Cottages by the Sea," attributed to W. S. Boughton, *East Hampton Star* (12 July 1889).

24. *American Architect and Building News, op. cit.*

25. *East Hampton Star* (30 August 1890).

26. *East Hampton Star* (8 June 1894).

27. *East Hampton Star* (25 January 1901; 5 April 1901).

28. *East Hampton Star* (18 October 1901).

29. *East Hampton Star* (23 May 1902).

30. deKay, *op. cit.*

31. *East Hampton Star* (21 August 1891).

32. deKay, "Summer Homes at East Hampton."

33. *East Hampton Star* (28 August 1903).

34. *Ibid.*

35. Though not a resort building and located in the business district of the village, Thorp's Odd Fellows Hall (1897) should be included among the robust late flowerings of the Shingle Style. Its cubic proportions and boldly arched entry, reminiscent of some of Bruce Price's work at Tuxedo Park, strikes an appropriately public, even monumental, note. For Price, see Scully, *The Shingle Style,* especially pp. 125–29, figs. 106–10.

36. deKay, "Summer Homes at East Hampton."

37. *Ibid.*

38. *Ibid.*

39. *East Hampton Star* (23 November 1984).

40. St. John Ervine, "An American Village" *London Observer* (20 January 1929); reprinted in *South Eastern Gazette* (18 March 1930).

41. deKay, "Summer Homes at East Hampton."

42. Roger H. Bullard, "Three Different Types of Country Clubs" *American Architect* (20 July 1926) pp. 43–56.

43. *Architecture* (October 1911) p. 146.

44. *Ibid.*

45. Charles deKay, "Eastern Long Island—Its Architecture and Art Settlements" *The American Architect* (1 April 1908) pp. 108–12.

46. *East Hampton Star* (30 August 1901).

47. *East Hampton Star* (13 December 1901).

48. Aymar Embury II "Architecture in East Hampton" *East Hampton Star* (24 October 1935).

49. *East Hampton Star* (14 October 1910).

50. *East Hampton Star* (19 September 1913).

51. James Tanner, "East Hampton, the Solid Gold Melting Pot" *Harper's Bazaar* (August 1958) pp. 95–97, 144,146.

52. Bunshaft is quoted in William K. Zinsser, "Far Out on Long Island" *Horizon* (May 1963) pp. 4–27. In this article, Edward Stone, another noted modernist architect, is pictured in front of his house at the end of Drew Lane; he subsequently had it torn down before quitting East Hampton.

53. See Scully, *Architectural Heritage of Newport,* p. 126; also Scully, *The Shingle Style Today or the Historian's Revenge* (New York: Braziller, 1974), which discusses the Spaeth House as well as other modernist efforts in the village and neighboring areas.

Inventory

This inventory documents over two hundred buildings within the incorporated village of East Hampton. These are arranged in three categories: Domestic Architecture 1680–1860; Domestic Architecture 1860–1981; and Public, Religious, and Commercial Buildings. The inventory of early houses is organized by house type; the buildings in the other two categories are organized chronologically.

Unfortunately, limited space prevents our including all the buildings documented during our architectural survey. The Inventory of Domestic Architecture 1680–1860 contains all the houses of that period that retain their historic integrity and also includes some houses substantially altered in the twentieth century whenever their earlier forms are recorded in usable photographs. Two houses built in the village but recently moved just east of the village boundary are listed. The Inventory of Domestic Architecture 1860–1981 is most complete for houses built before 1930, the cutoff date of the architectural survey for the National Register. We included most architect-designed houses up to 1930. We omitted the lesser works of prolific local architects, such as John Custis Lawrence, as well as less important houses for which the architect is unknown. A selection of houses built for local residents during this period demonstrates the influence of the architecture of the Summer Colony. For houses built after 1930 representative examples of the work of prominent architects were chosen. The final category lists all the important public and religious buildings in East Hampton and the commercial buildings of architectural interest. The number of commercial buildings included is small because so many of them have been altered.

The heading for each entry includes the number by which the building is cross-referenced; the name of the building (most are named after the builder or earliest known owner); the address; the architect and builder if known; the dates of construction and of major alterations. An asterisk after the address indicates the building was moved to that site. A plate number indicates where the building is illustrated elsewhere in the book.

Following the heading or text of the entry are the source references. Shortened references are given for the major sources, and these are listed in the Key to Short Titles and Abbreviations that follows. The reader should be aware that a reference to the *East Hampton Star* may be to the weekly column "The Way It Was . . . ," which contains excerpts from the newspaper issued that week seventy-five, fifty, and twenty-five years ago. So that for a house built in 1900, a reference to a 1950 issue of the *East Hampton Star* probably refers to the column "The Way It Was . . ." quoting from the *Star* published that week in 1900. Architectural plans listed as a reference without a date are the original plans for the building; if a date is given, the plans refer to an alteration.

The files of the architectural survey on which this inventory is based are in the Long Island Collection of the East Hampton Free Library. They can be consulted for additional information on the buildings listed here. They also provide documentation for another one hundred buildings that we were not able to include in this published inventory.

Key to Short Titles and Abbreviations

Corrector
Sag Harbor *Corrector*

de Kay, "Summer Homes"
de Kay, Charles. "Summer Homes at East Hampton, L.I."
Architectural Record 13:1 (January 1903): 19–33.

Edwards, "Reminiscences"
Edwards, Thomas. "Reminiscences of Old East Hampton
by the Sea." 1929. East Hampton Free Library (Manuscript).

EHFL
East Hampton Free Library

EHTR
*Records of the Town of East Hampton, Long Island, Suffolk
Co., N.Y.* Vols. I–V. Sag Harbor, N.Y.: Town of East
Hampton. 1887–1905.

Express
Sag Harbor Express

Hyde, *Atlas*
Atlas of Suffolk County, Long Island. Brooklyn: E. Belcher
Hyde, 1897, 1902, 1916.

Parsons Electric
Parsons Electric, Inc., East Hampton

Rattray, *Fifty Years*
Rattray, Jeannette Edwards. *Fifty Years of the Maidstone Club:
1891–1941.* East Hampton: The Maidstone Club, 1941.

Rattray, *History*
Rattray, Jeannette Edwards. *East Hampton History, Including Genealogies of Early Families.* Garden City, N.Y.: Country Life Press, 1953.

Rattray, *Main Street*
Rattray, Jeannette Edwards. *Up and Down Main Street: An
Informal History of East Hampton and Its Old Houses.* East
Hampton: the *East Hampton Star*, 1968.

Seabury, *275 Years*
Seabury, Samuel. *275 Years of East Hampton, Long Island,
New York.* New York: Bartlett Orr Press, 1926.

Scully, *Shingle Style Today*
Scully, Vincent. *The Shingle Style Today or The Historian's
Revenge.* New York: George Braziller, 1974.

Sleight (ed.), *Trustees Journal*
Sleight, H. D., ed. *Journal of the Trustees of the Freeholders
and Commonalty of East Hampton Town.* Vols. I–III. Riverhead, N.Y.: Harry Lee Publishing Co., 1927.

Star
East Hampton Star

Inventory of Domestic Architecture 1680–1860

Seventeenth-Century Houses

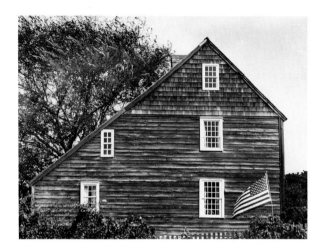

I-1 MULFORD HOUSE
12 James Lane
ca. 1680; eighteenth-century alterations

The Mulford house is East Hampton's finest and most nearly complete seventeenth-century dwelling. The house was built for Josiah Hobart about 1680 and was acquired by Samuel Mulford in 1698 and remained in the Mulford family throughout the following century. The original structure was a two-and-one-half story house with gables at the ends and twin facade gables on the front. A "porch" or entry contained the stairway in front of a center chimney and opened into a single room on either side. Outer walls were clapboarded and pierced by leaded casement windows. About 1720 the east end of the house was dismantled and rebuilt as a lean-to. A lean-to was also added across the back of the house and the facade gables were removed. Then about twenty years later the east half of the house was raised to a full two stories giving the house the form it retains today.

In 1948 the Brooklyn Museum proposed removing two rooms from the Mulford House for its collections. A storm of protest in East Hampton prompted local residents to raise $35,000 to purchase the property and stabilize the house, which was then presented to the East Hampton Historical Society. Noted restoration architect Daniel M. C. Hopping is cur-rently (1981) conducting an architectural investigation of the building.

Refs.: Edwards, "Reminiscences," 168–70.
Daniel M. C. Hopping, Zachary Studenroth, Frank Matero and Anne Weber, "Preliminary Historic Structure Report on the Mulford House," 1981.
Rattray, *Main Street,* 25–26.

Photo: Harvey A. Weber.

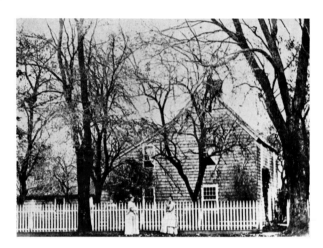

I-2 NATHANIEL HUNTTING HOUSE; THE HUNT-TING INN
94 Main Street
ca. 1699; eighteenth-century, 1875, 1900, 1912 alter-ations

Originally a two-story English-type house, this structure was built for the Reverend Nathaniel Hunt-ting, the second Presbyterian minister in East Hampton, who served from 1699 to 1746. Nine generations of Huntings succeeded to ownership of the house. The family built a lean-to addition on the rear in the eighteenth century. Since then the house has been greatly altered, notably in 1875 when converted to a boarding house and again in 1900 and 1912 when the building became an inn and new wings were added. Some of the early framing timbers, ornamented with chamfers and lamb's-tongue stops, are visible in the southeast rooms of the first and second floors.

Refs.: Edwards, "Reminiscences," 108–9.
Rattray, *Main Street,* 39–40.
Seabury, *275 Years,* 59.
Star, 18 October 1912, 24 December 1950.

Photo: Courtesy of the Huntting Inn.

Seventeenth-Century to Eighteenth-Century Transitional Houses

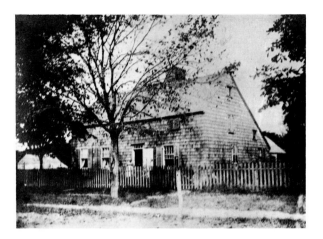

I-4 **STRATTON–DAYTON HOUSE**
83 Pantigo Road
ca. 1715; later alterations

This property was owned alternately by Strattons and Daytons from 1649 through 1946. In 1715 John Stratton sold Samuel Dayton three acres of land here and the house was built at about that time. Originally a one-and-three-quarter story English-type house, the structure was enlarged with a lean-to addition. The west room displays early framing refined with chamfers and lamb's-tongue stops and a bracketed post under the summer beam. The rest of the interior has been substantially altered. The back section of the lean-to has been removed.

Refs.: Rattray, *Main Street,* 59–60.

Photo: Courtesty of the East Hampton Free Library.

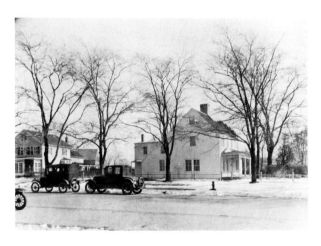

I-3 **MULFORD–HUNTTING HOUSE**
Hither Lane★
Late seventeenth or early eighteenth century; eighteenth-century, 1926 alterations

This house originally stood on the east side of Main Street facing south, and the earliest part is the southwest corner. The post and summer beam in the first-floor room are similar to those in the Nathaniel Huntting house (I-2). Once occupied by the Mulford family, it was owned in the nineteenth century by John M. Huntting. Percy Hammond, drama critic for the New York *Herald Tribune,* purchased the house in 1925 and had it moved to its present site and altered to plans drawn by Joseph Greenleaf Thorp.

Refs.: Rattray, *Main Street,* 44–45.
 Star, 27 April 1889, 30 October 1925.

Photo: Eugene L. Armbruster, 1924, Local History and Genealogy Division, The New York Public Library, Astor, Lenox and Tilden Foundations.

Lean-to Houses

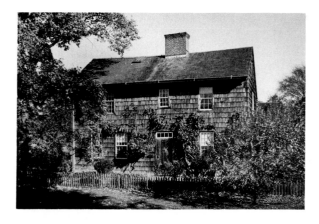

I-5 "HOME SWEET HOME" MUSEUM
14 James Lane
Early to mid–eighteenth century; twentieth-century alterations

This integral lean-to was probably built by the descendants of Robert Dayton, who was the original owner of this lot. The property was owned by Matthew Mulford by the mid-eighteenth century. The house contains seventeenth-century style paneling in the west parlor chamber, while the paneling in the parlor below is similar to Connecticut River Valley woodwork of the mid–eighteenth century. This later paneling and the form of the front stairway are the finest of their type in East Hampton. In the late nineteenth century this was one of the East Hampton houses promoted as the childhood home of John Howard Payne and the subject of his song, "Home, Sweet Home." Payne's grandparents, Aaron and Mary Isaacs, lived here, and it was thought that the young Payne stayed with them when in East Hampton. The house was remodelled during the ownership of Gustav Buek (1908–27), who collected period furniture and Payne memorabilia and made the house a Payne shrine. Buek moved the Pantigo mill (I-220) to the back yard in 1917, and the Village of East Hampton acquired the complex in 1927 preserving the site and structures as an historic museum.

Refs.: Rattray, *Main Street,* 23–25.

Photo: Harvey A. Weber.

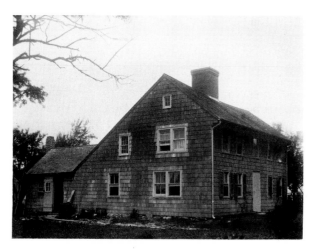

I-6 ISAAC HEDGES HOUSE
61 North Main Street
Early to mid–eighteenth century; later alterations

Isaac Hedges (1695–1776) probably built this double lean-to house. Many original features, including the chimney core and rear stairway, remain intact. Trenched rafters were reused in the roof construction.

Refs.: Rattray, *History,* 372.
Rattray, *Main Street,* 69–70.

Photo: Courtesy of the *East Hampton Star.*

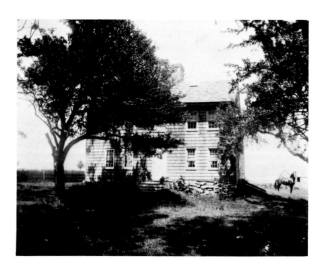

I-7 WILLIAM BARNES HOUSE
48 Egypt Lane
Early to mid–eighteenth century; 1904 alterations

The Barnes family owned this lean-to house until the mid-nineteenth century, and either William Barnes (1702–26) or his son, William (1723–1814), built the dwelling. The masonry core and main structural members of the house remain intact. Rafters have trenches cut on top about a foot apart with some connecting boards still in place. Ruger Donoho purchased the house in 1904, and the front stairway and divisions in the lean-to proper were removed at that time. A new staircase was built in the east end of the rear section and the house enlarged with a two-story porch on the right side and gambrel-roof addition. Donoho sold the house to fellow artist and noted American Impressionist, Childe Hassam, who used it as a studio and summer home.

Refs.: Rattray, *Fifty Years*, 36.
 Rattray, *History*, 36.
 Rattray, *Main Street*, 50.
 Star, 29 April 1954.

Photo: Courtesy of the East Hampton Free Library.

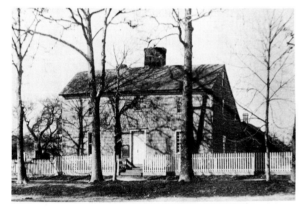

I-8 "OSBORNE OFFICE"
135A Main Street★
Early to mid–eighteenth century; 1898 alterations

Joseph S. Osborne had this lean-to house moved back from the street to allow for the construction of a modern house at the front of the lot. The original plaster cove cornice, front stairway, and paneled walls are intact. An unusual structural feature is the vertical planking in place of studs between sills and girts. The house contains a treasure of early wrought-iron hardware. The chimney was altered in rebuilding at the time of the move in 1898, and the rear roof slope may have been raised at that time.

Refs.: Edwards, "Reminiscences," 94.
 Rattray, *Main Street*, 107–8.
 Star, 7 October 1898.

Photo: H.K. Averill, Jr., 1880, courtesy of C. Frank Dayton.

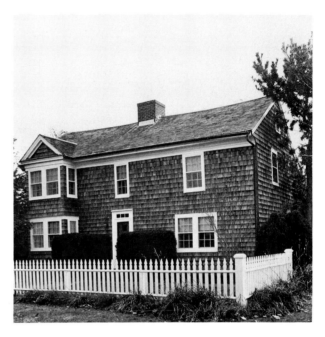

I-9 WILLIAM H. BABCOCK HOUSE
Middle Lane★
Early to mid–eighteenth century; later alterations

William H. Babcock owned this double lean-to house in the first half of the nineteenth century. It retains many original features. The two-story bay window and a double window in the front are late nineteenth century alterations. The chimney has been rebuilt. The house originally stood on the west side of Main Street north of the David Gardiner House (I-28) and was moved to its present location in 1964.

Refs.: Rattray, *History*, 36.
 Rattray, *Main Street*, 97–98.
 Star, 29 September 1938.

Photo: Harvey A. Weber.

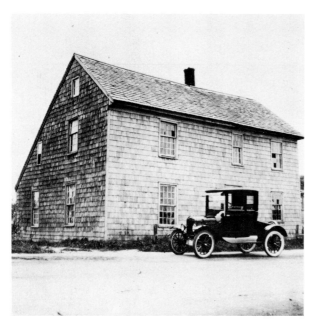

I-10 OSBORN HOUSE; "ROWDY HALL"
111 Egypt Lane★
Early to mid-eighteenth century; 1926 alterations

Originally a three-bay lean-to house, this dwelling once stood facing south on Main Street at the north corner of David's Lane. The Osborn family were early owners; later David H. Huntting purchased the house, and his adopted daughter, Annie, opened it to boarders in 1891. The boarding house was favored by young artists and due to their behavior became known as "Rowdy Hall." Annie Huntting built a new boarding house in 1895 (I-94), and this structure was moved to Gay Lane. Mrs. Harry L. Hamlin purchased the house in 1925 and had it moved to its present site. Joseph Greenleaf Thorp renovated the house for Mrs. Hamlin in 1926.

Refs.: Rattray, *Main Street,* 35–36.
Star, 4 June 1926.

Photo: Eugene L. Armbruster, 1923, Local History and Genealogy Division, The New York Public Library, Astor, Lenox and Tilden Foundations.

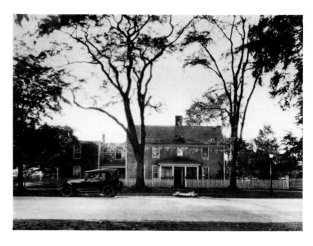

I-11 JONATHAN OSBORN HOUSE
101 Main Street
Early to mid-eighteenth century; twentieth-century alterations

Joseph Osborn (1754–1844) lived in this house, which may have been built by his father, Jonathan (1724–81). The rear of the lean-to is obscured by an upper addition. Other alterations include an addition on the south side and a modern front porch.

Refs.: Edwards, "Reminscences," 93–94.
Plans (alterations), Parsons Electric.
Rattray, *Main Street,* 101.

Photo: Eugene L. Armbruster, 1923, courtesy of the Queens Borough Public Library.

I-12 SAMUEL HUTCHINSON HOUSE
Further Lane★
Early to mid-eighteenth century; twentieth century alterations

This house was occupied by Dr. Samuel Hutchinson, who came to East Hampton in 1764. It originally stood on the north side of Pantigo Road opposite the Edward Mulford House (I-36) and was moved to its present site in 1949. The west half was the original single lean-to house, which was doubled at an early date. The dwelling was substantially altered and enlarged after the move.

Refs.: Rattray, *Main Street,* 54–55.

Photo: Eugene L. Armbruster, 1923, courtesy of the Queens Borough Public Library.

I-13 MILLER–POOR HOUSE
181 Main Street
Eighteenth century; 1900, 1906, 1911 alterations

Inside this house survives the frame of an eighteenth-century full lean-to house that was owned by the Miller family during most of the nineteenth century. In 1885 Mrs. Eleanor Papendiek bought the house from the Millers and had alterations made, including a two-story addition built by George Eldredge in 1892. James Harper Poor, who purchased the house in 1899, hired George Eldredge to remodel the house into a Shingle Style cottage. The house was given its present Elizabethan appearance in 1911, when stucco was applied over the shingles and other alterations made for J. H. Poor under the direction of Joseph Greenleaf Thorp.

Refs.: *Star,* 7 October 1892, 28 April 1911, 2 February 1950.

Photo: H. K. Averill, Jr., 1880, courtesy of C. Frank Dayton.

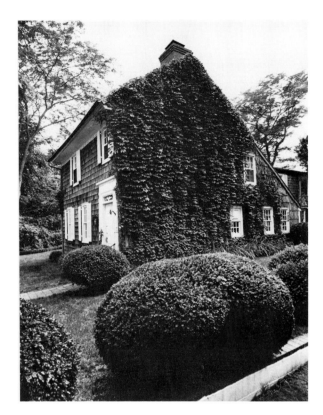

I-14 ISAAC W. MILLER HOUSE
223 Main Street
Early eighteenth century; 1929 alterations

This house was owned in the late nineteenth century by Isaac W. Miller. In 1927 New York architect Aymar Embury II purchased the house and two years later updated it with modern conveniences and Colonial Revival details, including a pilastered doorway, triglyph cornice, and new interior trim. The stairway was preserved intact with its closed stringer, square posts, and handrails without banisters. The early mantel in the living room came from another house. An unused fireplace found in the north side of the chimney during the 1929 renovations indicates that the house was to be doubled.

Refs.: Edwards, "Reminiscences," 188–89.
 Plans (14 December 1919), private collection.
 Rattray, *Main Street,* 139–41.

Photo: Harvey A. Weber.

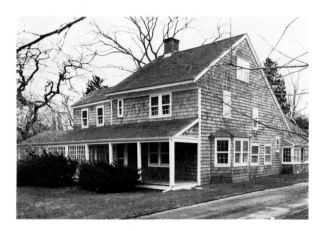

I-15 JOSEPH OSBORN HOUSE
Pudding Hill Lane★
Early to mid–eighteenth century; 1907 alterations

This single lean-to, probably built by Joseph Osborn (1705–86), was originally located on what is now Ocean Avenue, then Calf Pasture Lane. In 1855 it was the house farthest south from the village. The house was moved to its present site in 1888 and was remodeled and enlarged in 1907.

Refs.: Rattray, *Fifty Years,* 67–69.
Rattray, *Main Street,* 13–14.
Star, 29 December 1888, 9 May 1957.

Photo: Robert J. Hefner.

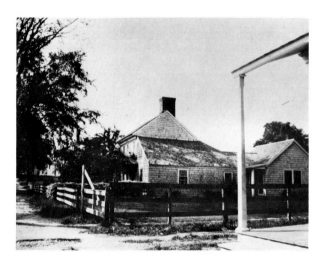

I-16 JONATHAN OSBORN HOUSE
9 Mill Hill Lane★
Early to mid–eighteenth century; 1926 alterations

Jonathan Osborn owned this house in the mid-nineteenth century. It was originally a single lean-to house with an early shed-roofed extension on the right side. In 1926 the house was moved from its original site north of the Isaac Hedges House (I-6) on North Main Street to its present location. With the move the chimney was rebuilt, the rear part of the house altered, and the roof of the shed addition raised. The house retains its original stairway and original woodwork with the cradle board adjoining the parlor fireplace.

Refs.: Rattray, *Main Street,* 66–67.

Photo: Eugene L. Armbruster, 1923, courtesy of the Queens Borough Public Library.

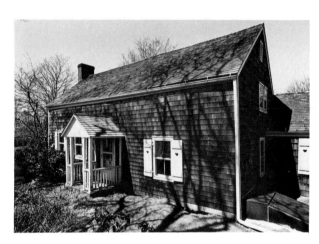

I-17 NOAH BARNES HOUSE
Georgica Road
Early to mid–eighteenth century; later alterations

The first recorded deed to this property is dated 13 August 1728 when Nathaniel Diment conveyed a house, barn, and seventeen acres to Noah Barnes. A later owner recalled seeing a beam inscribed *Noah Barnes 1741* in the structure. This is an unusual house type for East Hampton, being a one-and-three-quarter-story lean-to, four bays wide and without upper front windows. The summer beam in the west room is another unusual feature. The original chimney position and other details have been changed.

Refs.: Edwards, "Reminiscences," 215.

Photo: Harvey A. Weber.

I-18 "MILL COTTAGE"

36 James Lane
Eighteenth century; nineteenth- and twentieth-century alterations

This building displays a lean-to form, and the garret has old framing. The dwelling was converted into a barn and then reconverted into a house in 1887. It has since been enlarged into a modern residence.

Refs.: Edwards, "Reminiscences," 201.
 Rattray, *Main Street,* 20–22.

Photo: Mary Buell Hedges, courtesy of Adele Hedges Townsend.

Lean-to Houses Converted to a Full Two Stories

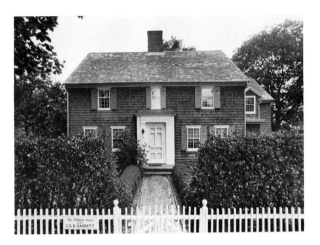

I-19 FITHIAN HOUSE

7 Fithian Lane★
Early to mid–eighteenth century; nineteenth-century and 1919 alterations

This house originally stood on Main Street opposite Newtown Lane on land owned by the Fithians since the late seventeenth century. Aaron Fithian (1689–1750) or his son, David (1728–1803), must have built this house. The back wall was raised to two stories in the early nineteenth century. The house retains the original front stairway, paneling, and other original features, although the chimney has been rebuilt, the right side of the lower story opened up, and additions attached at either end. Mrs. Norman Barns purchased the house from the Fithians in 1918 and a year later had it moved back on the lot to its present site and altered and enlarged under the direction of Joseph Greenleaf Thorp.

Refs.: Edwards, "Reminiscences," 69.
 C. G. B. Garrett, "The Fithian House," 1978, unpublished ms.
 Rattray, *Main Street,* 45.
 Star, 10 May 1918, 14 November 1919.

Photo: Harvey A. Weber.

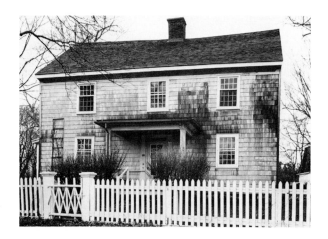

I-20 TIMOTHY MULFORD HOUSE
189 Main Street
Eighteenth century; 1869 alterations

This house must have been built by the Mulfords, Timothy Mulford having sold it in 1771 to Abraham Gardiner, who shortly resold it to Jeremiah Miller. It remains in the hands of Miller's descendants. Originally a lean-to house, the structure was renovated in 1869 by William Hedges.

Refs.: Rattray, *Main Street,* 129–30.

Photo: Robert J. Hefner.

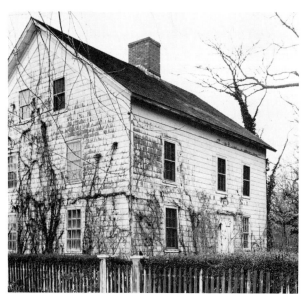

I-21 THOMAS WICKHAM HOUSE
136 Main Street
Eighteenth century; nineteenth- and twentieth-century alterations

Joists of round tree trunks visible from the cellar testify to the great age of this house, once the residence of Captain Thomas Wickham, a member of the Continental Congress. The house originally may have been a lean-to and it still faces south. It was covered with a hip roof prior to ca. 1865, when the present gable roof was added.

Refs.: Edwards, "Reminiscences," 117.
Rattray, *Main Street,* 31–32.

Photo: Robert J. Hefner.

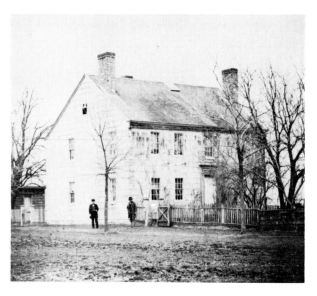

I-22 Lyman Beecher House
84 Main Street
Possibly eighteenth century; mid–nineteenth century, 1897, 1976 alterations

Said to have been a lean-to house originally, a distinct possibility given its southern exposure, this dwelling was owned and occupied by Reverend Lyman Beecher and his family from 1799 to 1810. When Beecher moved to Litchfield, Connecticut, he sold the house to Abram Hand, and Hand or a descendant converted it to a full two-story, end-chimney type of house.

Refs.: Rattray, *History,* 55.
Rattray, *Main Street,* 40.
Star, 9 August 1895, 19 March 1897.

Photo: The Long Island Historical Society.

I-23 DAVID B. MULFORD HOUSE, "CONGRESS HALL"
177 Main Street★
Eighteenth century; 1805, twentieth-century alterations

Originally a lean-to house, this structure was converted to a full two-story dwelling in 1805. It stood on the corner of Buells Lane and was moved to the south on the same lot in 1902. The name "Congress Hall" derives from its use during the third quarter of the nineteenth century when bachelor-owner David B. Mulford entertained the men of the community here.

Refs.: Rattray, *Main Street,* 123–24.

Photo: Harvey A. Weber.

One-and-One-Half Story Houses

I-24 Miller House
Apaquogue Road
Mid-eighteenth century; 1908 alterations

This story-and-a-half house belonged to Asa Miller in the middle of the nineteenth century, and his family probably built the house. It has a distinctive T-shaped stairway in front of the chimney, but the first floor plan otherwise resembles that of a lean-to house. Professor Robert W. Wood of Johns Hopkins University acquired the house in 1908 and had the rear half opened up into a single room. R. S. Bellows, a Boston architect, drew the plans for the L-shaped extension on the east side.

Refs.: Edwards, "Reminiscences," 218.
Rattray, *Fifty Years,* 150, 158.
Rattray, *History,* 37.
Star, 10 January 1908, 24 January 1908, 7 February 1908.

Photo: Harvey A. Weber.

I-25 CONKLIN-ELDREDGE HOUSE
Egypt Lane★
Mid-eighteenth century; 1860's, twentieth century alterations

Originally similar to the Miller House (I-24), this house once stood on North Main Street when it was owned by the Conklin family. Builder George Eldredge moved the structure to its present location and carried out some alterations during the 1860s. He probably added the kitchen ell at that time. Eldredge lived here until 1876, when he built a house next door (I-71). The dormers on the front slope of the roof are twentieth-century additions.

Refs.: Edwards, "Reminiscences," 19.

Photo: Robert J. Hefner.

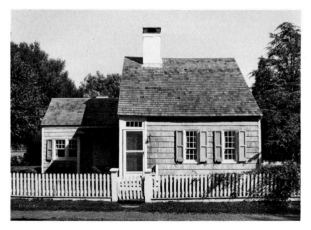

I-26 GARDINER HOUSE
48 James Lane★
Mid to late eighteenth century; later alterations

This single house stands on ground owned by the Gardiners since 1696. It is said to have been built at Three Mile Harbor, but the construction and moving dates are not known. The front part of the cottage retains its early plan, the rear has been opened up, and additions have been built on the north side and at the rear.

Refs.: Edwards, "Reminiscences," 202.
Rattray, *Main Street,* 19–20.

Photo: Harvey A. Weber.

One-and-Three-Quarter Story House

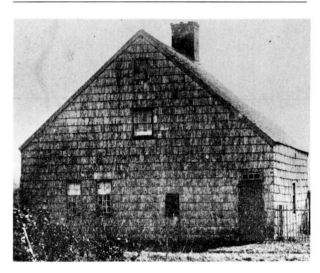

I-27 JOHN DAYTON HOUSE
Montauk Highway★
Eighteenth century; ca. 1900 alterations

Captain John Dayton (1727–1825) built this house near Georgica Pond. A one-and-three-quarter story cottage of unusual plan, it is a single house with a one-room extension. The rooms had corner fireplaces and the stairway was in an entry in the northwest corner of the house. About 1900 the structure was altered and enlarged to serve as a gatehouse for the Albert Herter estate (I-111). The house was moved back from the highway in the 1950s.

Refs.: Edwards, "Reminiscences," 194.

Photo: H.K. Averill, Jr., 1880, courtesy of C. Frank Dayton.

Gambrel-Roof Houses

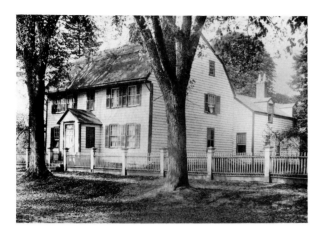

I-28 DAVID GARDINER HOUSE
95 Main Street★
1740; 1925 alterations

The oldest existing gambrel-roof building in East Hampton, this house was built for David Gardiner, the fourth proprietor of Gardiner's Island. This is also the earliest two-and-a-half story center-chimney house in the village. In 1924 Winthrop Gardiner had it moved back from the street and hired architect Joseph Greenleaf Thorp to remodel it. With subsequent changes and additions little is left of the original structure short of the framework, and even the top part of the roof is of new timbers. The chimney has been removed and additions built on three sides. Period paneling in the northeast chamber has been reused from some other part of the house and may have come from the parlor below. The house retains an early entrance porch.

Refs.: Edwards, "Reminiscences," 90.
 Rattray, *History,* 40.
 Rattray, *Main Street,* 99, 100.
 Sleight (ed.), *Trustees Journal,* 70–74.

Photo: Courtesy of the East Hampton Free Library.

I-29 JEREMIAH MILLER HOUSE
117 Main Street★
ca. 1799; 1885, 1889, 1905 alterations

East Hampton's second gambrel-roof house followed the center-hall two-chimney plan. It was built for Jeremiah Miller, who became East Hampton's first postmaster. He added a room on the north side for handling mail. Edward DeRose, a summer resident, purchased the house in 1885 from the Miller family and transformed it into a summer cottage. The improvements included moving the house back from the street, additions, interior renovations, and the construction of "an old-fashioned windmill on the rear of the grounds" (I-76). In 1889 further changes were made under the direction of architect I. H. Green. In 1905 J. G. Thorp planned interior alterations for a new owner. During these alterations the house was given a new front porch, a pediment on the front roof slope, and a gambrel roof and dormers on the wing. Interior changes included opening up the front stairhall to the two adjoining rooms and installing a flying stairs in the rear hall.

Refs.: Edwards, "Reminiscences," 95.
 Rattray, *Main Street,* 103–4.
 deKay, "Summer Homes," 30–31.
 Star, 26 December 1885, 24 March 1889, 6 September 1901, 1 April 1905.

Photo: Courtesy of the *East Hampton Star.*

Two-and-One-Half Story, Center-Chimney Houses

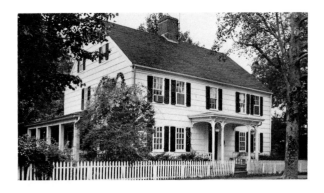

I-30 SHERRILL HOUSE
128 Main Street
ca. 1780; 1850's, 1870's alterations

This house stands on property which was owned by the Sherrill family from 1676 to 1956 and it succeeds an earlier dwelling on the site. The rear wing was added probably ca. 1850 and the entrance porch ca. 1870.

Refs.: Edwards, "Reminiscences," 113.
 Rattray, *Main Street,* 33.

Photo: Harvey A. Weber.

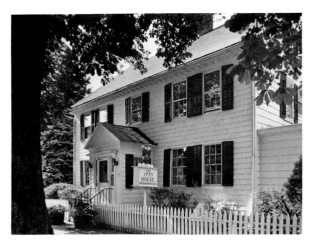

I-31 JONATHAN DAYTON HOUSE, 1770 INN
143 Main Street
Late eighteenth century; 1942 alterations

This house may have been built by Jonathan Dayton (1764–1842), who kept a store in the south end wing. The original building retains many fine features, like the front stairway and the paneling in the north front parlor, similar to that in "Home Sweet Home" (I-5). The entrance pent with red sandstone front steps dates from an early period. With the conversion to the "1770 Inn" in 1942, the southwest corner of the original first story was opened up and additions were built on the rear.

Refs.: Rattray, *Main Street,* 111–12.

Photo: Harvey A. Weber.

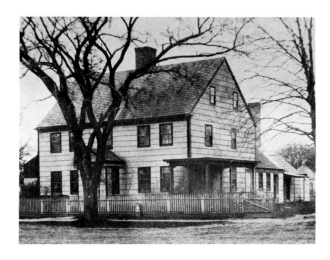

I-32 WILLIAM HEDGES HOUSE
Further Lane★
Late eighteenth century

This house was probably built by William Hedges (1737–1815), whose descendants occupied the dwelling through the nineteenth century. It originally stood on Main Street south of Clinton Academy (I-219). The neighboring East Hampton Free Library acquired the house in 1941 and rented it as a residence for several decades. In 1974 it was moved to its present site near the ocean.

Refs.: Rattray, *Main Street,* 115–16.

Photo: H. K. Averill, Jr., 1880, courtesy of C. Frank Dayton.

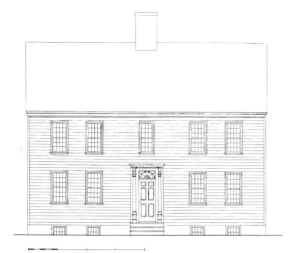

I-33 MILLER DAYTON HOUSE
19 Toilsome Lane
Samuel Schellinger, builder
1799; 1870s alterations

A sandstone plaque on the chimney bears the inscription: "I, Miller Dayton, built this house in the year 1799." Dayton engaged Amagansett carpenter Samuel Schellinger to build the house, and Schellinger's account book records the felling of the framing timbers in 1793. The center-chimney, two-and-a-half story house followed an early lean-to plan, even to having an oven at the rear rather than at the side of the kitchen fireplace. Overhanging bracketed eaves, the two-pane sash below garret level, a bay window on the south side, and a service ell at the rear date from the 1870s.

Refs.: Edwards, "Reminiscences," 131.
 Samuel Schellinger Account Book, private collection.

Illustration: Front elevation, restored (1830s), drawn by Clay Lancaster.

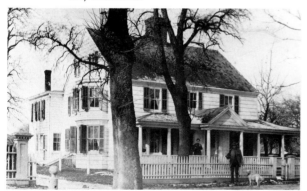

I-34 DANIEL OSBORN HOUSE
109 Main Street
ca. 1800; late nineteenth-century and 1963 alterations

The Osborn family owned this property in the seventeenth century. According to tradition Daniel Osborn (1774–1848) built the present house about 1800, incorporating the chimney and foundations of an earlier dwelling. Some interior doors have panes of glass in the two upper panels to allow for fire detection. The cellar is located under the southwest corner of the house. Late nineteenth-century alterations include a bay window on the south end and a front porch since removed.

Refs.: Rattray, *Main Street,* 101–2.

Photo: Courtesy of the *East Hampton Star.*

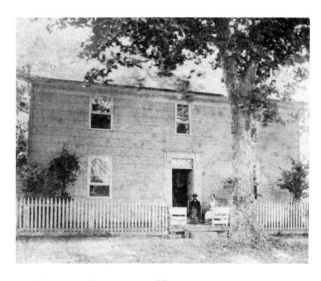

I-35 DAVID HUNTTING HOUSE
102 Main Street★
ca. 1800; twentieth-century alterations

The first known occupant of this house was David Hedges Huntting (1815–85). The dormer windows date from the early twentieth century. Davids Lane was opened in 1923 and the house was moved back on the lot. A modern porch spans the front.

Refs.: Edwards, "Reminiscences," 109.

Photo: Courtesy of the *East Hampton Star.*

Two-and-One-Half Story, Center-Hall Houses

I-36 EDWARD MULFORD HOUSE
124 Pantigo Road
1802–5

This house was built for Edward Mulford, a whaleship owner. Details such as the fluted pilasters at the front door, cutout consoles under the stairs, mahogany handrail, and panels under the windows are special refinements. The interior is largely intact, with the possible exception of the modern kitchen area at the southeast corner of the house.

Refs.: Edwards, "Reminiscences," 20.
 Daniel M. C. Hopping, "Mulford-Baker-Perkins-House," unpublished ms.
 Rattray, *Main Street,* 46–48.

Photo: Harvey A. Weber.

I-37 JAMES PARSONS MULFORD HOUSE
24 Jefferys Lane★
ca. 1815; 1923, 1932 alterations

This house originally stood on the east side of Main Street south of The Circle. James Parsons Mulford (1810–83) was the earliest known owner. Mary Talmage, architect of several later East Hampton houses, purchased this house about 1923 and moved it to its present location. The structure was substantially remodeled on the interior at the time of the move. Subsequent owners added the kitchen ell, designed by Aymar Embury II, in 1932.

Refs.: Edwards, "Reminiscences," 83.
 Rattray, *Main Street,* 43.

Photo: Harvey A. Weber.

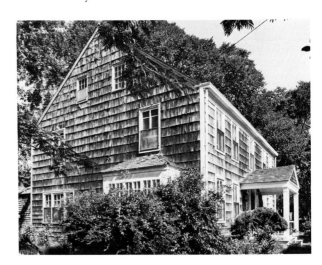

I-38 JOSIAH DAYTON HOUSE
35 Toilsome Lane
Benjamin Glover, builder
1829; later alterations

The Dayton family has owned this land since the seventeenth century. Josiah Dayton engaged Benjamin Glover of Sag Harbor to build this house on foundations laid by Charles Payne. An older house had stood on this site and its kitchen was incorporated into this dwelling. The house displays unusually elaborate woodwork for East Hampton.

Refs.: Josiah Dayton Account and Receipt Book, C. Frank Dayton Collection.
 Edwards, "Reminiscences," 129.

Photo: Harvey A. Weber.

I-39 ABRAHAM HUNTTING HOUSE
15 North Main Street
ca. 1835; later alterations

A variation on the center-hall, two-chimney plan, this house has chimneys located toward the outside walls and the north chimney serves a corner fireplace in the front room. The woodwork is late Federal in style. Abraham Huntting built the house and two sons, James Madison and Otis Huntting, kept a general store in a wing later removed.

Refs.: Edwards, "Reminiscences," 64.
 Rattray, Main Street, 73–75.

Photo: Robert J. Hefner.

I-40 BALDWIN COOK TALMAGE HOUSE
Briar Patch Road
ca. 1840; 1950 alterations

This is a rule-of-thumb house, with one inter-room and one end-wall chimney, and a one-and-three-quarter story shed-roof extension on the side for a kitchen. Architectural details are plain Greek Revival in style. The house was sold out of the family in 1950 and the interior was renovated.

Refs.: Edwards, "Reminiscences," 221.
 Rattray, History, 582.

Photo: Harvey A. Weber.

Two-and-One-Half Story Single Houses

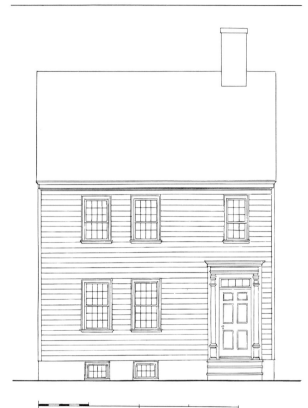

I-41 **JACOB HEDGES HOUSE**
73 Pantigo Road
Early nineteenth century; 1879, 1902 alterations

Jacob Hedges (1784–1869) was the original owner of this house, which remained in the family until the 1970s. The first floor follows a lean-to plan for room arrangement, fireplace position, and front and back stairs. The trim, however, is characteristically Federal in style. In 1879 the rear addition was built, and in 1902 the porch was added at the front.

Refs.: Rattray, *Main Street,* 60.

Illustration: Front elevation, restored, drawn by Clay Lancaster.

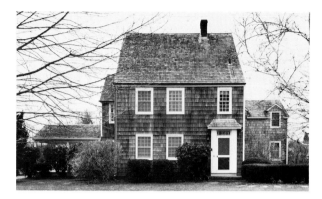

I-42 **STAFFORD HEDGES HOUSE**
Cross Highway★
Early nineteenth century

This house originally stood on the north side of Pantigo Road opposite the John Youngs House (I-54) and is similar to the nearby Jacob Hedges house (I-41). Stafford Hedges (1786–1833) probably built this dwelling, and his son, David, who moved the Pantigo Mill nearby, was the last of the family to live here. The house was moved to its present site in 1954.

Refs.: Rattray, *Main Street,* 57–58.

Photo: Robert J. Hefner.

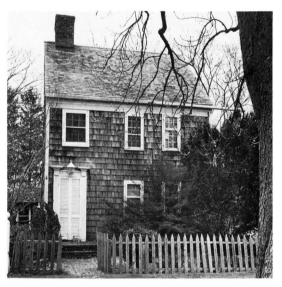

I-43 **SAMUEL G. MULFORD HOUSE**
146 Main Street
ca. 1800; 1890, 1970 alterations

This house was owned in the Mulford family during the nineteenth and early twentieth centuries. In 1890 a new chimney was built in the house, and the present door enframement, which came from the Claremont Inn in New York City, was installed ca. 1970. A small outbuilding reported to have been a smokehouse remains on the property.

Refs.: Edwards, "Reminiscences," 118.
 Rattray, *Main Street,* 29.
 Star, 10 October 1890.

Photo: Harvey A. Weber.

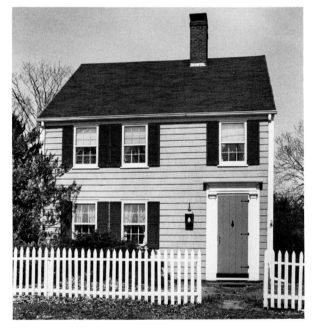

I-44 TALMAGE JONES HOUSE
Montauk Highway
Early to mid-nineteenth century; twentieth-century
 alterations

This house was built for Talmage Jones, Ezekiel Jones' brother (see I-45). It is a single house with parlor and kitchen fireplaces facing west and north in a common chimney and a straight flight of steps in an adjoining hall. The Federal style woodwork is notable. A one-story kitchen ell was raised to two stories about 1940.

Refs.: Edwards, "Reminiscences," 193.
 Rattray, *History,* 37.

Photo: Harvey A. Weber.

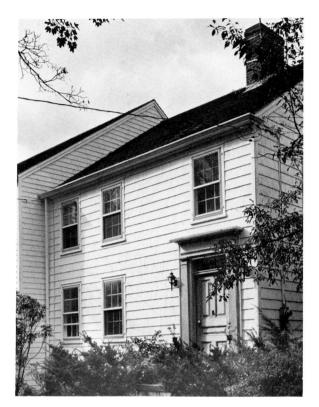

I-45 EZEKIEL JONES HOUSE
Montauk Highway
Early to mid-nineteenth century; ca. 1940 alterations

Probably built for Ezekiel Jones, this house is a near twin to the Talmage Jones House next door (I-44). The most notable alteration was the addition of a large modern extension to the west around 1940.

Refs.: Edwards, "Reminiscences," 192–93.
 Rattray, *History,* 37.

Photo: Harvey A. Weber.

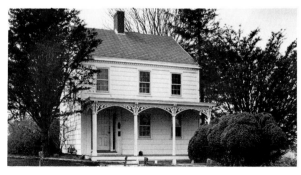

I-46 NATHAN CONKLIN BARNES HOUSE
148 Pantigo Road
Early to mid-nineteenth century; ca. 1870 alterations

Thought to have been built for Nathan Conklin Barnes before his marriage in 1824, this house relates to the Jacob Hedges House (I-41). The front porch dates from the 1870s.

Refs.: Edwards, "Reminiscences," 21.
Rattray, *Main Street,* 49.

Photo: Harvey A. Weber.

Two-and-One-Half Story Single Houses with End Chimneys

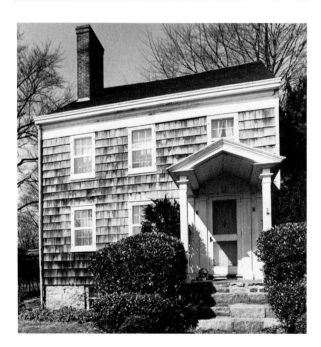

I-47 HORACE ISAACS HOUSE
199 Main Street★
Rebuilt in 1836

In May, 1836, the Town Trustees purchased Horace Isaacs' house and lot on the east side of the common for a parsonage. After deciding to build a new residence for the minister, they sold the house itself back to Isaacs for $650. John C. King, who built the

new manse, moved the old building to the present site and may have remodeled it for Isaacs. The plan is an inversion of the main pavilion that King built for the manse. Tradition has it that the transported house was set atop an old foundation, substantiated by irregularities in the masonry. First-floor joists indicate a number of alterations to the original structure.

Refs.: Rattray, *Main Street,* 131–32.

Photo: Harvey A. Weber.

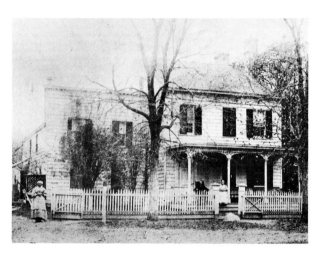

I-48 THOMAS S. ISAACS HOUSE
120 Main Street
ca. 1836; 1900 alterations

This house was built for Thomas S. Isaacs (1807–75), a shoemaker who operated a shop next door in the mid-nineteenth century. A new Presbyterian church was built on adjoining land to the north in 1860, and after Isaacs' death the house was acquired for the parsonage. The dwelling originally resembled the Presbyterian Manse built in 1836. The old manse was a three-bay structure with a one-story, shed-roof wing with a false front on the north side. An early photograph of the Thomas Isaacs house shows a two-story wing with a false front. This north wing was rebuilt into the north section seen today around 1900.

Refs.: Edwards, "Reminiscences," 11.
Rattray, *Main Street,* 33–34.

Photo: Courtesy of the East Hampton Free Library.

I-49 DAVID G. THOMPSON HOUSE
217 Main Street★
ca. 1836; 1902–16 alterations

The original part of this house resembles the Thomas S. Isaacs House (I-48) and must date from about the same time. Like the William Osborn House next door (I-51), this dwelling follows a row-house plan. Interior doors with six equally sized panels correspond to doors in New York City residences of the 1830s. Corner blocks in door and window trim relate to those in the Josiah Dayton House (I-38). The structure was apparently built for David G. Thompson shortly after his marriage to Sarah Diodati Gardiner. Mrs. Thompson sold the house about 1882 to John Alexander Tyler, the son of President John Tyler and Julia Gardiner Tyler, a native of East Hampton. The house was moved back from the street and the north addition built between 1902 and 1916.

Refs.: Rattray, *Main Street,* 137–38.

Photo: Harvey A. Weber.

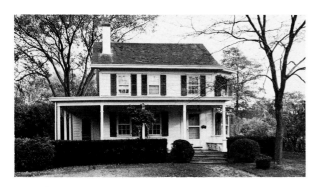

I-50 HENRY B. TUTHILL HOUSE
4 James Lane
Mid-nineteenth century; 1886 alterations

Refs.: Edwards, "Reminiscences," 167–68.
 Star, 13 March 1886.

Photo: Harvey A. Weber.

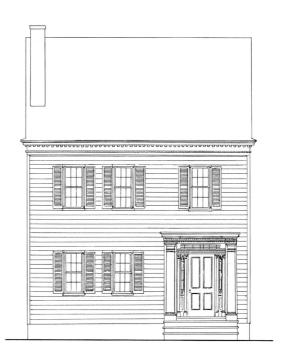

I-51 WILLIAM LEWIS HUNTTING OSBORN HOUSE; MAIDSTONE ARMS INN
207 Main Street
ca. 1840; 1924 alterations

The Osborn house has the purest Greek Revival trim in East Hampton. The frontispiece is elaborated with leaded transom and sidelights, pilasters, and an entablature articulated with dentils. The staircase features tapered balusters. Mantels and interior door and window frames are bold and plain. The plan resembles that of a city row house with stairhall to one side of a suite of two rooms connected by a wide doorway. Chimney stacks are against the outside wall. This building remained in the Osborn family until 1924, when the Hampton Hotels Corporation acquired it and converted it to the Maidstone Arms. At that time the porch and dormers were added.

Refs.: Rattray, *Main Street,* 133–35.

Illustration: Front elevation, restored, drawn by Clay Lancaster.

153

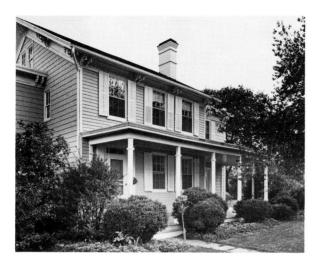

I-52 EZEKIEL HOWES HOUSE
26 James Lane
Mid–nineteenth century; 1882 alterations

Refs.: *Express,* 30 March 1882.
 Rattray, *Main Street,* 20.

Photo: Harvey A. Weber.

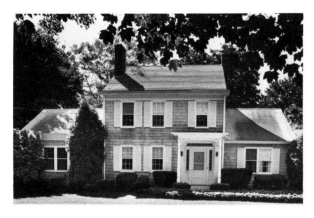

I-53 CHARLES OSBORNE HOUSE
27 Edwards Lane★
ca. 1840

This house originally stood on the corner of Main Street and Dayton Lane and was moved to this site in 1940. George Eldredge, who became a prominent East Hampton builder, made the moldings and other architectural details for the house.

Refs.: Rattray, *Main Street,* 108–9.

Photo: Harvey A. Weber.

Two-and-One-Half Story, Center-Hall House with End Chimneys

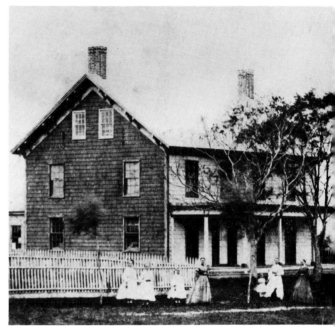

I-54 JOHN YOUNGS HOUSE
100 Pantigo Road
1848; 1886, 1908, later alterations.

John Youngs, a blacksmith from Moriches, moved to East Hampton in 1846 and built this house two years later. Youngs' shop was located at the corner of Pantigo Road and Accabonac Highway. Samuel T. Stratton added a large wing in 1886 and his residence was then described as "one of the pleasantest and largest in the village." A late nineteenth-century photograph shows this house with a one-story porch across the front, french doors on the first level, and brackets at the eaves. Subsequent alterations include the removal of the large wing in 1908.

Refs.: Edwards, "Reminiscences," 20.
 Rattray, *Main Street,* 47–48.
 Star, 17 April 1886, 3 July 1886, 10 April 1908.

Photo: Courtesy of the *East Hampton Star.*

Nineteenth-Century, One-and-One-Half and One-and-Three-Quarter Story Houses

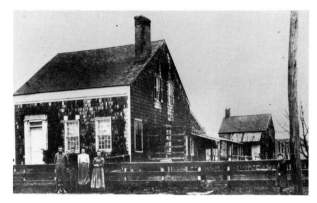

I-56 ISAAC S. OSBORN HOUSE
88 Newton Lane
Mid-nineteenth century; twentieth-century alterations

Jonathan Osborn owned this land in 1794 and his son, Isaac S. (1800–1890), probably built this house. In the twentieth century the front roof slope was raised and other major alterations made.

Refs.: Rattray, *Main Street,* 82.

Photo: Courtesy of the *East Hampton Star.*

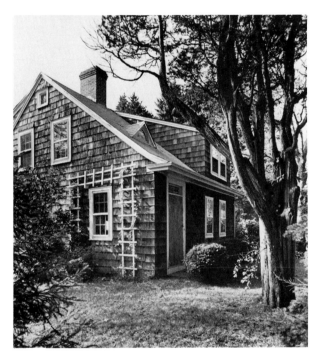

I-55 JONES HOUSE
Montauk Highway
Early nineteenth century; later alterations

Outwardly a simple "Cape Cod cottage," this house, probably built by a member of the Jones family, shows great sophistication of planning and detail. The stairway, rooms, and fireplaces are carefully arranged. An elliptical arch in the hall and a colonnetted mantel and carved plaque over double doors in the parlor display skill and refinement. The main part of the house remains mostly intact. A later addition has been attached at the rear.

Refs.: Edwards, "Reminiscences," 193.
Rattray, *History,* 37.

Photo: Harvey A. Weber.

I-57 WILLIAM BENNETT HOUSE
43 North Main Street
Lewis Jones, builder
1849

Captain William Bennett, first mate of the whaleship *Italy,* had an earlier lean-to house on this site demolished and engaged Lewis Jones to build the present structure, partly from old materials. The finished room at the front of the cellar was the original kitchen.

Refs.: Rattray, *Main Street,* 70–71.

Photo: Harvey A. Weber.

Inventory of Domestic Architecture 1860–1981

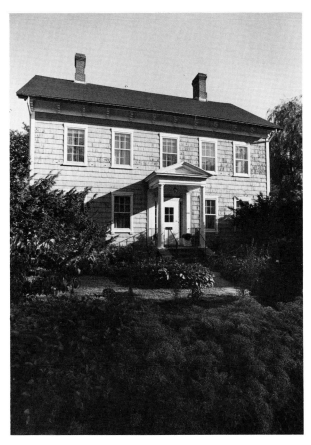

I-58 JEREMIAH MULFORD HOUSE
140 Main Street
ca. 1860; twentieth-century alterations

Captain Jeremiah Mulford had this house built for a boarding house on the site of an earlier dwelling. The house follows the center-hall, two-chimney pattern, then almost a century old in East Hampton, but it displays the new style with bracketed overhanging eaves.

Refs.: Edwards, "Reminiscences," 117–18.
 Mary Miller to Abigail Halsey, "An East Hampton Childhood," EHFL.
 Rattray, *Main Street,* 30.

Photo: Harvey A. Weber

I-59 STEPHEN HEDGES HOUSE
28 Accabonac Highway
1864

The Hedges family owned this land since the early eighteenth century. Stephen Hedges built this house in front of an older dwelling which he converted into a barn that has not survived. The house is stylistically restrained for the period, exterior elaboration consisting of brackets under the main eaves and on the front porch. The interior trim is simple.

Refs.: Edwards, "Reminiscences," 59.

Photo: Harvey A. Weber.

I-60 HENRY S. TERBELL HOUSE
Ocean Avenue
George Eldredge, builder
1869–70; 1895, 1901, 1908, 1915 alterations

In 1869 Henry S. Terbell bought fifty-seven acres here, comprising the south side of Ocean Avenue, with the exception of the Mershon property, and extending to the ocean. Terbell, the founder of the Equitable Company in New York, built this house about 1870, but its original form is unrecorded. In 1895 Terbell hired George A. Eldredge to carry out some exterior alterations. In 1901 Terbell's son hired architect Walter E. Brady of Southampton to design alterations, executed again by Eldredge at a cost of approximately $6,000. Apparently at this time the house acquired its present form, as the *Star* noted that the "new design" was "strictly Colonial". When E. D. Terbell acquired this property it included thirty-two acres. He opened Terbell Lane and sold off lots until 1908 when he sold the house and its diminished six and one-half acre lot to Arthur Kennedy of New York. Kennedy also altered the house and sold it in 1915 to Robert A. Gardiner who "greatly changed and improved" the structure, renaming it "Maidstone Hall."

Refs.: Plans (1915), EHFL, and Parsons Electric.
　　Star, 25 October 1895, 25 January 1901, 8 March 1901, 3 September 1915, 2 May 1919, 13 November 1933, 10 January 1951.

Photo: Courtesy of the *East Hampton Star.*

This house was built about 1871 as a summer home for Reverend Stephen Mershon, minister of the East Hampton Presbyterian Church from 1854 until 1866. A dynamic and influential preacher, Mershon was responsible for the construction of two church buildings (I-224, I-225). Mershon was also partially responsible for the early development of the Divinity Hill section of the Summer Colony.

The second owner, Professor Mayo-Smith, a political economist at Columbia University, hired Stafford Tillinghast to build a large addition to the structure in 1889. The following year A. O. Jones built an addition to the front piazza and enlarged the rear portion of the building for Mayo-Smith. In 1901 a later owner carried out further alterations, namely the construction of another large addition and a veranda. The house today little resembles its original form.

Refs.: *Corrector,* 9 May 1874.
　　Express, 27 February 1873, 31 July 1873, 28 August 1873, 4 September 1873.
　　Raymond A. Smith, "East Hampton, A Summer Resort as Early as 1840," *Southampton Season,* n.d., EHFL.
　　Star, 5 October 1889, 21 September 1890, 9 March 1950.

Photo: Robert J. Hefner.

I-61 **STEPHEN MERSHON HOUSE,
SEA SIDE COTTAGE**
Ocean Avenue
ca. 1871; 1889, 1890, 1901 alterations

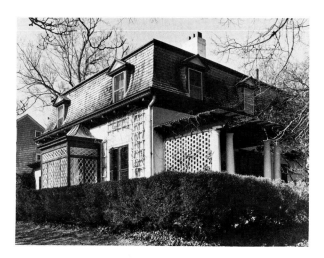

I-62 **WILLIAM KING HOUSE**
187 Main Street
1872; later alterations

Refs.: Rattray, *Main Street,* 125.

Photo: Harvey A. Weber.

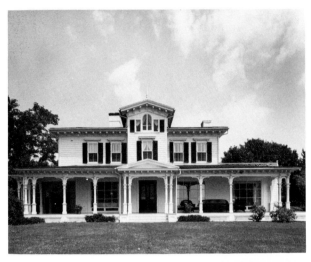

Charles Peter Beauchamp Jefferys, a civil engineer from Pennsylvania, had this house built on land bordering Hook Pond and may have designed it himself. He named it "Sommariva," meaning highest point of the shore, after a place he had visited in Italy. In 1914 Mrs. Henry L. Hobart, Jefferys's daughter, had the house moved to its present site about one hundred yards east of the original site and at that time some renovation and reconstruction took place. A descendant recalls that the house was once painted a deep barn red.

Refs.: *Corrector,* 30 May 1874.
 Star, 9 January 1914, 7 August 1914, 27 September 1934.

Photos: Harvey A. Weber.

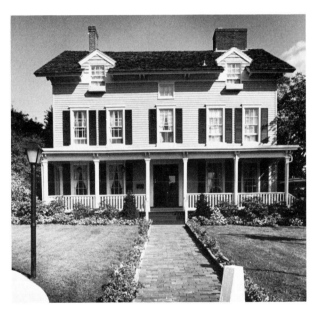

I-64 JOHN D. HEDGES HOUSE
74 James Lane
1873; 1935 alterations

The Hedges family owned this land since the seventeenth century. In 1873 John D. Hedges tore down the old family house on the site and replaced it with this dwelling. Mrs. Harry L. Hamlin renovated and enlarged the structure for use as an inn in 1935.

Refs.: Edwards, "Reminiscences," 203–4.
 Plans (1935), EHFL.
 Rattray, *Main Street,* 19–20.

Photo: Harvey A. Weber.

I-63 C. P. B. JEFFERYS HOUSE, "SOMMARIVA"
Jefferys Lane★
1872–73; later alterations

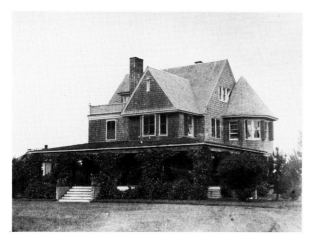

I-65 T. DeWitt Talmage House
Lily Pond Lane
George Eldredge, builder
1873–74; 1893, 1902 alterations

Reverend T. DeWitt Talmage of the Brooklyn Tabernacle, in association with his brother-in-law, Reverend Stephen Meshon, and his nephew, Daniel Talmage, built four cottages in this vicinity in 1873–1874, including this one (see I-66).

This cottage was a two-story, L-shaped house with a three-story tower in the L, ornamented with such details as finials and cast-iron cresting on the tower. It was "neatly painted in light drab, trimmed with red," according to an 1874 newspaper description. In 1893, however, Talmage had this cottage extensively renovated by Joseph Greenleaf Thorp as reported in the *Star:*

> "... Mr. Talmage's cottage ... has been almost entirely rebuilt. New wings have been added and a pretty bay window reaching from the ground to the second story graces the eastern elevation, while the sloping roof gives the structure that quaint style so common among our seaside cottages."

Refs.: *Corrector,* 30 May 1874.
 Express, 28 August 1873, 25 June 1874.
 Rattray, *Fifty Years,* 18.
 Rattray, *History,* 57.
 Star, 11 September 1886, 10 March 1893, 2 December 1927, 4 March 1943.

Photo: Courtesy of the *East Hampton Star.*

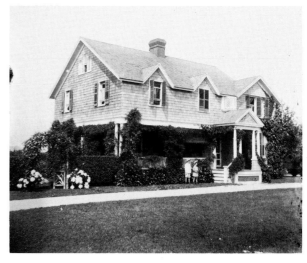

I-66 Daniel Talmage House
Cottage Avenue
George Eldredge, builder
1873–74; 1900 alterations

Daniel Talmage first came to East Hampton as a child in the 1850s to live with his uncle, Reverend Stephen Mershon, pastor of the Presbyterian Church. He returned to East Hampton in 1873 and in association with Reverend Mershon and another uncle, the Reverend T. DeWitt Talmage, acquired land and built cottages for rental and sale on Lily Pond Lane and Cottage Avenue. Daniel Talmage most likely acted as an agent for Dan Talmage's Sons Company, a family mercantile business founded by his father and based in New York City.

Talmage had four cottages built in 1873–74, one for himself and one for his uncle, the Reverend T. DeWitt Talmage (I-65). Daniel Talmage, through the family firm, continued to build cottages in this vicinity for sale and rental as late as 1885. Most of these cottages were rented and eventually sold to other clergymen (I-67, I-68, I-69). In 1898 a court-ordered auction of the East Hampton holdings of the estate of Dan Talmage's Sons Co. was held. Forty-one building sites on Ocean Avenue, Lily Pond Lane, Lee Avenue, and Cottage Avenue were auctioned and thirty-nine were sold. Houses were built on many of these lots in the next several years.

Daniel Talmage's own cottage was sold at the auction to one M. Martin, who immediately resold it to Theron G. Strong, who hired George A. Eldredge to remodel it. Eldredge drew his own plans and, according to a report in the *Star,* the old house was "... lost in the new." In 1900 Strong had Eldredge

build the two-story wing on the north side of the house.

Refs.: *Corrector,* 30 May 1874.
 Express, 30 October 1879, 19 February 1880, 25 April 1880, 17 September 1885.
 Rattray, *Fifty Years,* 140.
 Raymond A. Smith, "East Hampton, A Summer Resort as Early as 1840," n.d., EHFL.
 Star, 16 September 1891, 19 August 1898, 16 September 1898, 6 January 1899, 22 November 1918.

Photo: Courtesy of the *East Hampton Star.*

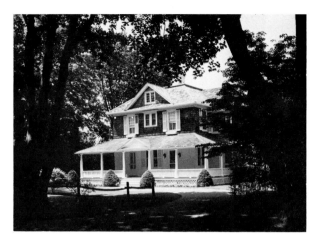

I-68 JOHN R. PAXTON HOUSE
Cottage Avenue
ca. 1873–85; 1893, 1901, 1912 alterations

Reverend John R. Paxton, a minister at the West Presbyterian Church in New York City from 1882–95, first came to East Hampton in 1892. The following year Paxton purchased the cottage he had previously rented from Dan Talmage's Sons Co. Paxton's daughter recalled that most of the clergy lived on Divinity Hill in the Talmage cottages "completely sans water, sans gas, sans electricity, sans everything the kitchen pump was our only water supply." In 1901 Paxton built another house on adjoining property (I-131) but retained ownership of this cottage.

This house has been substantially altered. In 1893 George A. Eldredge built a large addition to the structure for Paxton, and in 1901 Eldredge renovated the house. In 1912 E. M. Gay built another large addition.

Refs.: *Corrector,* 30 May 1874.
 Express, 25 April 1880, 17 September 1885.
 Rattray, *Fifty Years,* 61.
 Star, 19 April 1901, 7 April 1893, 29 November 1912, 16 November 1923, 3 September 1942, 1 April 1943.

Photo: Harvey A. Weber.

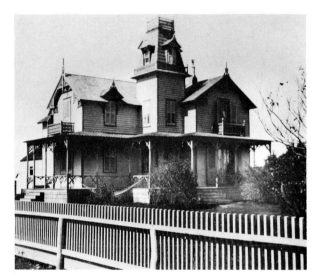

I-67 W. R. MacKAY HOUSE
Cottage Avenue
1873–74; 1899, 1919 alterations

The Reverend W. R. MacKay of Pittsburgh had purchased this cottage from the firm of Dan Talmage's Sons by 1887. As seen in a ca. 1892 photograph, the MacKay house was built in the high Victorian Gothic style. In 1896 plans for alterations were drawn by Joseph Greenleaf Thorp but were not carried out until 1899 for Reverend MacKay's widow. These alterations were estimated to cost $3,500 and by one account were termed a "reconstruction" of the house. In 1919 George A. Eldredge bought the house, planning to remodel and furnish it for rental.

Refs.: *Corrector,* 30 May 1874.
 Express, 25 April 1880, 17 September 1885.
 Star, 2 July 1887, 24 January 1896, 1 December 1899, 2 February 1950.

Photo: Courtesy of Elizabeth Kelley.

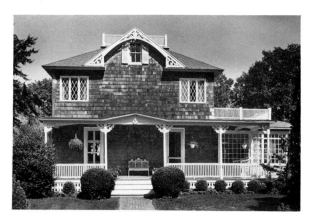

I-69 JAMES B. McLEOD HOUSE
Cottage Avenue
Frank Grimshaw, builder
ca. 1873–85; later alterations

This cottage, built for Dan Talmage's Sons Co. on Divinity Hill, was owned in 1897 by Reverend James B. McLeod.

Refs.: *Corrector,* 30 May 1874.
 Express, 25 April 1880, 17 September 1885.
 Hyde, *Atlas,* 1897.
 Star, 23 March 1900.

Photo: Harvey A. Weber.

In 1873 Dr. James Shaif Satterthwaite purchased approximately three acres from John D. Hedges and the following year built a fanciful Stick-Style cottage on the site. The *Corrector* described it as a "large and handsome summer residence, the first one here, if not the first on Long Island, of the Long Branch pattern . . . a mingling of the Gothic, Grecian and Italian styles of architecture." The firm of Briggs & Corman of Newark, New Jersey, designed the house and R. V. Breece of Long Branch, New Jersey, was the contractor.

Charles G. Thompson, a trustee of the New York Life Insurance and Trust Company, purchased the house in 1893 and undertook the extensive remodeling which produced the structure seen today. Thompson announced that the firm of McKim, Mead and White would proceed with the remodeling. But the *Star* noted in August, 1894: "George A. Eldredge has the contract to reconstruct the Satterthwaite house. The exterior of the building will be completely remodeled after designs of a colonial style drawn by Mr. Eldredge." The work lasted into the Spring of 1895. The addition of the north wing and additions to the servants' wing were made in 1910 according to plans furnished by J. C. Lawrence.

Refs.: *Corrector,* 30 May 1874.
 Star, 29 September 1893, 1 March 1895, 17 June 1943, 5 October 1944, 30 September 1965.

Photo: Courtesy of the *East Hampton Star.*

I-70 SATTERTHWAITE–THOMPSON HOUSE
Ocean Avenue
Briggs & Corman, architects
R. V. Breece, builder
1874; 1894, 1910 alterations

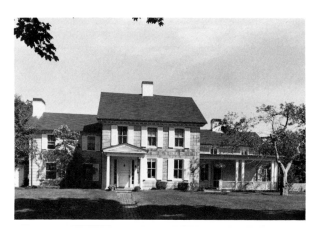

I-71 GEORGE ELDREDGE HOUSE
84 Egypt Lane
George Eldredge, builder
1876; twentieth-century alterations

In the 1860s George Eldredge moved an eighteenth-century house to Egypt Lane to use as his own residence (I-25). In 1876 he built this house next door and made the older house available to his son, George A. Eldredge. The living room in this dwelling spans the front mass and the stairhall is located behind the chimney. The dining room and kitchen wing extend to the south. The wing on the north end is a modern addition. Interior details are eclectic but restrained.

Refs.: *Express,* 25 May 1876.

Photo: Harvey A. Weber.

I-73 "THE CHALET"
James Lane
1879; 1899 alterations

Charles Peter Beauchamp Jefferys built this house for his brother-in-law next to his own house, "Sommariva" (I-63). The house was altered in 1899 with the addition of a large three-story wing built by George A. Eldredge.

Refs.: *Express,* 21 August 1879, 4 September 1879.
Star, 6 January 1899, 14 October 1948.

Photo: Harvey A. Weber.

I-72 STAFFORD TILLINGHAST HOUSE
13 Woods Lane
Stafford Tillinghast, builder
1875–78

Refs.: *Express,* 11 April 1878.
Rattray, *Main Street,* 16.

Photo: Harvey A. Weber.

I-74 BENJAMIN F. WORTHINGTON HOUSE
30 Egypt Lane
ca. 1880

Refs.: Hyde, *Atlas,* 1902.

Photo: Robert J. Hefner.

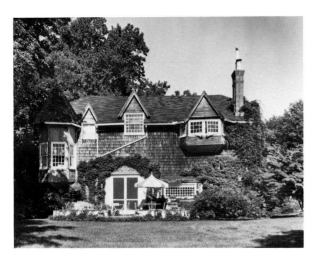

I-75 THOMAS MORAN HOUSE
229 Main Street
Stafford Tillinghast, builder
1884; 1890 alterations

Thomas Moran, the well-known American artist, and his wife, Many Nimmo Moran, also an artist and engraver of note, first summered in East Hampton in 1878. Six years later Moran engaged Stafford Tillinghast to build this house and studio. The house was designated a National Historic Landmark in 1966.

Refs.: Rattray, *Main Street,* 141.
 Star, 15 May 1886, 11 October 1890.

Photo: Harvey A. Weber.

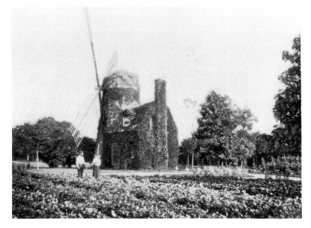

I-76 EDWARD DEROSE WINDMILL COTTAGE
117B Main Street
J. E. Aldrich, builder
1885

Edward DeRose had this windmill cottage built at the rear of his newly purchased property (I-29) in 1885. The construction of this mock windmill documents a new appreciation of these structures as picturesque objects as early as 1885, when two of East Hampton's mills, the Gardiner Mill and the Hook Mill, were still in operation.

Refs.: deKay, "Summer Homes," 30–31.
 Star, 13 March 1885, 26 December 1885.

Photo: *Architectural Record,* January 1903.

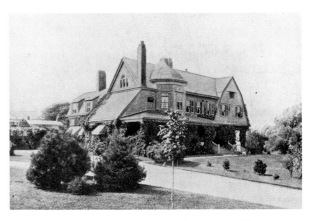

I-77 EVERETT HERRICK HOUSE, "PUDDING HILL"
Ocean Avenue
I. H. Green, Jr., architect
John Aldrich, builder
1887; 1899, 1906 alterations

Dr. Everett Herrick of New York built this house on what was known as Pudding Hill, formerly the location of an early house which was torn down. The site, at the time, commanded "a splendid view of the ocean." Dr. Herrick commissioned I. H. Green, Jr. of Sayville to design his summer cottage. In 1899 Dr. Herrick ordered a two-story addition and in 1906 he hired Green to design a second two-story addition to the south end of the house. Dr. Herrick was a founder and the first president of the Maidstone Club, and Green designed the first two clubhouses, both of which burned.

Refs.: *Architecture and Building* (23 April 1887), 17.
 Rattray, *Fifty Years,* 16.
 Star, 11 June 1887, 16 July 1887, 13 October 1899, 2 October 1931.

Photo: Courtesy of the East Hampton Free Library.

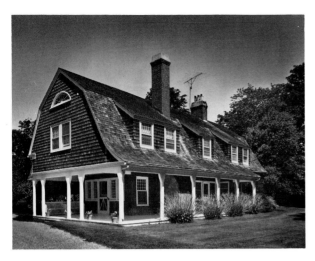

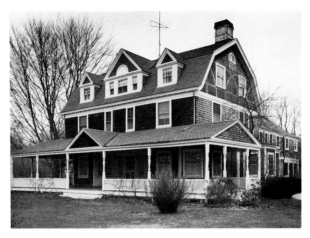

I-79 ROBERT SOUTHGATE BOWNE HOUSE
Ocean Avenue
James L'Hommedieu, builder
1889

Robert Southgate Bowne of Flushing was first president of the Long Island Railroad and a founder of the Maidstone Club. In 1889 he and James Gallatin each purchased two acres of land on Ocean Avenue and contracted with James L'Hommedieu, a builder from Great Neck, to build them each a summer cottage on their respective lots.

Refs.: Rattray, *Fifty Years,* 21–22.
 Star, 5 January 1889, 6 April 1928, 2 February 1939.

Photo: Robert J. Hefner.

I-78 GEORGE E. MUNROE HOUSE
Ocean Avenue
I. H. Green, Jr., architect
1888; 1894, 1905 alterations

Dr. George E. Munroe practiced medicine in New York and, while summering in East Hampton, was a vice-president and second president of the Maidstone Club. In 1888 he purchased this site on Pudding Hill next to the Herrick property from the Misses Elkins, who had removed the eighteenth-century Joseph Osborn house on the site to Pudding Hill Lane (I-15). Munroe, a friend of Dr. Herrick, used the same architect, I. H. Green, Jr., to design his new house. This T-shaped plan with its simple gambrel-roof was published widely, and several later East Hampton cottages followed a similar design. Additions to the structure were made in 1894 and 1950.

Refs.: *American Architect and Building News* (7 December 1907): 1667.
 deKay, "Summer Homes," 299.
 Rattray, *Fifty Years,* 64.
 Rattray, *Main Street,* 13.
 Star, 13 October 1888, 22 September 1905, 27 October 1938, 23 March 1939.

Photo: Harvey A. Weber.

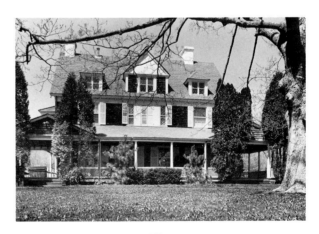

I-80 JAMES GALLATIN HOUSE
Ocean Avenue
James L'Hommedieu, builder
1889

James L'Hommedieu of Great Neck built this house for James Gallatin across the street from his brother's house, which has since been demolished.

Refs.: *Star,* 5 January 1889, 2 February 1939.

Photo: Harvey A. Weber.

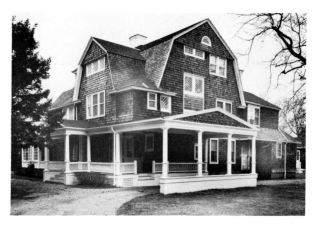

I-82 MRS. WILLIAM DRAPER HOUSE
Lee Avenue★
John Aldrich, builder
1890

John Aldrich built this house, originally located at the corner of Ocean Avenue and Pudding Hill Lane, for Mrs. William Draper of Flushing. George Baxter acquired the house and moved it to this site in 1919.

Refs.: *Star,* 12 April 1890, 4 April 1919.

Photo: Robert J. Hefner.

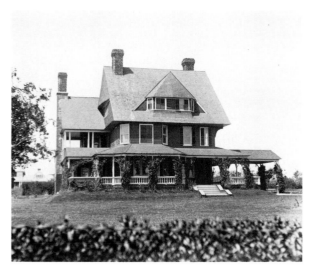

I-81 WARREN G. SMITH HOUSE
Ocean Avenue
1889; 1890, 1892, 1901, 1916 alterations

Warren G. Smith, T. DeWitt Talmage's son-in-law, began renting one of the Talmage cottages in 1886. In 1889 Smith bought this lot directly across from the Mershon cottage and built this house. Smith began altering the building almost as soon as it was completed. Alterations were recorded in 1890, 1892, and 1901. For the latter renovation, J. G. Thorp was the architect and the work was apparently extensive. Smith's intention, as noted in the *Star,* was to "rebuild his house after an entirely new design, and on a larger and more expansive scale." In 1916 a new owner employed architect J. C. Lawrence to plan another remodeling.

Refs.: Plans, Parsons Electric.
 Rattray, *Fifty Years,* 124–25.
 Star, 5 January 1889, 12 February 1890, 15 July 1892, 18 October 1901, 24 October 1902, 16 September 1916, 17 November 1916.

Photo: Courtesy of the *East Hampton Star.*

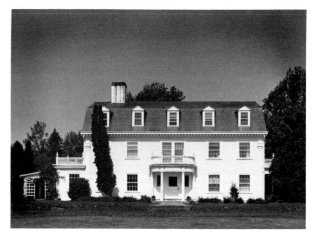

I-83 WILLIAM ALMY WHEELOCK HOUSE
Georgica Road
I. H. Green, Jr., architect
Philip Ritch, builder
1891; 1929 alterations

W. A. Wheelock, president of the Citizens National Bank in New York, bought fifteen acres here from F. E. Grimshaw in 1890 and started a family compound. He built cottages for his son, Dr. William Efner Wheelock, and daughter, Mrs. G. A. Strong (I-84, I-95). This house, built for himself in 1891, was designed by I. H. Green, Jr. In 1929 it was extensively altered by Aymar Embury II in the Adamesque-Colonial Style.

Refs.: Rattray, *Fifty Years*, 25–26.
 Star, 13 September 1890, 22 November 1890.

Photo: Harvey A. Weber.

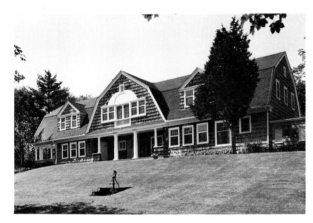

I-84 WILLIAM E. WHEELOCK HOUSE
Georgica Road
I. H. Green, Jr., architect
1891; 1892, 1904, 1978–80 alterations

This house formed part of the family compound built for William A. Wheelock (see I-83). Designed by I. H. Green, Jr. and built for Wheelock's son, Dr. William Efner Wheelock, a physician and lawyer, the house was furnished with antiques purchased from local residents. Wheelock also commissioned a local blacksmith, James M. Strong, to forge replicas of door latches and handles found in the eighteenth-century Town House (I-218) for his house. The house later became the summer residence of John Hall Wheelock, the poet, who was W. E. Wheelock's son.

In 1892 George Eldredge built an addition on the rear of the house, and in 1904 A. O. Jones completed an addition on the north end of the front facade. The latter addition was removed in 1978 and became a separate structure on the property. In 1978–80 the house was renovated under the supervision of Robert A. M. Stern, architect.

Refs.: Rattray, *Fifty Years*, 25–26.
 Star, 15 May 1891, 29 May 1891, 29 July 1892, 29 July 1904.

Photo: Harvey A. Weber.

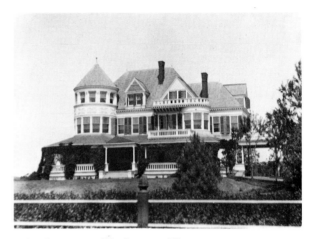

I-85 CHARLES H. ADAMS HOUSE
Lee Avenue
William B. Tuthill, architect
C. H. Aldrich and E. E. Duryea, builders
1891; 1930 alterations.

This house was built for Charles H. Adams, who was elected a New York state senator in 1872 and a U.S. representative in 1876. William B. Tuthill, architect of Carnegie Hall, designed this mansion, which was reported to cost $20,000. A contemporary account noted that the house "looks more as if it belonged in Newport than in East Hampton, and is grandly proportioned and equipped." The house was renovated in 1930 according to plans drawn by Aymar Embury II.

Refs.: *Architecture and Building* (27 December 1890).
 Plans, EHFL.
 Plans (1930), Parsons Electric.
 Star, 5 July 1890, 12 July 1890.

Photo: Courtesy of the *East Hampton Star*.

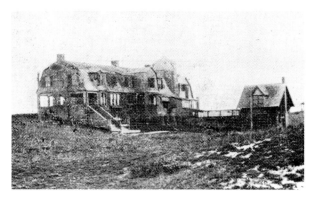

I-86 LAURA SEDGWICK HOUSE
West End Avenue
1891; 1894, 1896, 1899, 1935 alterations

Laura Sedgwick hired Joseph Greenleaf Thorp to design an addition to her house in 1894. Other additions included a forty-foot extension built on the west end of the house designed by Thorp in 1896 and the addition of the windmill tower in 1899. George A. Eldredge was the contractor for all of these major alterations.

Refs.: *Star,* 23 January 1891, 28 March 1894, 13 March 1896, 28 July 1949.

Photo: Courtesy of Averill D. Geus.

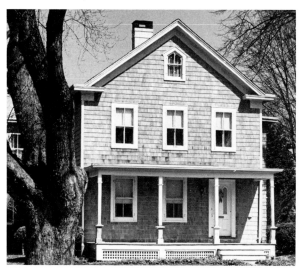

I-87 JAMES E. GAY HOUSE
65 Pantigo Road
George A. Eldredge, builder
1891

Refs.: *Star,* 10 July 1891.
Photo: Harvey A. Weber.

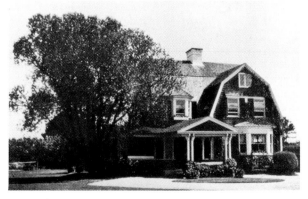

I-88 MRS. E. J. VAUGHAN HOUSE
Lee Avenue
George A. Eldredge, architect and builder
1892

Refs.: *Star,* 8 October 1926, 2 July 1942.

Photo: Courtesy of the East Hampton Free Library.

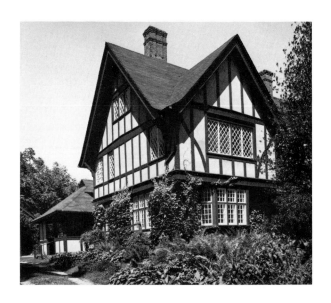

I-89 JOSEPH GREENLEAF THORP HOUSE
12 Woods Lane
Joseph Greenleaf Thorp, architect
George A. Eldredge, builder
1893

Joseph Greenleaf Thorp designed this house for his own use. Thorp was the premier resident architect of East Hampton, responsible for much of the quality architecture in the Summer Colony not designed by outside architects. Although an architect's own house often serves as an advertisement and model, Thorp built no other houses in East Hampton that were so distinctly English. In 1912 when he traveled to Italy to join his mother and sister, Thorp sold this house to its present owner.

Refs.: *Star,* 11 August 1893, 12 January 1894.

Photo: Harvey A. Weber.

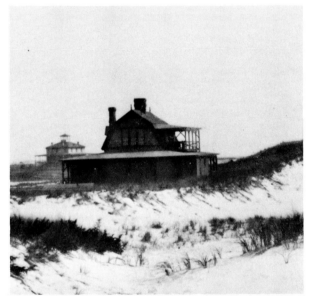

I-90 HOWARD RUSSELL BUTLER HOUSE
West End Avenue
Babcock and Grimshaw, builders
1893; 1900, 1906 alterations

This house was built for marine artist Howard Russell Butler. The house has undergone major alterations, most notably in 1900 when a forty-foot-square extension was added and again in 1906 when Butler hired A. O. Jones to add a nineteen foot by twenty-five foot art gallery space.

Refs.: *Star,* 31 November 1916, 2 October 1931, 27 May 1943, 18 September 1952.

Photo: George Bradford Brainard, courtesy of the Brooklyn Public Library, Brooklyn Collection.

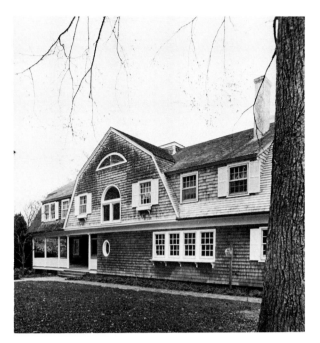

I-91 LORENZO G. WOODHOUSE HOUSE, GREYCROFT
63 Huntting Lane
I. H. Green, Jr., architect
George A. Eldredge, builder
1893–94; 1980–81 alterations

This was the main house of Lorenzo G. Woodhouse's estate, Greycroft. The original estate included a carriage house and a windpump and water tower, both of which survive. The elaborate landscaping of the estate included a Japanese water garden in the area which is now a village-owned nature trail. In the 1930s, Mrs. Lorenzo E. Woodhouse gave the estate to Leighton Rollins for use as an acting school. The house again became a residence in 1946. It has been remodeled many times, most recently in 1980–81 by Robert A. M. Stern, architect.

Refs.: *Star,* 7 May 1894, 12 March 1897, 27 April 1944, 15 June 1944, 24 August 1944.

Photo: Harvey A. Weber.

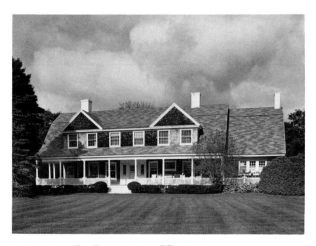

I-92 JOHN D. SKIDMORE HOUSE
Georgica Road
I. H. Green, Jr., architect
Philip Ritch, builder
1894

This house was built for John D. Skidmore and his son, Samuel T. Skidmore, who started boarding in East Hampton in 1882. According to a report in the *Star,* "Mr. Green of Sayville is the architect, but Mr. Skidmore's son was the original designer."

Refs.: *Star,* 8 June 1894.

Photo: Harvey A. Weber.

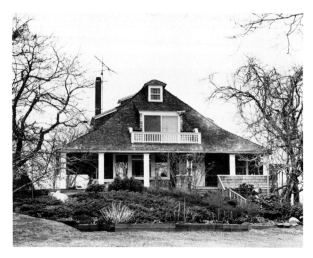

I-93 THOMAS RICHEY HOUSE
Georgica Road
Frank Grimshaw, builder
1894; 1920, 1979 alterations

The Reverend Thomas Richey, a professor at Chelsea Square Seminary, first summered in East Hampton in 1891. Three years later he built this house on the inner dunes off Georgica Road. Both the objective and subjective appeals of this setting, described at the time as "unique," were set forth in detail in the *Star:*

> As you approach it from the village it cannot be seen from the highway; being hid by a circle of sand hills. A road has been cut through the bank and once within the enclosure you find yourself shut out from the world, with broad meadows spreading out before you. Crossing the lot to the dune on the west side you come to the house, and after climbing the stairs to the piazza, see spread out before you a beautiful scene. First your eye catches the comforting pines into whose very branches the veranda pushes itself, then the meadows dotted with foliage, the rolling hills, the ponds of shining water and beyond the ocean. Talk about peaceful and secluded rest. We doubt if there is another spot better calculated to secure undisturbed, solid comfort, than upon that veranda.

The Reverend Edward H. Jewett built nearby at the same time, but that house has been demolished. Richey built the house next door in 1895 for his son (I-97), and the three houses together overlooked "a natural amphitheatre, which . . . [was] to be laid out as a private park."

After the Reverend Richey's death, his house went to his daughter, Mrs. Samuel Seabury. About 1920 she added the library, enlarged the kitchen, and altered the upstairs accordingly. In 1979 the oriel and entrance were added to the east facade.

Refs.: Rattray, *Fifty Years,* 18, 64.
 Star, 7 December 1894.

Photo: Robert J. Hefner.

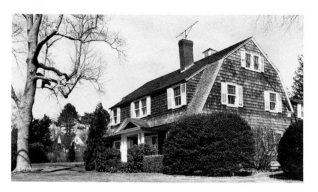

I-94 ANNIE HUNTTING HOUSE
30 Woods Lane
I. H. Green, Jr., architect
Philip Ritch, builder
1895; 1897, 1898, 1909 alterations

Annie Huntting ran a boarding house on Main Street next to the Presbyterian Church which she sold in 1895 and which is now located at 111 Egypt Lane (I-10). That same year she had a new house for boarders designed by I. H. Green, Jr., which originally measured twenty-eight feet by thirty feet with an eighteen-foot-square wing. A fifteen-foot addition on the west side dating from 1897 enlarged the house considerably. Another addition built by George A. Eldredge the following year provided a new kitchen and servants' rooms. In 1909 a rear extension was moved back to form a separate cottage, and a new addition replaced it.

Refs.: *Star,* 8 March 1895, 5 April 1895, 16 April 1897, 2 July 1897, 1 April 1898, 22 October 1909.

Photo: Harvey A. Weber.

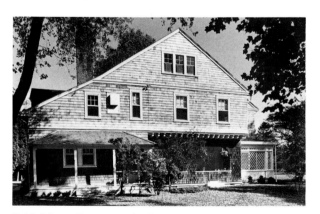

I-95 MRS. GEORGE A. STRONG HOUSE
Georgica Road
Theodore Weston, architect
George A. Eldredge, builder
1895

This was the third house in the Wheelock family compound (I-83, I-84). Built for W. A. Wheelock's daughter, Mrs. George A. Strong, this house was designed by Theodore Weston, also a summer resident of East Hampton, who was better known for his engineering works. The *Star* described this house as "a model summer cottage, with six rooms on the first floor and ten on the second, besides a large hall fifteen x thirty-six feet in dimensions."

Refs.: *Star,* 21 December 1894, 1 March 1895.

Photo: Harvey A. Weber.

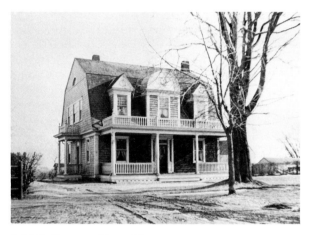

I-96 J. FINLEY BELL HOUSE
10 Pantigo Road
George A. Eldredge, builder
1895; later alterations

George A. Eldredge built this house for Dr. J. Finley Bell, who practiced medicine in East Hampton for twelve years. An early photograph documents the original appearance of the house. The dormers have since been altered.

Refs.: Rattray, *Main Street,* 36.
　　　Star, 11 January 1945.

Photo: Courtesy of Donald M. Halsey.

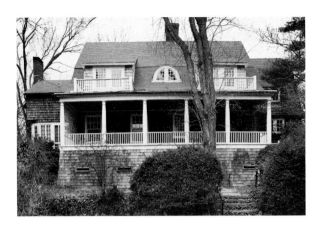

I-97 ALBAN RICHEY HOUSE
Georgica Road
Frank Grimshaw, builder
1895; 1906, 1939 alterations

This house was built in 1895 for the Reverend Alban Richey, son of the Reverend Thomas Richey, who built his house next door in 1894 (I-93). In 1906 J. C. Lawrence designed a large addition, and in 1939 the house was renovated under the direction of architect E. Ritzema Perry.

Refs.: Plans, Parsons Electric.
 Star, 6 September 1895, 6 October 1905, 9 March 1906.

Photo: Harvey A. Weber.

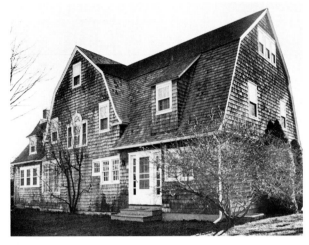

I-99 SECOND MRS. S. FISHER JOHNSON HOUSE
43 Dunemere Lane
Joseph Greenleaf Thorp, architect
George A. Eldredge, builder
1896; 1981 alterations

Refs.: Star, 25 September 1896, 23 October 1896, 1 January 1897.

Photo: Harvey A. Weber.

I-98 T. SMITH HOUSE
Apaquogue Road
Frank Grimshaw, builder
1895

Refs.: Star, 18 October 1945, 8 November 1945.

Photo: Harvey A. Weber.

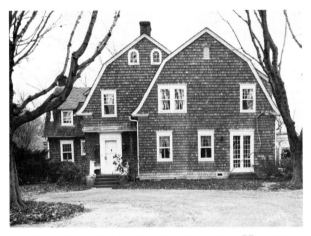

I-100 THIRD MRS. S. FISHER JOHNSON HOUSE
43A Dunemere Lane
Joseph Greenleaf Thorp, architect
George A. Eldredge, builder
1896

Refs.: Star, 25 September 1896, 23 October 1896, 1 January 1897.

Photo: Robert J. Hefner.

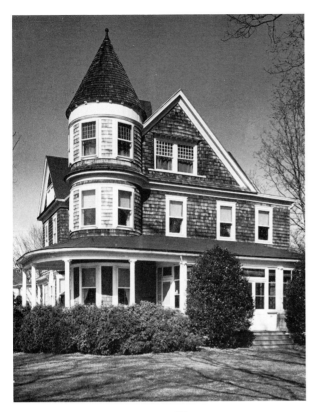

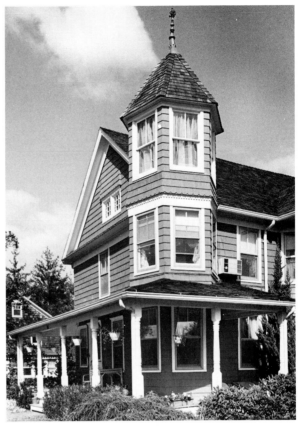

I-101 JAMES E. HUNTTING HOUSE
30 Huntting Lane
James E. Huntting, builder
1896

James Edward Huntting, the general manager of the East Hampton Lumber and Coal Company, designed and built this house for himself.

Refs.: *Star,* 9 July 1895, 7 February 1896.

Photo: Harvey A. Weber.

I-102 JAMES MADISON STRONG JR. HOUSE
12 Accabonac Highway
ca. 1896

Refs.: Rattray, *Main Street,* 61.

Photo: Harvey A. Weber.

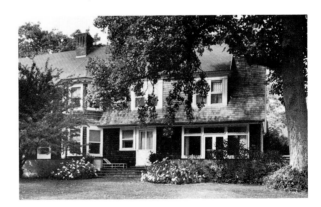

I-103 CYRUS L. W. EIDLITZ HOUSE
Ocean Avenue
Cyrus L. W. Eidlitz, architect
1897; 1898, 1901 alterations

Cyrus L. W. Eidlitz designed this house for his own use. A well-known New York architect, Eidlitz designed the New York Times building in 1904. Although this house is unambitious, he designed a more distinguished house across the street for his sister, Mrs. Schuyler Quackenbush, in 1898 (I-107).

Also in 1898 Eidlitz added an extension on the front veranda of this house, and three years later a second-story addition was built on the west end of the structure.

Refs.: Plans, EHFL.
 Rattray, *Fifty Years,* 22.
 Star, 10 July 1896, 26 March 1897, 27 September 1901, 26 September 1948.

Photo: Harvey A. Weber.

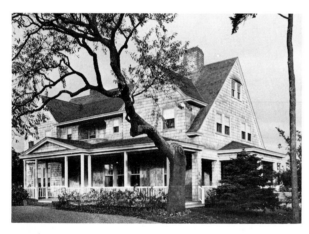

I-104 **MRS. F. STANHOPE PHILLIPS HOUSE, GREY GARDENS**
West End Avenue
Joseph Greenleaf Thorp, architect
George A. Eldredge, builder
1897; 1980 alterations

J. G. Thorp designed this house for Mrs. F. Stanhope Phillips. In 1913 it was sold to Robert Carmer Hill, whose wife was an avid gardener and who gave the house the name Grey Gardens. In 1924 they sold the house to Phelan Beale and his wife, Edith Bouvier Beale. Mrs. Beale and her daughter were the subject of a 1974 documentary film entitled *Grey Gardens.* The house was extensively renovated in 1980.

Refs.: *Star,* 4 December 1896, 30 April 1897, 8 February 1924, 2 August 1947.

Photos: Harvey A. Weber.

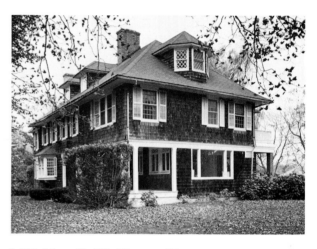

I-105 **MRS. R. W. NESBIT HOUSE**
62 Dunemere Lane
George A. Eldredge, builder
1897

At the time this house was built the *Star* noted that Dunemere was "fast becoming one of the cottage streets in the village," already boasting four summer residences. In 1907 Mrs. Nesbit bought a strip of land to the north and had the cottage moved to the center of her enlarged lot.

Refs.: *Star,* 17 September 1897, 27 October 1907, 31 October 1957.

Photo: Harvey A. Weber.

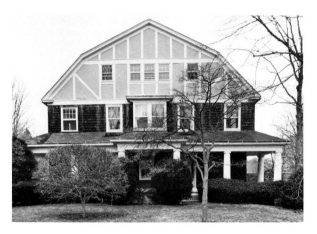

I-106 NORMAN BARNS HOUSE
34 Huntting Lane
1897

Refs.: *Star,* 12 March 1897, 23 September 1904.

Photo: Robert J. Hefner.

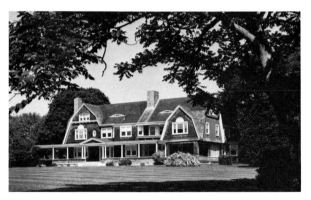

I-107 FIRST SCHUYLER QUACKENBUSH HOUSE
Lee Avenue
Cyrus L. W. Eidlitz, architect
George A. Eldredge, builder
1898

This house was designed for Scuyler Quackenbush by Mrs. Quackenbush's brother, architect C. L. W. Eidlitz, whose own house stood across the street (I-103). In his article on East Hampton architecture Charles deKay described this as a "handsome villa, something more than cottage, less than manse."

Refs.: deKay, "Summer Homes," 25.
 Star, 7 October 1898.

Photo: Harvey A. Weber.

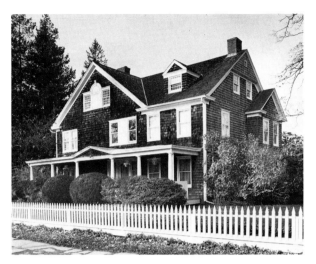

I-108 JOSEPH S. OSBORNE HOUSE
135 Main Street
1898

Refs.: *Star,* 7 October 1898.

Photo: Harvey A. Weber.

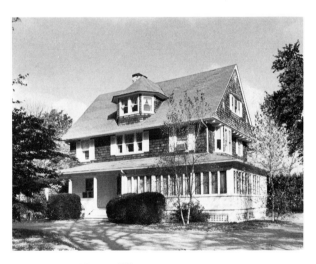

I-109 J. W. HAND HOUSE
24 Huntting Lane
1898

Refs.: *Star,* 18 March 1898.

Photo: Harvey A. Weber.

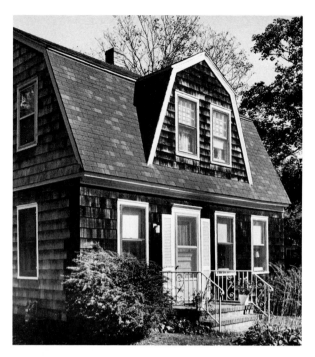

I-110 JOHN KING HOUSE
100 Buells Lane
A. O. Jones, builder
1898

Refs.: *Star,* 25 March 1898.

Photo: Harvey A. Weber.

In 1894 Mary Herter bought seventy-five acres here, and in 1898 her son, Albert, and his wife, Adele, both artists, built this imposing house at the head of Georgica Pond. Designed by Grosvenor Atterbury, it is convex in plan to take advantage of the view and was originally painted a light beige with dark trim. Stables added on one side in 1899 were complemented by the studio added to the other side in 1912. The Creeks was one of the few summer homes in East Hampton to have extensive grounds, and Mrs. Herter's formal gardens were widely admired. In 1951 the Herters' son, Christian A. Herter, then a U.S. congressman from Massachusetts and later Governor of Massachusetts (1953–57) and U.S. Secretary of State (1959–61), sold the estate to the artist Alfonso Ossorio. His sculptures now decorate the grounds and his inventive paint scheme highlights the lines of the house.

Refs.: American Architect and Building News (2 September 1908).
 Architecture (September 1919): plate 85.
 Architecture Plus (January/February 1974): 64–73.
 deKay, "Summer Homes," 32.
 Charles deKay, "Villas all Concrete," *Architectural Record* (February 1905): 85–100.
 Rattray, *Fifty Years,* 136–37.
 Star, 18 November 1898, 25 November 1898, 19 July 1912.

Photo: *Architecture,* September 1919.

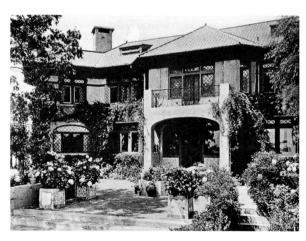

I-111 ALBERT HERTER HOUSE, THE CREEKS
Montauk Highway
Grosvenor Atterbury, architect
Frank Grimshaw, builder
1899; later alterations

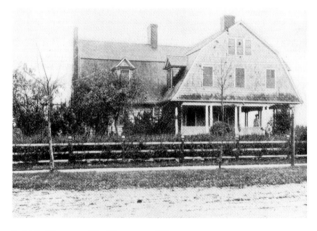

I-112 CLARA F. OGDEN HOUSE
Lily Pond Lane
George A. Eldredge, architect and builder
1899

Refs.: deKay, "Summer Homes," 28.
 Star, 3 February 1899, 24 February 1899, 8 July 1948.

Photo: *Architectural Record,* January 1903.

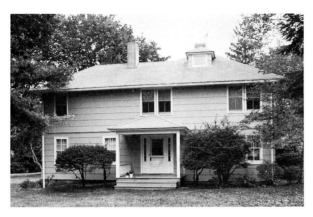

I-113 JOHN CUSTIS LAWRENCE HOUSE
Montauk Highway
John Custis Lawrence, architect
1899

Refs.: *Star,* 1 September 1899.

Photo: Harvey A. Weber.

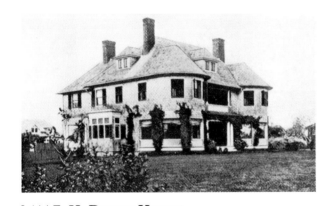

I-114 F. H. DAVIES HOUSE
Ocean Avenue
Joseph Greenleaf Thorp, architect
George A. Eldredge, builder
1899; 1910, 1916, 1948 alterations

This house built for F. H. Davies was illustrated in Charles deKay's 1903 article on cottage architecture in East Hampton. In 1910 an addition and other alterations were carried out under the supervision of J. C. Lawrence. Probably around 1948 the northwest servants' wing, which may have been original to the structure, was removed to the lot next door.

Refs.: deKay, "Summer Homes," 24.
 Star, 14 April 1899, 1 September 1899, 20 October 1916, 17 October 1934, 14 November 1935.

Photo: *Architectural Record,* January 1903.

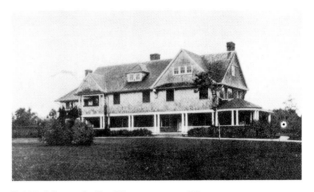

I-115 MRS. C. L. HACKSTAFF HOUSE
Lee Avenue
Joseph Greenleaf Thorp, architect
Loper Brothers, builders
1899; 1902, 1969 alterations

Charles deKay, in his article on East Hampton architecture, praised Thorp's design, calling this "another well-proportioned frame house. . . . The ample porches are not exaggerated; the facades are not broken up so as to worry the eye; the interiors are very simple but comfortable." George A. Eldredge built an addition on the south end of the house in 1902 and in 1969 the porches were enclosed.

Refs.: deKay, "Summer Homes," 25.
 Star, 24 October 1902, 16 April 1949, 6 October 1949.

Photo: *Architectural Record,* January 1903.

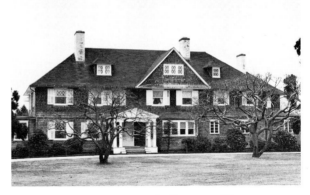

I-116 FIRST FREDERICK G. POTTER HOUSE
Lee Avenue
Joseph Greenleaf Thorp, architect
Loper Brothers, builders
1899

Frederick G. Potter had this house built next door to his sister's house (I-88). The cost of this cottage was estimated to be between $12,000 and $15,000, and Loper Bros. of Port Jefferson agreed to ninety days for the completion of the building. In 1905 Potter again hired Thorp to design a house, this time on Lily Pond Lane (I-148).

Refs.: *Star,* 24 February 1949, 7 April 1949, 2 June 1949.

Photo: Robert J. Hefner.

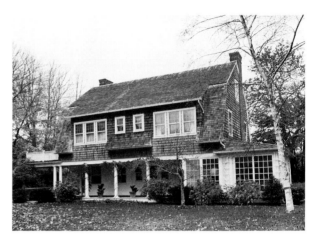

I-118 MARVIN T. LYON HOUSE
Cottage Avenue
Joseph Greenleaf Thorp, architect
George A. Eldredge, builder
1899

Refs.: *Star,* 16 September 1898, 3 February 1899, 31 March 1899, 16 June 1949.

Photo: Harvey A. Weber.

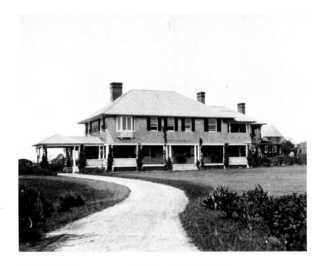

I-117 E. CLIFFORD POTTER HOUSE
Ocean Avenue
Joseph Greenleaf Thorp, architect
George A. Eldredge, builder
1899

This house was built for E. Clifford Potter, who had developed Park Avenue in New York City. Potter bought the lot at the auction of the estate of Dan Talmage's Sons Co. in 1898 (see I-66). The house was illustrated in Charles deKay's "Summer Homes at East Hampton," in which deKay praised Thorp for his "unpretentious architecture," calling the Potter House "one of his simplest yet most successful efforts."

Refs.: deKay, "Summer Homes," 25, 27.
 Rattray, *Fifty Years,* 38, 168.
 Star, 16 September 1898, 4 November 1898.

Photo: Courtesy of the *East Hampton Star.*

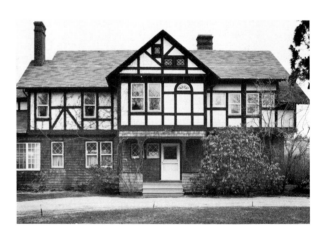

I-119 SECOND LOUISE WORTHINGTON HOUSE
Lily Pond Lane
E. Duryea, builder
1899

Mrs. Louise Worthington contracted with E. Duryea of Riverhead to build this house on land she had purchased of Henry Mulford. At the same time Duryea built her a house on the dunes, said to look "as if it might have been left there by a high tide," on a site behind this house.

Refs.: *Star,* 22 December 1899, 15 December 1949, 1 December 1955.

Photo: Robert J. Hefner.

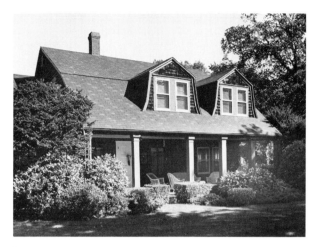

I-121 GEORGE THOMAS HOUSE
Pudding Hill Lane
Henry Jander, builder
1899

Refs.: *Star,* 19 May 1899.

Photo: Harvey A. Weber.

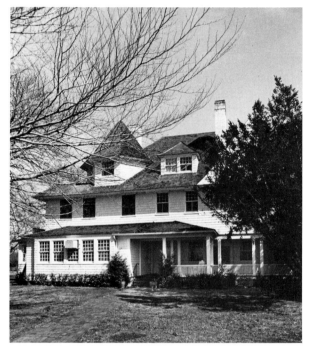

I-120 GEORGE P. CAMMAN HOUSE, JEWISH CENTER OF THE HAMPTONS
44 Woods Lane
George A. Eldredge, builder
1899; 1915 alterations

George A. Eldredge built this house for Mr. and Mrs. George P. Camman. Mrs. Camman was the daughter of Frederick Gallatin, who built a Renwick-designed summer cottage on Ocean Avenue in 1878. In 1914 Camman sold this house to Lewis M. Borden, who had $10,000 worth of improvements made the following year. In 1959 Evan Frankel acquired the house for the Jewish Center of the Hamptons. It now serves as a synagogue and community center.

Refs.: *Star,* 25 November 1898, 15 January 1915, 19 October 1939, 28 December 1939.

Photo: Harvey A. Weber.

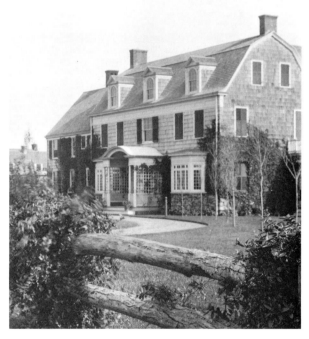

I-122 WILLIAM M. CARSON HOUSE
Lee Avenue
A. O. Jones, builder
1899; 1901, 1903 alterations

A. O. Jones built this house for William Moore Carson at a cost of about $10,000. Carson had acquired the lots at the 1898 auction of the lands of Dan Talmage's Sons Co. Jones altered the house for Carson in 1901, adding two bay windows on the rear and a new piazza. After 1903 the west wing was added and the fenestration changed at the second level.

Refs.: deKay, "Summer Homes," 32.
 Star, 16 September 1898, 6 January 1899, 19 April 1901.

Photo: Fullerton, courtesy of the Suffolk County Historical Society.

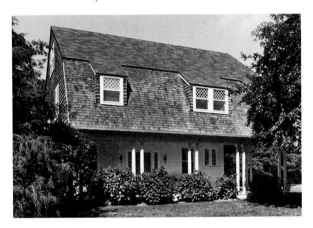

I-123 LOUISE WORTHINGTON HOUSE
Cottage Avenue
Charles Woodhull, builder
1899

Refs.: *Star,* 16 September 1898, 6 January 1949.

Photo: Harvey A. Weber.

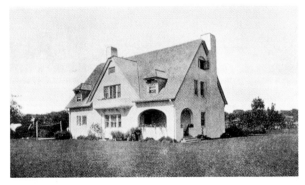

I-124 BENJAMIN RICHARDS HOUSE
Dunemere Lane
Grosvenor Atterbury, architect
Jabez E. Van Orden, builder
1900

Refs.: deKay, "Summer Homes," 32.
 House and Garden (April 1903), 213, 214.
 Star, 8 December 1899.
 Charles deKay, "Villas All Concrete," *Architectural Record* (February 1905): 85–100.

Photo: *House and Garden,* April 1903.

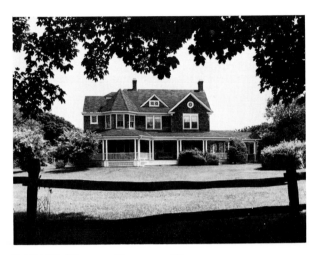

I-125 W. TYSON DOMINY HOUSE
Lily Pond Lane
Walter E. Brady, architect
Everett Babcock, builder
1900

W. Tyson Dominy bought Aaron Conklin's bathing houses, located at the site of the present Main Beach Bathing Pavilion, in 1892. He sold the property a month later to Austin Culver, but leased land across the street, later the site of the Sea Spray Inn, and built a rival line of bath houses. He sold out to Culver in 1896. In 1898 Dominy bought a lot at the auction of the estate of Dan Talmage's Sons Co. and soon had this house built for rental. Walter E. Brady of Southampton designed the house and Everett Babcock of Amagansett was the builder.

Refs.: Rattray, *Fifty Years,* 129–30.
 Star, 15 December 1949.

Photo: Harvey A. Weber.

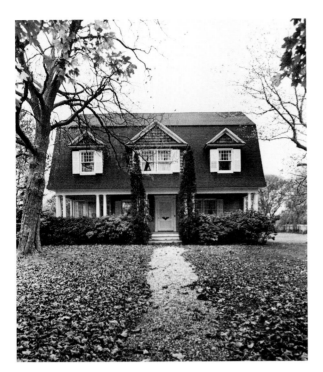

I-126 JOHN D. STOKES HOUSE
Cottage Avenue
George A. Eldredge, architect and builder
1900

Refs.: Rattray, *History,* 57.
　　　Star, 24 November 1899, 1 December 1899, 26 April
　　　　1901.

Photo: Harvey A. Weber.

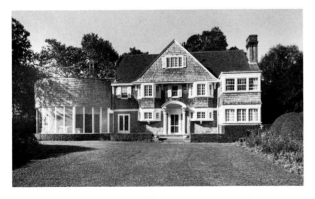

I-127 THOMAS NASH HOUSE
Lee Avenue
Thomas Nash, architect
A. O. Jones, builder
1900; 1904, 1969 alterations

Thomas Nash, who also designed the Episcopal Church in East Hampton (I-235), built this house for his own use. A recent owner, architect Robert A. M. Stern, replaced an unsympathetic 1951 addition with the present east porch in 1969. Vincent Scully described this addition as "Stern's gentlest and most generous design."

Refs.: Scully, *Shingle Style Today,* 34.
　　　Star, 5 October 1950, 30 November 1950.
　　　Mary Watson, "At East Hampton, Long Island. The
　　　　Summer Home of Thomas Nash, Esq.," *American
　　　　Homes and Gardens* (September 1907): 347–50.

Photo: Harvey A. Weber.

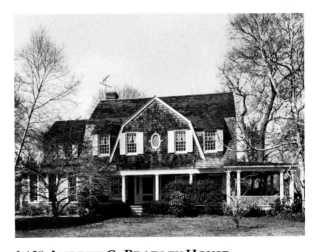

I-128 ANDREW C. BRADLEY HOUSE
60 Woods Lane
Joseph Greenleaf Thorp, architect
1900

A contemporary account of this house noted that it was "one of the largest, if not the largest, houses in East Hampton" with 9,000 feet of floor space, although this must be an exaggeration. The 1902 map indicates that when this house was built it had a larger wing to the north than at present.

Refs.: Hyde, *Atlas,* 1902.
　　　Star, 2 December 1898, 19 January 1900, 5 January
　　　　1950, 2 February 1950.

Photo: Harvey A. Weber.

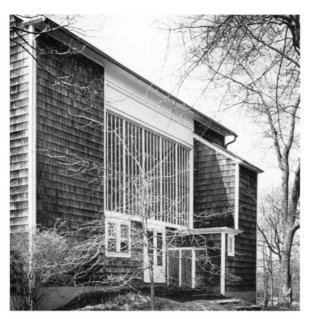

I-129 EDWARD SIMMONS HOUSE
Briar Patch Road
George A. Eldredge, builder
1900

Edward Simmons, a mural painter, had a large studio measuring forty feet by fifty-four feet included in the plan of this house.

Refs.: *Star,* 16 November 1900.

Photo: Harvey A. Weber.

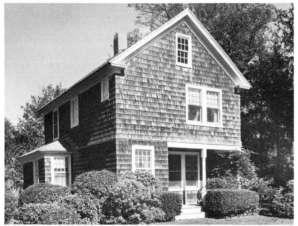

I-130 ULYSSES LEE HOUSE
104 Buells Lane
ca. 1900

Refs.: Hyde, *Atlas,* 1902.

Photo: Harvey A. Weber.

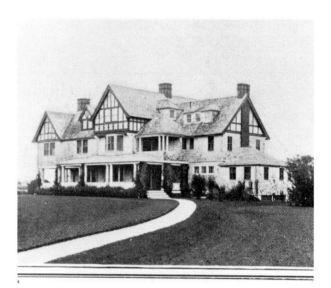

I-131 SECOND JOHN R. PAXTON HOUSE
Lily Pond Lane
Joseph Greenleaf Thorp, architect
George A. Eldredge, builder
1901; 1906, 1923 alterations

J. G. Thorp designed this house for Reverend John R. Paxton, one of the colony of clergymen on Divinity Hill. In 1906 an addition, probably the east wing, was built, and in 1923 extensive alterations, including the removal of stucco and half-timbering from the gables, were made.

Refs.: deKay, "Summer Homes," 26.
　　　 Star, 19 April 1901, 16 November 1923, 6 February 1931, 9 November 1950.

Photo: *Architectural Record,* January 1903.

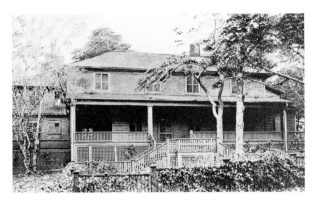

I-132 AUGUSTUS THOMAS HOUSE
Briar Patch Road
George A. Eldredge, builder
1901; 1905 alterations

George A. Eldredge built this house for the play-
wright, Augustus Thomas, who was also a sculptor
and actor. Thomas E. Babcock built a large two-story
addition in 1905.

Refs.: Plans, Parsons Electric.
　　　Star, 10 May 1901, 6 May 1905, 9 July 1926.

Photo: Courtesy of Averill D. Geus.

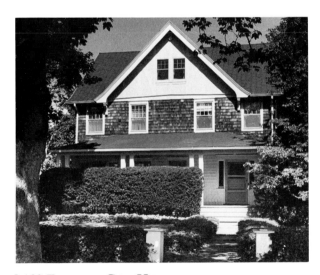

I-133 EDWARD GAY HOUSE
38 Huntting Lane
George A. Eldredge, builder
1901

Refs.: *Star,* 2 August 1901.

Photo: Harvey A. Weber.

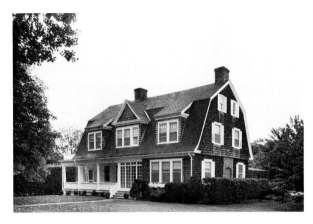

I-134 GEORGE A. ELDREDGE HOUSE
41 Huntting Lane
George A. Eldredge, builder
1901

Refs.: *Star,* 12 July 1901, 19 July 1901, 30 August 1901.

Photo: Harvey A. Weber.

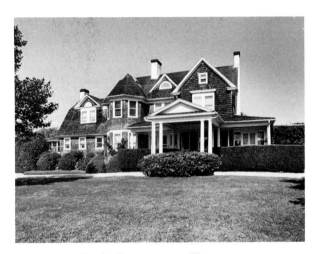

I-135 MRS. E. A. BLAKEMAN HOUSE
Terbell Lane
Frank Grimshaw, builder
1901

Refs.: *Star,* 1 March 1901, 1 November 1901.

Photo: Harvey A. Weber.

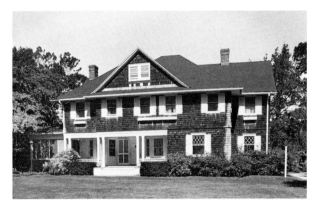

I-136 **W. W. BENJAMIN HOUSE**
Crossways
George A. Eldredge and John Custis Lawrence,
 architects
George A. Eldredge, builder
1902

Refs.: Plans, EHFL.
 Star, 18 October 1901, 23 May 1902.

Photo: Harvey A. Weber.

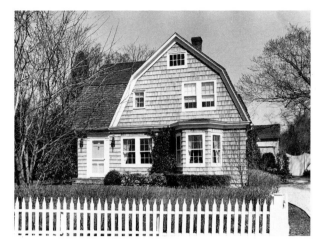

I-138 **FRED ROSS HOUSE**
24 Egypt Lane
1902

Refs.: *Star, 26 September 1902.*

Photo: Robert J. Hefner.

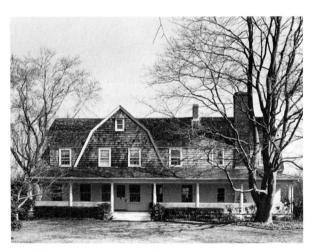

I-137 **MAX E. SCHMIDT HOUSE**
68 Woods Lane
I. H. Green, Jr., architect
Breckenridge and Ashby, builders
1902

Refs.: *Star,* 20 December 1901.

Photo: Harvey A. Weber.

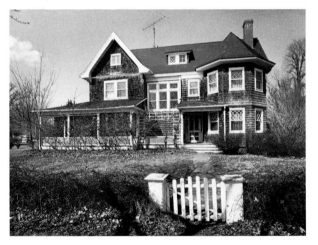

I-139 **MRS. GEORGE A. OSBORN HOUSE**
173 Main Street
George A. Eldredge, architect
1902

Refs.: Rattray, *Main Street,* 90, 123.

Photo: Harvey A. Weber.

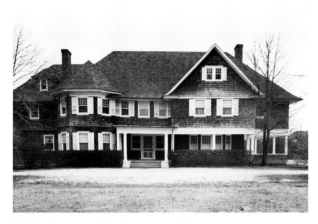

I-140 ARTHUR T. DUNBAR HOUSE
Lee Avenue
George A. Eldredge, architect and builder
1903; 1903 alterations

Arthur T. Dunbar of New York had this house built in the spring of 1903. Later the same year, he hired T. E. Babcock to build an addition and make alterations to the structure.

Refs.: *Star,* 12 August 1927, 11 December 1952, 8 January 1953, 29 October 1953.

Photo: Robert J. Hefner.

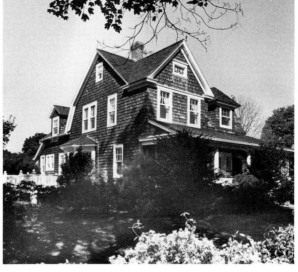

I-142 MRS. W. C. WHITE HOUSE
18 Huntting Lane
Walter Brady, architect
Charles O. Gould and H. E. Street, builders
1904

Refs.: *Star,* 26 August 1904, 16 September 1904.

Photo: Harvey A. Weber.

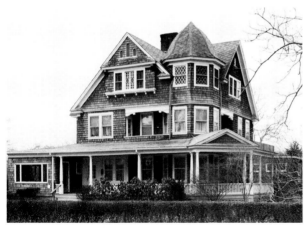

I-141 HENRY D. HEDGES HOUSE
29 Huntting Lane
A. O. Jones, builder
1903; later alterations

Refs.: *Star,* 3 April 1953, 1 October 1953.

Photo: Robert J. Hefner.

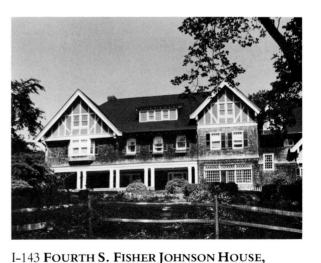

I-143 FOURTH S. FISHER JOHNSON HOUSE, ONADUNE
Georgica Road
John Custis Lawrence, architect
George A. Eldredge, builder
1903–4; 1907 alterations

S. Fisher Johnson had this house built on an inner dune on Georgica Road. At the time the house was described as "one of the most pleasantly located and costly residences in town, situated on a high terrace on the dunes" with expansive views to the north, south, and west. In 1907, just before John D. Rockefeller, Jr. rented the house for the summer, a small, two-room addition was constructed. The Johnsons also built three rental houses on Dunemere Lane from 1895–97 (I-99, I-100).

Refs.: Plans, EHFL.
 Star, 28 August 1903, 26 July 1907, 2 October 1952.

Photo: Harvey A. Weber.

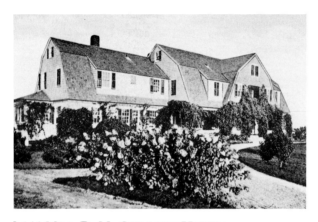

I-144 **MRS. B. M. OSBORNE HOUSE**
Terbell Lane
John Custis Lawrence, architect
Thomas E. Babcock, builder
1904; later alterations

Refs.: Plans, EHFL.
 Star, 23 September 1904, 14 October 1904.

Photo: Courtesy of the Queens Borough Public Library.

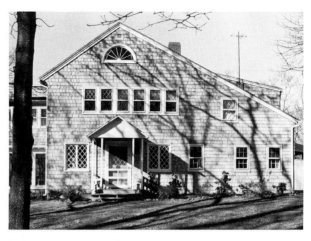

I-145 **LAWRENCE ASPINWALL HOUSE**
Briar Patch Road
Thomas E. Babcock, builder
1904; later alterations

Refs.: *Star,* 18 May 1928, 16 September 1954.

Photo: Robert J. Hefner.

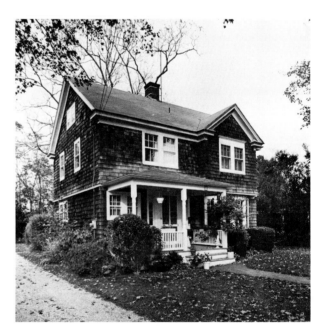

I-146 **W. T. BELL HOUSE**
90 Buells Lane
1904

Refs.: *Star,* 22 January 1904.

Photo: Robert J. Hefner.

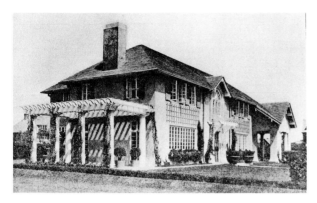

I-147 EDWARD T. COCKCROFT HOUSE
Lily Pond Lane
Albro & Lindeberg, architects
Thomas E. Babcock, builder
1905

This house was designed by Harrie T. Lindeberg of the New York firm of Albro & Lindeberg. Lindeberg also designed Cockcroft's New York City townhouse at 59 East 77th Street. This East Hampton house was well publicized at the time and appeared on the cover of *House and Garden*.

Refs.: *The American Architect and Building News* (12 October 1907).
 House and Garden (January 1910): cover.
 Harrie T. Lindeberg, "The Essentials of Small-House Planning," *Country Life in America* (15 May 1911): 23–27.
 Birch Burdette Long, "The Use of Color in Architecture," *The Brick Builder* (June 1914): 126–27.
 Star, 19 January 1906, 13 November 1913.

Photo: *The American Architect and Building News*, 12 October 1907.

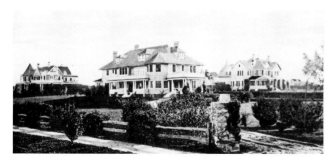

I-148 SECOND FREDERICK G. POTTER HOUSE
Lily Pond Lane
Joseph Greenleaf Thorp, architect
Thomas E. Babcock, builder
1905

Refs.: *Star*, 21 October 1926, 24 March 1955.

Photo: (left) "The Lanterns" designed by George A. Eldredge in 1892, burned in 1935. (center) Second Frederick G. Potter House. (right) W. Tyson Dominy House (125). Courtesy of the Queens Borough Public Library

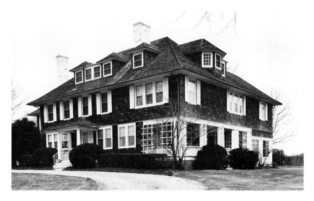

I-149 MRS. C. B. RANDELL HOUSE
70 Dunemere Lane
Joseph Greenleaf Thorp, architect
Thomas E. Babcock, builder
1905

Refs.: *Star*, 29 September 1905, 15 September 1955.

Photo: Robert J. Hefner.

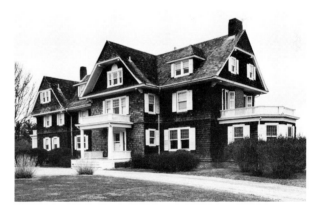

I-150 JOHN T. BAKER HOUSE
Lily Pond Lane
John Custis Lawrence, architect
T. E. Babcock, builder
1907

Refs.: Plans, EHFL and Parsons Electric.
 Star, 4 October 1956.

Photo: Robert J. Hefner.

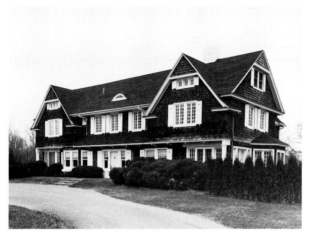

I-151 ARTHUR H. VAN BRUNT HOUSE
Ocean Avenue
John Custis Lawrence, architect
Thomas E. Babcock, builder
1907; 1977 alterations

Refs.: Plans, EHFL.
 Star, 4 December 1931.

Photo: Robert J. Hefner.

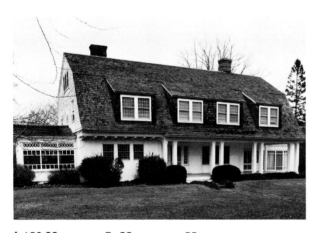

I-152 HARRIET S. HASTINGS HOUSE
Pudding Hill Lane
John Custis Lawrence, architect
Edward M. Gay, builder
1909

Refs.: Plans, Parsons Electric.
 Star, 10 September 1909, 18 November 1937.

Photo: Robert J. Hefner.

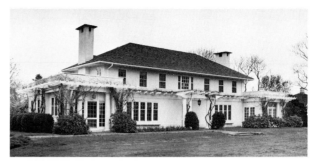

I-153 FIRST FREDERICK K. HOLLISTER HOUSE
Lily Pond Lane
Albro & Lindeberg, architects
E. W. Davis, builder
1910

Harrie T. Lindeberg of the New York architectural firm of Albro & Lindeberg designed this house for Dr. Frederick K. Hollister. The house was the subject of an article in *Country Life in America,* and Aymar Embury admired it in another article, noting that "the long horizontal lines of the building are accented in every way to harmonize with the lines of beach and horizon."

Refs.: Aymar Embury II, "Building the Summer Home," *House and Garden* (6 June 1911): 20.
 Philip M. Riley, "A Small House Giving a Large Effect," *Country Life in America* (15 May 1911): 28–29.
 Star, 12 November 1909, 20 September 1934, 11 October 1934.

Photo: Harvey A. Weber.

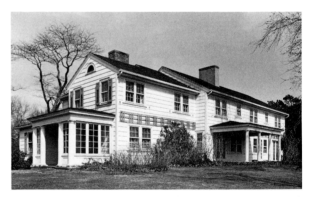

I-154 FRANCIS NEWTON HOUSE
Georgica Road
William Welles Bosworth, architect, after plans by Grosvenor Atterbury
George A. Eldredge, builder
1907–10

Refs.: Interview with Mrs. Lucius Robinson, 16 February
1979.
Plans, Parsons Electric.
Star, 27 September 1934.

Photo: Harvey A. Weber.

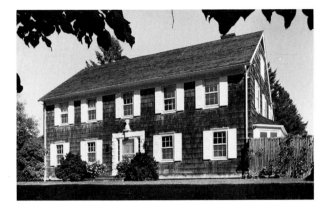

I-155 **FIRST MARY TALMAGE HOUSE**
Jones Road
Mary B. Talmage, architect
Edward M. Gay, builder
1910

This was probably the first cottage that Mary B.
Talmage designed and built for rental. A 1910 news-
paper article described its design as "very old, yet
entirely new among the modern houses of the town,
[being] patterned after the houses built in this place
one and two hundred years ago, the short roof in front
and the long sloping roof in back."

Refs.: *Star,* 17 October 1935.

Photo: Harvey A. Weber.

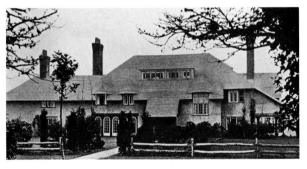

I-156 **JOHN E. ERDMANN HOUSE; COXWOULD**
Lily Pond Lane
Albro & Lindeberg, architects
Smith and Davis, builders
1912; 1927 alterations

Dr. John E. Erdmann, a prominent New York
surgeon, had this house built in 1913, and he lived
here until 1954. Harrie T. Lindeberg designed the
house, which features a wood shingle roof that undu-
lates in a manner reminiscent of thatched roofs. The
name *Coxwould* pays tribute to the inspiration of this
form, the Coxwold cottages of England. The origi-
nal roof burned and was replaced in 1927. The house
was famous for its topiary hedges representing five
family members.

Refs.: C. Matlack Price, "The Recent Work of Albro &
Lindeberg," *Architecture* (January 1915).
Rattray, *Fifty Years,* 192
Star, 13 September 1912, 8 July 1927.

Photo: *Architecture,* January 1915.

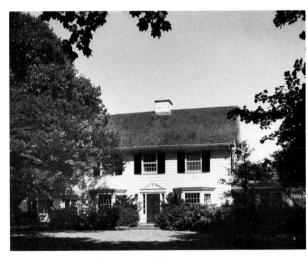

I-157 **GEORGE LAMONT HOUSE**
Cottage Avenue
John Custis Lawrence, architect
1912

Refs.: Plans, Parsons Electric.
Star, 17 February 1913.

Photo: Harvey A. Weber.

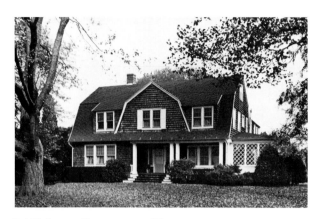

I-158 JOHN FLANNERY HOUSE
82 Woods Lane
Joseph Greenleaf Thorp, architect
Smith and Davis, builders
1912

Refs.: Plans, Parsons Electric.
 Star, 18 October 1912, 24 January 1913.

Photo: Harvey A. Weber.

I-159 J. D. VOORHEES HOUSE
80 Dunemere Lane
John Custis Lawrence, architect
Edward M. Gay, builder
1913

 A newspaper account noted that this house was "of the Normandy type, with stucco covering and green stained roofs."

Refs.: Plans, EHFL.
 Star, 20 September 1912, 17 April 1914.

Photo: Harvey A. Weber.

I-160 B. FRANKLIN EVANS HOUSE
Lily Pond Lane
John Custis Lawrence, architect
Smith and Davis, builders
1913

 A contemporary account noted that this house was "one of the largest in the cottage settlement, having a frontage of 127 feet." In all there were nineteen rooms. When it was built, it was "covered with old-fashioned twenty-four-inch shingles, laid 12 inches to the weather and stained a cement gray, with the roofs of a soft green." The interior was as "colonial" as the exterior, with wainscoting, an open beam ceiling in the living room, and a large, "old-fashioned," open fireplace.

Refs.: Plans, EHFL.
 Star, 13 September 1912, 29 November 1912, 19
 September 1913, 27 June 1913.

Photo: Harvey A. Weber.

I-161 C. S. DAYTON HOUSE
114 Buells Lane
1913

Refs.: Hyde, *Atlas,* 1916.

Photo: Harvey A. Weber.

I-162 **E. S. AVERY HOUSE**
Lily Pond Lane
John Custis Lawrence, architect
Edward M. Gay, builder
1914; 1961 alterations

This house measured twenty-eight feet by one hundred thirty-four feet and it was, according to local tradition, the first one-story summer house built in East Hampton.

Refs.: Plans, EHFL and Parsons Electric.
 Star, 17 July 1914, 27 April 1939, 17 July 1939.

Photo: Harvey A. Weber.

Refs.: Plans, Parson Electric.
 Star, 21 December 1920, 15 June 1939.

Photo: Harvey A. Weber.

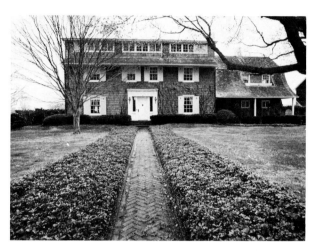

I-164 **SECOND MRS. F. STANHOPE PHILLIPS HOUSE**
75 Dunemere Lane
I. H. Green, Jr., architect
Philip Ritch, builder
1915

Refs.: Plans, Parsons Electric.
 Star, 19 November 1915.

Photo: Harvey A. Weber.

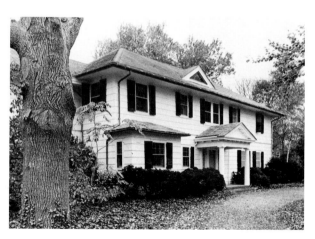

I-163 **JAMES EDWARDS HOUSE**
Georgica Road
John Custis Lawrence, architect
Edward M. Gay, builder
1914

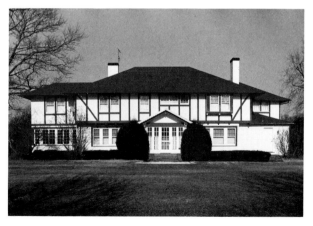

I-165 **SECOND SCHUYLER QUACKENBUSH HOUSE**
Lee Avenue
John Custis Lawrence, architect
Edward M. Gay, builder
1915; 1929 alterations

This house, the second built for Schuyler Quackenbush, was probably built for rental (see I-107). J. C. Lawrence renovated the house in 1929 for Mrs. McAlpin Burton.

Refs.: Plans, EHFL.
 Star, 30 October 1914, 19 March 1920, 11 October 1920.

Photo: Robert J. Hefner.

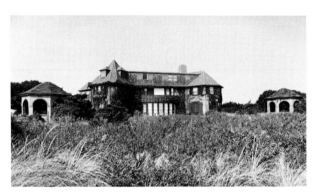

I-167 WILLIAM H. WOODIN HOUSE
Lily Pond Lane
Grosvenor Atterbury, architect (attributed)
Frank B. Smith, builder
1916

This house is attributed to architect Grosvenor Atterbury because he designed its complementary gardener's cottage in 1925 (I-183). It was built for William H. Woodin, president of the American Car & Foundry Company, who served briefly as Secretary of the Treasury under Franklin D. Roosevelt.

Refs.: Rattray, *Fifty Years,* 70.
 Star, 31 December 1915.

Photo: Harvey A. Weber.

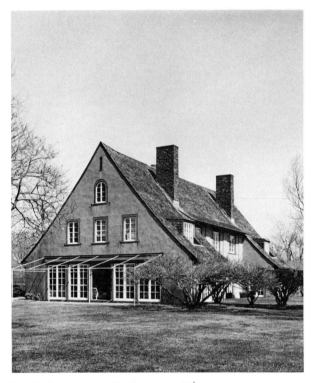

I-166 CLARENCE F. ALCOTT HOUSE
Lily Pond Lane
Harrie T. Lindeberg, architect
Frank B. Smith, builder
1915

Refs.: Plans, Parsons Electric.
 C. Matlack Price, "The Recent Work of Albro & Lindeberg," *Architecture* (January 1915).
 Star, 19 November 1915, 24 October 1935.

Photo: Harvey A. Weber.

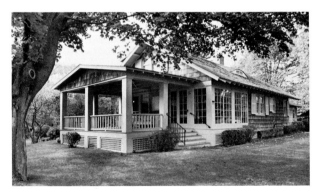

I-168 LORENZO E. WOODHOUSE BUNGALOW
105 Egypt Lane
John Custis Lawrence, architect
ca. 1916

Refs.: Plans, EHFL.
 Star, 25 August 1916, 27 April 1928.

Photo: Harvey A. Weber.

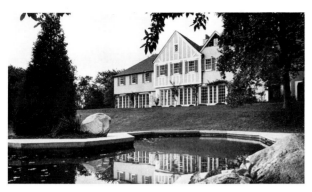

I-169 F. L. STANTON HOUSE
Georgica Road
1916; 1928 alterations

Alfred Bell acquired this house in 1928 and had J. C. Lawrence design alterations, which included interior renovations and "twelve-foot extensions on each side and . . . a four-foot addition placed on the front of the house."

Refs.: *Star,* 23 February 1917, 3 January 1928, 24 February 1928.

Photo: Harvey A. Weber.

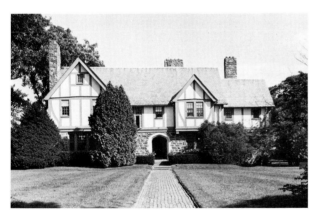

I-170 RECTORY OF ST. LUKE'S EPISCOPAL CHURCH
22 James Lane
Thomas Nash, architect
Gillies and Campbell, builders
1916

Refs.: *Star,* 20 October 1916, 23 October 1916.
"Vestry Minutes 1907–1921," St. Luke's Episcopal Church.

Photo: Harvey A. Weber.

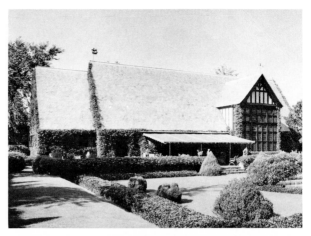

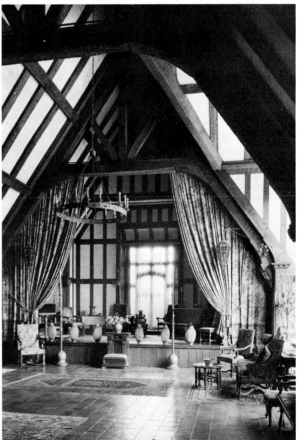

I-171 LORENZO E. WOODHOUSE PLAYHOUSE
80 Huntting Lane
F. Burrall Hoffman, architect
1917; 1953 alterations

Mrs. Lorenzo E. Woodhouse had the Playhouse built for her daughter, Marjorie. Both Isadora Duncan and Ruth St. Denis are said to have danced here. Mrs. Woodhouse had the Playhouse remodeled for residential purposes in 1953.

The Playhouse was built on the grounds of the Lorenzo E. Woodhouse estate. The main house, The Fens, designed by Joseph Greenleaf Thorp, was built in 1904 and demolished in 1949. Other surviving buildings are the gardener's cottage, the carriage house, and the laundry.

Mrs. Woodhouse was a philanthropist, and East Hampton was often the object of her generosity. She founded the Garden Club in 1911, donating her Japanese water garden, which now comprises part of the village's Nature Trail. In 1911 she purchased the site for and in 1912 financed the building of the East Hampton Free Library, later donating the Cloister and the Red Room. In 1921 she restored Clinton Hall to its eighteenth century appearance, removing a large hall that had been used for entertainment, and then ten years later she helped finance the construction of Guild Hall to meet the need created by that restoration.

Refs.: Plans, Parsons Electric.
 Star, 11 June 1953.

Photos: Samuel Gottscho, courtesy of Gottscho–Schleisner, Inc.

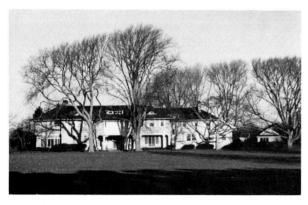

I-172 GEORGE W. SCHURMAN HOUSE
Further Lane
Arthur C. Jackson, architect
Edward M. Gay, builder
1917

Refs.: Plans, EHFL.
 Star, 15 December 1916.

Photo: Robert J. Hefner.

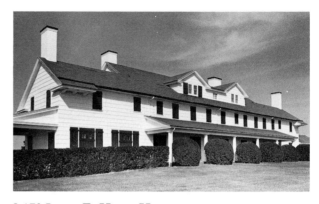

I-173 JOHN E. HELM HOUSE
Nichols Lane
John Custis Lawrence, architect
Edward M. Gay, builder
1917

Refs.: *Star*, 22 September 1916, 10 November 1916, 1 September 1922.

Photo: Harvey A. Weber.

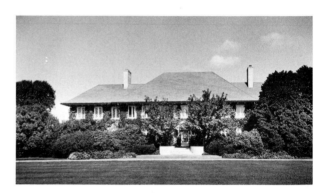

I-174 WALLACE REID HOUSE
Further Lane
Arthur Truscott in association with John Custis Lawrence, architects
Edward M. Gay, builder
1917; 1946 alterations

According to a report in the *Star*, this house measured one hundred fifty-two feet by thirty-three feet and included a large enclosed porch at the west end overlooking a formal garden with a view of the village beyond. A later owner reportedly improved and renovated the property.

Refs.: Plans, EHFL.
 Star, 3 August 1917, 17 August 1917, 28 March 1946.

Photo: Harvey A. Weber.

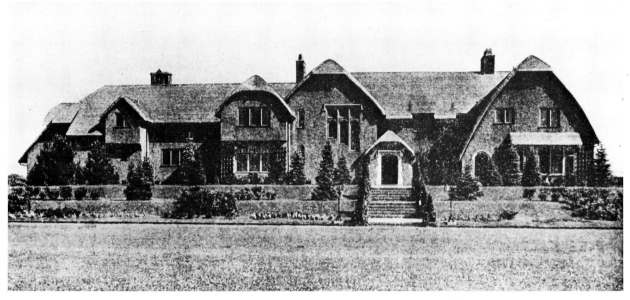

I-175 **ROBERT APPLETON HOUSE, NID
DE PAPILLON**
Old Beach Lane
Frank Eaton Newman, architect
Edward M. Gay, builder
1918

This fanciful house was designed by New York
architect Frank Eaton Newman for Robert Appleton.
E. M. Gay built the house at a cost of approximately
$60,000. Appleton acquired more land in this area and
in 1919 owned one hundred acres with ocean front-
age of 1,500 feet.

Refs.: *Architectural Record* (October 1919): 380–82.
　　　Plans, EHFL.
　　　Star, 31 August 1917, 7 November 1919.

Photo: *Architectural Record,* October 1919.

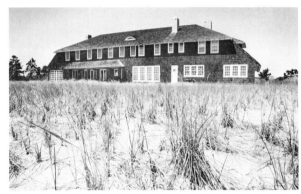

I-176 **FOURTH FREDERICK K. HOLLISTER HOUSE**
Drew Lane★
John Custis Lawrence, architect
Edward M. Gay, builder
1920

Dr. Frederick K. Hollister had previously built
three houses in this vicinity, (I-153). This rental house
on Drew Lane measured thirty-two feet by one
hundred ten feet and had seven master bedrooms and
six servants' bedrooms. In 1975 the house was moved
back from the ocean.

Refs.: Plans, EHFL, and Parsons Electric.
　　　Star, 15 August 1919, 19 March 1920.

Photo: Harvey A. Weber.

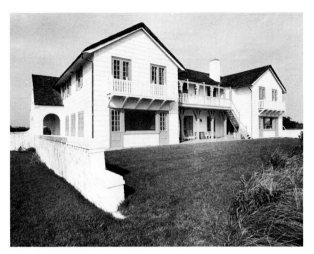

I-177 HERBERT COPPELL HOUSE
Lily Pond Lane
John Custis Lawrence, architect
Edward M. Gay, builder
1920; 1928 alterations

Herbert Coppell had this house, one hundred-ten feet long and forty feet wide, built in 1920. The original drawings show a house with a Lindeberg roof and simpler detailing. Renovation designs by Robert Tappan are extant but undated. A 1928 newspaper item noted that the Herbert Coppell place was being "rebuilt" at that time by local contractor F. B. Smith. Plans for the house drawn by Robert Tappan were probably carried out at that time.

Refs.: Plans (1920), EHFL.
Plans (alterations), Parsons Electric.
Star, 19 March 1920, 6 March 1931.
17 April 1931, 26 November 1953.

Photo: Harvey A. Weber.

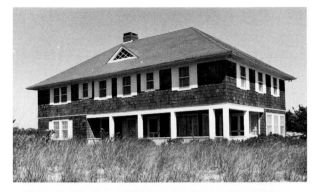

I-178 MARY L. MAYO HOUSE
Lily Pond Lane
John Custis Lawrence, architect
Edward M. Gay, builder
1920

Refs.: Plans, EHFL.
Star, 17 October 1919, 19 March 1920.

Photos: Harvey A. Weber.

I-179 HAMILTON KING HOUSE
Apaquogue Road
Lewis Colt Albro, architect
1921

Hamilton King, a painter, and his wife purchased this property, which had two fishermen's cottages standing on it, and in 1921 they hired architect Lewis Colt Albro to design a house incorporating the two structures. Albro joined the two cottages with a long living room and all the exterior surfaces were covered with grey stucco.

Refs.: Barbara Castella, "An Artist's Home of Unique Charm," *Arts and Decoration* (June 1928): 56.
Star, 8 April 1921.

Photo: Harvey A. Weber.

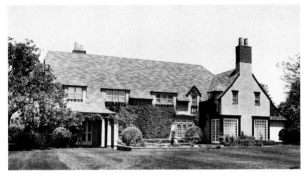

I-180 WILLIAM S. JENNEY HOUSE
140 Egypt Lane
Polhemus and Coffin, architects
Frank B. Smith, builder
1917–21

Refs.: *Architectural Record* (November 1923): 417–18.
Architecture (October 1923).
Star, 9 August 1921.

Photo: Harvey A. Weber.

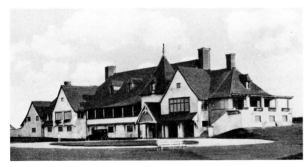

I-181 THE MAIDSTONE CLUB
Old Beach Lane
Roger Bullard, architect
Rogers and Blydenburgh, builders
1922–24; 1953 alterations

The following notice in the *Star* announced the founding of the Maidstone Club in 1891:

> . . . an association is to be incorporated for the purpose of building and maintaining a large casino in East Hampton The plot of land purchased comprises eighteen acres running through from the street to the pond with forty feet on street and 500 feet of waterfront. The grounds are most beautifully situated overlooking the pond, dunes and ocean. . . . The price to be paid for the land is $14,000. Five acres of the plot will be laid out in tennis courts. . . . The capital stock of the company is to be $25,000 to be sold at $100 per share, each share having the power of one vote. . . . One of the fundamental rules . . . is that no intoxicating liquors will at any time be allowed upon the premises. . . .

The Club was the gathering place for the Summer Colony. The first two clubhouses, both designed by I. H. Green, Jr., were located at the end of Maidstone Lane overlooking Hook Pond. The first clubhouse, built in 1892, burned in 1901 and its replacement burned in 1922. The second clubhouse, built in 1902, was described in the *Star* as "one of the largest and finest clubhouses on Long Island," measuring 190 feet in length and eighty feet in width and covering 20,137 square feet of ground. A sixteen-foot wide piazza extended around the entire building, "affording a promenade 570 feet in length."

Even before the fire, as early as 1917, the Club directors considered building on the dunes, and after the second clubhouse was destroyed, this new site was chosen. Roger Bullard designed the present building, which was extensively altered in 1953 by Aymar Embury II. The "Beach Club" below the clubhouse, consisting of the pool and cabanas, was designed by John H. Jewett and built in 1928.

Refs.: *American Architect* (20 July 1926): 43–56.
Rattray, *Fifty Years,* 38.
Star, 11 September 1891, 14 March 1902, 16 February 1923, 20 June 1924, 23 March 1928, 25 May 1928, 16 April 1953.

Photo: Courtesy of Averill D. Geus.

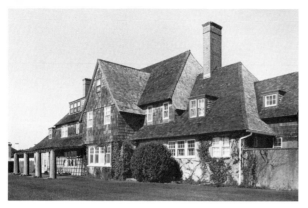

I-182 PAUL SALEMBIER HOUSE
Lily Pond Lane
Roger Bullard, architect
Edward M. Gay, builder
1924; 1927 alterations

This cottage was built for Paul Salembier, an executive with Salembier and Villate, New York dealers in raw silks. It was remodeled three years later after plans drawn by Grosvenor Atterbury.

Refs.: Plans, EHFL and Parsons Electric.
 Star, 7 December 1923.

Photo: Harvey A. Weber.

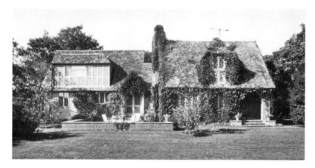

I-183 WOODIN GARDENER'S COTTAGE
Lily Pond Lane
Grosvenor Atterbury, architect
Frank B. Smith, builder
1926

Grosvenor Atterbury designed this two-family gardener's cottage for William H. Woodin, whose house (I-167) is also attributed to Atterbury.

Refs.: *Star,* 30 October 1925, 8 January 1926.

Photo: Harvey A. Weber.

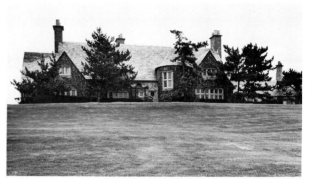

I-184 ELLERY JAMES HOUSE
West End Avenue
Roger H. Bullard, architect
Frank Johnson, builder
1926

Refs.: *American Architect* (5 June 1929): 711–20.
 Architectural Record (November 1933): 361–62.
 Star, 15 January 1926.

Photo: Harvey A. Weber.

I-185 LAWRENCE OAKLEY HOUSE
Drew Lane
John Custis Lawrence, architect
Edward M. Gay, builder
1926

Refs.: Plans, EHFL, and Parsons Electric.
 Star, 6 October 1925, 4 December 1925.

Photo: Harvey A. Weber.

I-186 ELTINGE F. WARNER HOUSE, CIMA DEL MUNDO
Lily Pond Lane
Robert Tappan, architect
1926

Eltinge F. Warner, in discussions with his architect, Robert Tappan, decided that a Spanish farmhouse would be appropriate for this site on the dunes. The house originally had a stucco finish of a beach-like coral color. The high walls provided privacy from neighbors and protection from winds. As Warner was the publisher of *Arts & Decoration,* the house was well publicized in that magazine, notably in an article by Tappan.

Refs.: Mary Fannon Roberts, "Spain for Beauty, America for Comfort," *Arts & Decoration* (February 1928): 52, 54, 92, 94.
Robert Tappan, "Cima del Mundo," *Arts & Decoration* (April 1927): 48–49, 114.
Star, 6 August 1926, 12 August 1927.

Photo: Harvey A. Weber.

I-187 PAUL NUGENT HOUSE
11 Davids Lane
Joseph Greenleaf Thorp, architect
Frank B. Smith, builder
1926

Refs.: Plans, Parsons Electric.
Star, 18 December 1925, 8 January 1926, 6 August 1926.

Photo: Harvey A. Weber.

I-188 GRANTLAND RICE HOUSE
West End Avenue★
John Custis Lawrence, architect
Edward M. Gay, builder
1928.

J. C. Lawrence designed this house on the dunes for the famous sportswriter Grantland Rice. Rice's friend Ring Lardner built the house next door at the same time (I-191). Like Lardner's house, the Rice house was seriously damaged in the 1931 hurricane and moved back from the beach at that time.

Refs.: Plans, EHFL and Parsons Electric.
Star, 24 February 1928, 13 March 1931.

Photo: Robert J. Hefner.

I-189 FREDERICK CODY HOUSE
Further Lane
John Custis Lawrence, architect
Edward M. Gay, builder
1928

Refs.: *Star,* 6 July 1928.

Photo: Harvey A. Weber.

I-190 NATHANIEL A. CAMPBELL HOUSE
West End Avenue
Robert Tappan, architect
1928

This property was once the site of the Everett Edward McCall house, which burned in 1927. Nathaniel A. Campbell purchased the vacant lot and hired architect Robert Tappan to design this house.

Refs.: *Star,* 20 April 1928.

Photo: Harvey A. Weber.

I-191 RING LARDNER HOUSE, IONA DUNE
West End Avenue★
Edward M. Gay, builder
1928

The famous short-story writer, Ring Lardner, had this house built on the dunes. The structure was severely damaged in the hurricane of 1931 and was moved back from the beach at that time.

Refs.: *Star,* 28 October 1927, 13 March 1931.

Photo: Robert J. Hefner.

I-192 LOUIS FAUGERES BISHOP HOUSE
Ocean Avenue
L. Bancel LaFarge, architect
1929–30

Refs.: Plans, Parsons Electric.
 Star, 2 May 1930, 29 August 1930.

Photo: Harvey A. Weber.

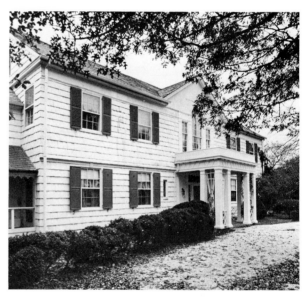

I-193 GEORGE ROBERTS HOUSE
Middle Lane
Aymar Embury II, architect
Frank Johnson, builder
1930–31

Refs.: Plans, Parsons Electric.
 Star, 8 December 1955.

Photo: Harvey A. Weber.

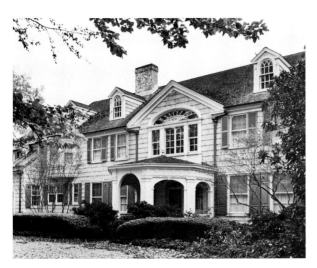

I-194 SHEPHARD KRECH HOUSE
Briar Patch Road
Arthur C. Jackson, architect
1931–32

Refs.: Plans, Parsons Electric.
 Star, 24 July 1931, 13 November 1931, 13 May 1932.

Photo: Harvey A. Weber.

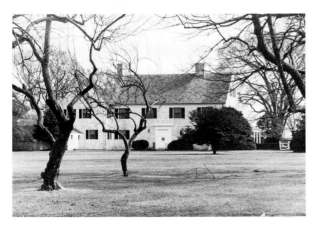

I-195 HARRY F. COOK HOUSE
Hither Lane
E. Ritzema Perry, architect
1932

Refs.: Plans, EHFL, and Parsons Electric.
 Star, 25 November 1932.

Photo: John Spear.

I-196 MYRTLE SHEPARD HOUSE
Dunemere Lane
G. Piers Brookfield, architect
1937; 1948 alterations

This house is the earliest example of the influence of International Style modernism on the architecture of the village. In 1948 the house was renovated under the supervision of Aymar Embury II, architect.

Refs.: *Star,* 5 April 1962.

Photo: Harvey A. Weber.

I-197 ROBERT MOTHERWELL HOUSE
Georgica Road
Pierre Chareau, architect
1946; 1956 alterations

Robert Motherwell engaged French architect Pierre Chareau to design a house made of sheet iron gathered from army surplus supplies and incorporating several large panes of glass from an old greenhouse. In 1956 architect Robert Rosenberg planned renovations for a subsequent owner.

Refs.: Rene Herbst, *Pierre Chareau* (Paris: Editions du Salon des Arts Menagers, 1954), 11–12.
Plans (alterations), Parsons Electric.
James Tanner, "East Hampton: The Solid Gold Melting Pot," *Harper's Bazaar* (August 1958): 95–97, 144, 146.

Photo: Rene Herbst, *Pierre Chareau*.

I-198 ROBERT ROSENBERG HOUSE
Further Lane
Robert Rosenberg, architect
1952

Refs.: *Star,* 19 June 1952.

Photo: Harvey A. Weber.

I-199 FIRST OTTO SPAETH HOUSE
Further Lane
George Nelson and Gordon Chadwick, architects
1955

Refs.: James DeLong, "The Renaissance of the Wood Shingle," *House Beautiful* (March 1966): 128.
Scully, *Shingle Style Today,* 26–28.
"The Grand Old Shingle," *Architectural Forum* (October 1957): 148–53.

Photo: Harvey A. Weber.

I-200 PARDUE HOUSE
Hook Pond Lane
Alfred Scheffer, architect
1958

Refs.: *Star,* 16 January 1958, 19 June 1958.

Photo: Richard Wood.

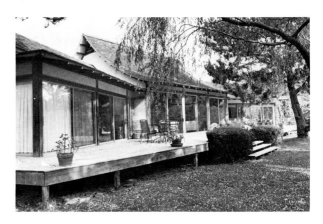

I-201 DUDLEY MILLER HOUSE
Highway Behind the Pond
Robert Venturi and William Short, architects
1961–62; later alterations

Refs.: Plans, Parsons Electric.
 Star, 14 December 1961.

Photo: Harvey A. Weber.

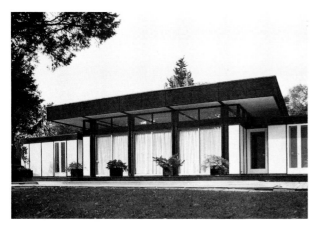

I-202 ROBERT SCULL HOUSE
Georgica Road
Paul Lester Weiner, architect
ca. 1962

Photo: Harvey A. Weber.

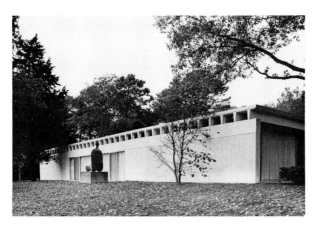

I-203 GORDON BUNSHAFT HOUSE
Georgica Close Road
Gordon Bunshaft, architect
1963–64

Refs.: "Record Houses of 1966," *Architectural Record* (Mid-
 May 1966).
 William K. Zinsser, "Far Out on Long Island,"
 Horizon (May 1963): 14.

Photo: Harvey A. Weber.

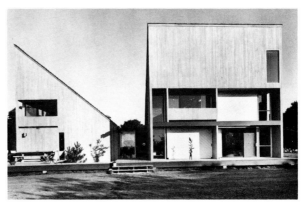

I-204 CHALIF HOUSE
Terbell Lane
Barbara and Julian Neski, architects
1965

Refs.: "A Saltbox Split in Two," *Architectural Forum* (September 1965): 59–61.

Photo: Hans Namuth, courtesy of Neski
 Associates/Architects.

I-205 DAVID HOFFMAN HOUSE
Georgica Road
Richard Meier, architect
1967

Refs.: Tina Durham, "Breaking Out in All Directions,"
 American Home (April 1969): 66–67.
 Richard Meier, Architect (New York: Oxford University Press, 1976): 34–37.

Photo: Ezra Stoller, © ESTO.

I-206 RENNY SALZMAN HOUSE
Further Lane
Richard Meier, architect
1967–69

Refs.: *Five Architects: Eisenman, Graves, Gwathemy, Hejduk, Meier* (New York: Oxford University Press, 1975).
 Richard Meier, Architect (New York: Oxford University Press, 1976): 38–45.
 Scully, *Shingle Style Today*, 38.

Photo: Ezra Stoller, © ESTO.

I-207 DONALD BLINKEN HOUSE
Lily Pond Lane
John Bedenkapp, architect
ca. 1970

Photo: Harvey A. Weber.

I-208 MARSHALL COGAN HOUSE
Terbell Lane
Charles Gwathemy and Robert Siegal, architects
1971

Refs.: Anne Stagg, "A Surge of Space," *House and Garden* (March 1971): 114–21.
 "Record Houses of 1973," *Architectural Record* (Mid-May 1973): 6.

Photo: Harvey A. Weber.

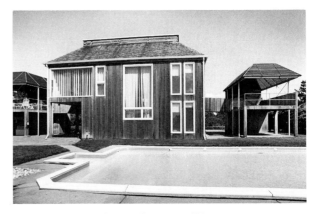

I-209 SECOND OTTO SPAETH HOUSE
Highway Behind the Pond
Hardy, Holzman and Pfeiffer, architects
1972

Refs.: "Her 'Happiest' Paradox," *House Beautiful* (August 1972): 60–62.

Photo: Harvey A. Weber.

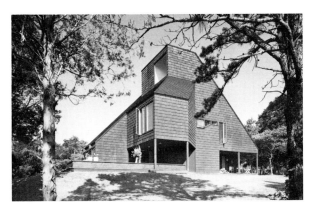

I-210 BROSS HOUSE
East Hollow Road
Alfredo De Vido, architect
1972.

Photo: Ezra Stoller, © ESTO.

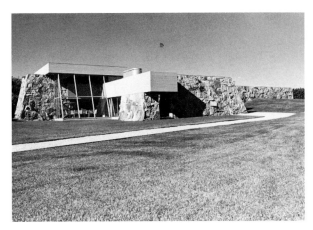

I-212 RICHARD LLOYDS HOUSE
Further Lane
Norman Jaffe, architect
1977

Refs.: *Architectural Digest* (December 1978).

Photo: Hal McKusick, courtesy of Norman Jaffe.

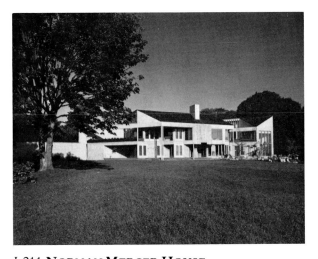

I-211 NORMAN MERCER HOUSE
Ocean Avenue
Robert A. M. Stern and John S. Hagmann in association with Alfredo De Vido, architects
1972–74

Refs.: Scully, *Shingle Style Today,* 33–34.

Photo: Edmund H. Stoecklein, courtesy of Robert A. M. Stern, Architects.

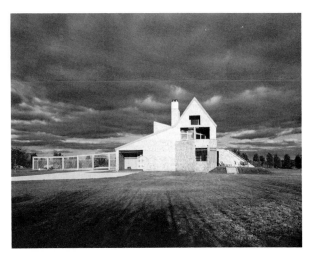

I-213 LAWRENCE FLINN HOUSE
Further Lane
Jaquelin Robertson, architect
1980

Refs.: "Record Houses of 1981," *Architectural Record* (Mid-May 1981).

Photo: Edmund H. Stoecklein, courtesy of Eisenman/Robertson.

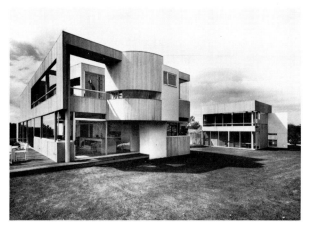

I-214 HOUSE ON FURTHER LANE
Further Lane
Mayers and Schiff, architects
1980

Refs.: "Record Houses of 1980," *Architectural Record* (Mid-
 May 1980).
 New York Times Magazine, 25 May 1980.

Photo: Norman McGrath, courtesy of Mayers and Schiff.

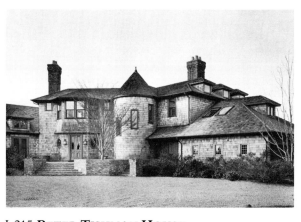

I-215 PETER TISHMAN HOUSE
Briar Patch Road
Eugene Futterman, architect
1980–81

Refs.: Kelsey Maréchal, "What is a Futterman?" *The
 Hamptons* (September 1981): 44.

Photo: Harvey A. Weber.

SOUTH ELEVATION

I-216 CORBEL PROPERTY HOUSE
Georgica Road
Robert A. M. Stern, architect
1981

Illustration: Courtesy of Robert A. M. Stern, Architects.

EAST ELEVATION

WEST ELEVATION

I-217 BRUCE BOZZI HOUSE
Cottage Avenue
Robert A. M. Stern, architect
1981

Illustration: Courtesy of Robert A. M. Stern, Architects.

Inventory of Public, Religious, and Commercial Buildings

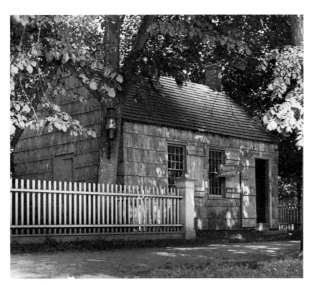

I-218 **TOWN HOUSE**
151 Main Street★
1730–33

Construction of this building was first proposed at a town meeting on 8 January 1730, but it was still unfinished near the end of 1733. It was to be "Eighteen feet square and seven and a half betwen Joynts," that is, in height between floor and ceiling joists. Built on the common at the north end of Main Street, it served as a school and a town meeting place. By the late nineteenth century the building had been moved down Main Street to a site in front of the Jeremiah Miller House (I-29). In 1901 it was moved to a location behind the Methodist Church (I-232) near the original site. The East Hampton Historical Society acquired the structure and moved it to its present location in 1958.

Refs.: Rattray, *Main Street*, 62, 104.
 Sleight (ed.), *Trustees Journal*, 1725–1772, 59–60, 64–65.
 Star, 26 June 1891, 10 July 1931.

Photo: Mary Buell Hedges, courtesy of Adele Hedges Townsend.

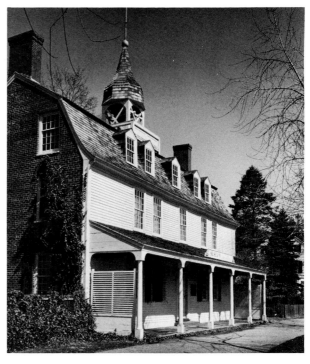

I-219 **CLINTON ACADEMY**
151 Main Street
1784–85; 1886, 1921 alterations

Promoted by the Reverend Samuel Buell, East Hampton's third Presbyterian minister, and named after Governor George Clinton, the Academy was chartered in 1787 and became the first accredited high school in New York State. Coeducational from the beginning, its purpose was to prepare students for entering college. During the Academy's first four decades the average enrollment was eighty students a year. The Academy building is unique in East Hampton for its brick ends and is the only public building with a gambrel roof. By 1881 the structure had fallen into disuse, and five years later it was converted into a village hall with the addition of a south wing designed by James Renwick, Jr. and built by George Eldredge. This addition housed an auditorium in which entertainments were held for both summer colony and local residents. The *East Hampton Star* and East Hampton Free Library occupied parts of the old building until the Library was relocated in 1912. In 1921 Mrs. Lorenzo E. Woodhouse sponsored the restoration of the structure under the direction of John Custis Lawrence and Joseph Greenleaf Thorp. The addition was removed at that time. Since its restoration Clinton Academy has served as a museum for the East Hampton Historical Society.

Refs.: Plans (1921), EHFL.
 Rattray, *Fifty Years,* 17.
 Rattray, *Main Street,* 113–14.
 Star, 21 August 1886, 16 October 1886, 27 November 1886, 26 September 1919, 25 April 1957.

Photo: Harvey A. Weber.

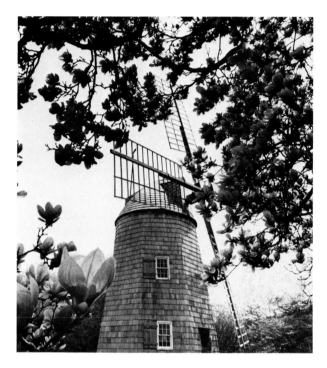

I-220 **Pantigo Windmill**
James Lane★
Samuel Schellinger, builder
1804

Samuel Schellinger built this wind-powered gristmill for Huntting Miller on Mill Hill at the south end of Main Street in 1804. Schellinger, an Amagansett craftsman, became one of the first American millwrights to employ cast-iron machinery in windmills, and he brought this new technology to eastern Long Island when he built the Beebe windmill in Sag Harbor in 1820. The Pantigo windmill operated on Mill Hill until 1845 when it was moved to a site on the north side of Pantigo Road, about a half mile east of Main Street. The mill was later moved to the corner of Pantigo Road and Egypt Lane. A severe storm in 1879 broke the windshaft and the mill was never put back in running order. The mill stood as a derelict until 1917 when Gustav Buek moved it to the rear of his house, "Home Sweet Home," across the com-

mon from the Mill Hill where it was built.

The Pantigo windmill was the first smock mill built in East Hampton with intermediate gearing to drive two pair of millstones. The two older surviving South Fork windmills, the Gardiner's Island mill (1795) and the windmill at Water Mill (1800), both had one pair of millstones driven directly from the brake wheel. During the mid-nineteenth century a cast-iron cross was installed on the end of the windshaft to secure the sail stocks. This is the earliest record of ironwork on a windshaft of a Long Island windmill. In England, iron crosses or poll-ends fastened to wooden windshafts to hold the stocks were common. All the important internal machinery survives in the Pantigo mill. The wooden gearing is all of the original design, except the clasp-arm brake wheel, which was installed at a later date.

Refs.: Edwards, "Reminiscences," 18.
 Express, 21 August 1879.
 Samuel Schellinger Account Book, private collection.

Photo: Harvey A. Weber.

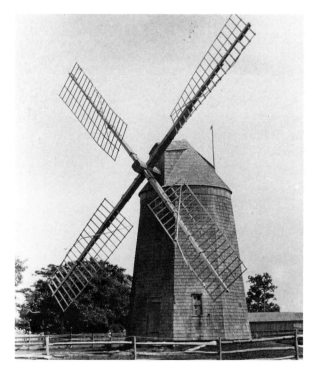

I-221 **GARDINER WINDMILL**
James Lane
Nathaniel Dominy V, builder
1804

Nathaniel Dominy V built this windmill in 1804 to replace another wind-powered gristmill built in 1769 either on the same or a nearby site. This mill, like the Pantigo mill, was a new type of smock mill employing intermediate gearing to run two pairs of millstones. Nathaniel Dominy V was a prominent East Hampton cabinetmaker and clockmaker as well as a millwright. Between 1795 and 1811 Dominy built nine windmills on eastern Long Island and three of these, besides the Gardiner mill, still stand: the Gardiner's Island mill (1795), the Hook mill (1806) and the Shelter Island mill (1810).

Funds to build the Gardiner mill were raised by selling shares, and the mill continued to be owned by a syndicate until midcentury. During the late nineteenth century the mill was owned by Jonathan Thompson Gardiner, who kept it in operation into the first decade of the twentieth century.

The Gardiner mill still contains an unusual gearing system that drives the millstones from below, instead of from above as is found in the other Long Island windmills. The mill also retains the system of internal wooden gears and shafts, favored by Nathaniel Dominy, for revolving the cap to turn the sails of the mill into the wind.

Refs.: Nathaniel Dominy V Account Book, 1798–1847, Henry Francis du Pont Winterthur Museum, microfilm in EHFL.
Felix Dominy, Nathaniel Dominy V and Nathaniel Dominy VII Account Book, 1809–1862, EHFL.

Photo: Herbert Bates, ca. 1900, courtesy of Adele Hedges Townsend.

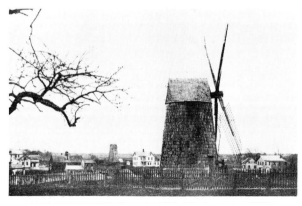

I-222 **HOOK WINDMILL**
North Main Street
Nathaniel Dominy V, builder
1806

Two years after completing the Gardiner mill, Nathaniel Dominy V was engaged by a mill company at the north end of the village to build another of the new type smock mills. This mill stands in "the Hook" on an artificial mound on what remains of the north end common. The Hook mill replaced a post mill that had been built on the site in 1736. The company of four men who owned the post mill expanded to eight men to finance the new smock mill. The windmill continued to be managed by a company until 1859 when Nathaniel Dominy VII, the grandson of the builder, owned all the shares. Dominy operated the mill himself until 1908; during this time Dominy also owned the Pantigo mill and the windmill at Wainscott. The Hook mill was acquired by the Village of East Hampton in 1922. It was restored to working order in 1939 and was operated seasonally into the 1950s.

The Hook windmill is larger than Dominy's Gardiner mill, and it has a boat-shaped instead of a conical cap. Because of the 1939 refitting the Hook mill contains more machinery than any other Long Island windmill. As well as the machinery to drive the millstones and turn the cap, the mill contains a sack hoist, a cup elevator to carry the grain up into the mill, a screener to clean the grain, and a corn bolter and a flour bolter to sift the product.

Refs.: Nathaniel Dominy V Account Book, 1798–1847, Henry Francis du Pont Winterthur Museum, microfilm in EHFL.

Photo: The Hook Windmill is in the foreground. The Pantigo Windmill, without its sails, is in the background. This 1880 photograph shows the treeless landscape in which these windmills operated. Photograph by H. K. Averill, Jr., 1880, courtesy of C. Frank Dayton.

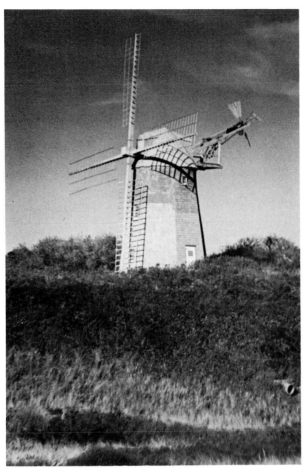

I-223 **HAYGROUND WINDMILL**
Further Lane★
1809

This wind-powered gristmill was built in 1809 on the triangular common at the center of the village of Hayground, midway between Bridgehampton and Water Mill. The mill was run on this site until 1919 and was the last Long Island windmill to operate commercially. In 1950 the mill was moved to an estate on the dunes in East Hampton.

The Hayground windmill retains all its principal internal machinery, which is similar to that found in the other East Hampton mills. But the Hayground mill differs in having a fantail to revolve the cap automatically, always keeping the sails facing into the wind. The fantail is not original to the mill but was installed, probably in the 1830s, to replace a manually operated tail-pole.

Photo: Henry A. Weber

I-224 **SESSION HOUSE**
Main Street★
1858

The Reverend Stephen Mershon persuaded his Presbyterian congregation to build this meeting house for Wednesday evening prayer meetings just three years before the new church (I-225) was erected. The Session House was originally located on the west side of Main Street in the present business district, but was moved in 1905 to the corner of Main Street and David's Lane next to the church. In 1926 the structure was again moved to its present site farther back on the same lot.

Refs.: Rattray, *Main Street,* 97.
 Star, 2 January 1886, 19 June 1886, 13 August 1926.

Photo: Harvey A. Weber.

I-226 THE APAQUOGUE
Apaquogue Road
1884

I-225 FIRST PRESBYTERIAN CHURCH OF EAST HAMPTON
Main Street
Coburn and Hurst, builders
1861; 1960 alterations

Constructed in 1861 by Coburn and Hurst of Syracuse, New York, this building replaced the meeting house that had been built in 1717. The Reverend Stephen Mershon, a dynamic revivalist minister and pastor of the Presbyterian congregation from 1854 to 1866, encouraged the construction of this church. The building was in the Romanesque Revival style, with five tall round-arched openings on each side and two towers flanking twin entrances on the front. The main facade, in need of repair by 1960, was altered to its present style as designed by Arthur Newman, architect. The towers were removed and a new tower, with a steeple and portico, was centered on the facade. The tower clocks from the 1861 church were placed in the new tower. Other architectural details were also altered at that time.

Refs.: Rattray, *Main Street*, 22.
 Seabury, *275 Years*, 50.
 Star, 29 January 1887, 5 June 1907.

Photo: Harvey A. Weber.

This house stands on the site of the first boarding house in the Summer Colony, operated by Abraham D. Candy. A teacher at Clinton Academy, Candy owned a 107 acre farm here and rented to boarders starting in the early 1840s. In 1882 the farm was sold to Mrs. E. A. Laforest of New York, and in the winter of that year the house burned to the ground. Two years later she built a new boarding house called The Apaquogue, and in 1895 she transferred title to her son, Harry A. Laforest. The boarding house was pictured and publicized in the *Star* that spring:

> The spot upon which The Apaquogue is located is famous as a summer boarding place. . . . On the first floor are the large sitting room and parlors. . . . The dining room . . . overlooks the ocean on the south side . . . off from this room is a smaller dining room for the accommodation of nurses and children. . . . On the upper floors we found twenty-two large . . . bedrooms, with pipe water brought from a well, on each floor. The location of the house is such that most delightful marine and landscape views can be had from each room.

In 1912 the property was sold to Mrs. A. A. Cater of New York, who hired E. M. Gay to convert the building to a summer residence. The improvements called for renovation of the interior and the construction of a rear wing for servants quarters. However,

these plans may not have been executed, for the *Star* reported the sale of the Apaquogue Hotel by the East Hampton Lumber and Coal Co. to Julian S. Myrick in 1919, noting that Myrick intended to alter the hotel into a summer residence.

Refs.: *Express,* 1 June 1882.
　　Star, 22 March 1895, 17 May 1895, 22 March 1912, 25 April 1919.

Photo: Harvey A. Weber.

I-227 **W. S. EVEREST WAGON SHOP**
83A Buell's Lane
John Aldrich, builder
1886

John Aldrich built this shop for W. S. Everest, a wheelwright and blacksmith. It was originally located on the street. In 1886 Aldrich also built Everest's home at 83 Buell's Lane.

Refs.: *Express,* 29 April 1886.
　　Star, 27 March 1886, 24 April 1886, 22 May 1886.

Photos: Harvey A. Weber.

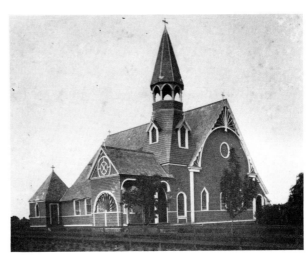

I-228 **ST. PHILOMENA'S CHURCH; MOST HOLY TRINITY CHURCH**
79 Buells Lane
George E. Halsey, builder
1894; 1897, 1938 alterations

Mass was celebrated in the homes of five or six Catholic families in East Hampton starting in 1859. In 1894 the parish had this church built for a cost of over $7,000. The architect was identified only as "Architect Aldrich; brother of John Aldrich," the builder. A contemporary account reported that St. Philomena's, as it was called until 1962, "is a handsome edifice, both inside and outside. Its architectural lines are artistic, and its broad slate roof lends a substantial appearance to the structure. The interior is finished in hard wood and the aisles carpeted with green Brussels." Only a few years later, in 1897, the weight of the roof was found to be compromising the stability of the building, and the Church board decided to replace it with a shingle roof. The steeple was altered in 1938 after a hurricane damaged the original.

Refs.: *Star,* 29 September 1893, 22 June 1894, 21 September 1894, 8 October 1897.

Photo: Courtesy of the East Hampton Free Library.

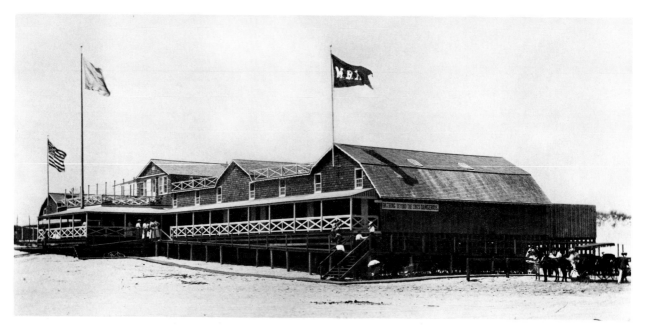

I-230 CULVER'S BATHING PAVILION, MAIN BEACH PAVILION
Ocean Avenue
1900–1901

Austin H. Culver had plans drawn in 1900 for the reconstruction of the older Maidstone bathhouses, built probably in the 1870s, into a new bathing pavilion. The plans called for moving and connecting them into one large structure with a piazza across the front, a "sun bath" at the rear, and a bathroom for "warm sea baths" on the second floor.

Refs.: *Star,* 21 September 1900, 21 December 1900, 8 March 1901, 11 June 1926.

Photo: Mary Buell Hedges, courtesy of Adele Hedges Townsend.

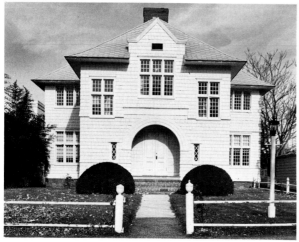

I-229 ODD FELLOWS HALL
26 Newtown Lane
Joseph Greenleaf Thorp, architect
1897

The Hampton Lodge of the Odd Fellows, founded in 1890, had eighty-five members by the time this building was constructed. Designed in the Shingle Style by J. G. Thorp, the Hall was originally painted a dark green. Steel trusses provide support for the open second floor.

Refs.: *Star,* 24 December 1897, 4 February 1898.

Photo: Harvey A. Weber.

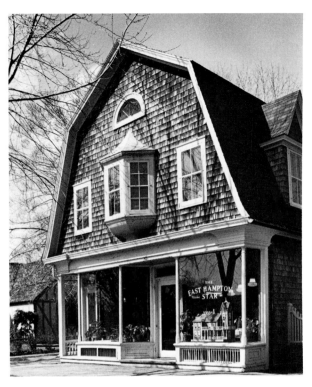

I-231 EDWARDS DRUG STORE, *EAST HAMPTON STAR* OFFICE
153 Main Street
George A. Eldredge with John Custis Lawrence, architects
George A. Eldredge, builder
1901; 1906, 1940 alterations

Everett Edwards had this structure built in 1901 to house his pharmacy. George A. Eldridge's design may have been influenced by James Renwick's addition to Clinton Academy which stood just to the north. A contemporary newspaper account noted that the exterior of the store . . . will . . . more nearly resemble a colonial cottage than a business building." The interior furnishings designed by J. C. Lawrence included a ceiling of "opal glass of a green shade, laid in panels," and a white mosaic tile floor. In 1906 the rear of the building was extended to provide room for East Hampton's first central telephone office. In 1940 a second rear addition was built, and Arnold Rattray, publisher of the *East Hampton Star,* moved the newspaper's offices to this site.

Refs.: Rattray, *Main Street,* 116.
 Star, 25 January 1901, 24 October 1935, 4 April 1940.

Photo: Harvey A. Weber

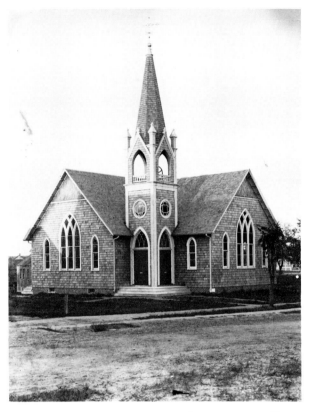

I-232 UNITED METHODIST CHURCH OF EAST HAMPTON
35 Pantigo Road
A. O. Jones, builder
1901

The Methodist congregation brought a resident pastor to East Hampton in 1894 and renovated the old North End school house, known as the Eelpot, for their first church. This new church was built on the same site in 1901. The Eelpot was moved to the back of the lot and in 1960 was moved again to Amagansett.

Refs.: Rattray, *Fifty Years,* 149.
 Rattray, *Main Street,* 63.
 Star, 9 November 1950.

Photo: Courtesy of the *East Hampton Star.*

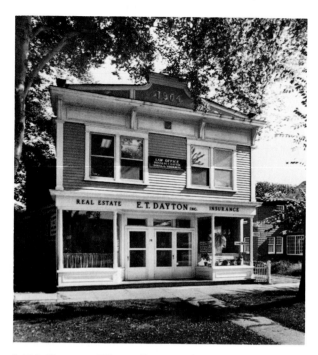

I-233 GEORGE HAND BUILDING
78 Main Street
John Custis Lawrence, architect
1904

Refs.: *Star,* 26 February 1904.

Photo: Harvey A. Weber.

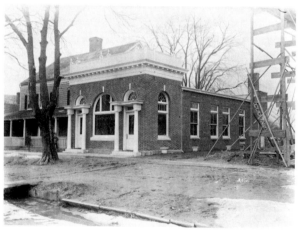

I-234 EAST HAMPTON POST OFFICE
41 Main Street
Joseph Greenleaf Thorp, architect
Thomas E. Babcock, builder
1908; later alterations

The East Hampton Post Office was located on this site in a north wing of the Parsons House by 1894. The wing was destroyed in the fire of 1907, and Postmaster S. C. Parsons hired J. G. Thorp to design a new post office. A newspaper account noted the new building's "white marble trimmings," which have since been removed. The post office moved to a larger building at 1 Main Street in 1917.

Refs.: Rattray, *Main Street,* 93.
 Star, 23 August 1907, 27 January 1933.

Photo: Courtesy of the *East Hampton Star.*

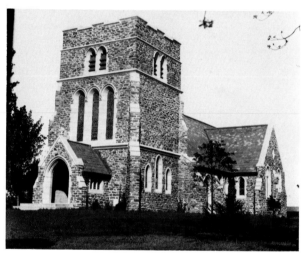

I-235 ST. LUKE'S EPISCOPAL CHURCH
18 James Lane
Thomas Nash, architect
1909–10

The first Episcopal services in East Hampton were held in Clinton Academy in 1855, and three years later a small frame church was constructed to house the congregation. Many summer residents belonged to this church, and the building was enlarged during the 1880s to meet the needs of an expanding membership. In 1910 the frame building was replaced by the larger stone structure seen today.

Refs.: *Architecture* (September 1912): 167–69.
 Star, 17 June 1910, 24 October 1935.

Photo: Courtesy of the *East Hampton Star.*

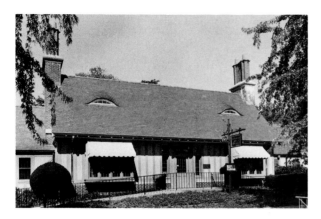

I-236 EAST HAMPTON FREE LIBRARY
159 Main Street
Aymar Embury II, architect
1910–11; 1930, 1946, 1953, 1963, 1967, 1976 alterations

With the donation of books and funds from Mrs. Everett Herrick, Mrs. Lorenzo G. Woodhouse, and Charles G. Thompson, adding to a small collection already assembled at the home of Mr. and Mrs. John D. Hedges, the Free Library was founded and located in Clinton Hall in 1897. The East Hampton Library Company, also a private association established early in the nineteenth century, had become inactive by this time and in 1900 disbanded and donated their books and papers to the new library. In 1911, Mr. and Mrs. Lorenzo E. Woodhouse (see I-171) purchased the present site, and the Library building, the Woodhouses' gift to the community, was begun. Aymar Embury II submitted three designs for the structure and this Elizabethan Style building was selected.

The Library has been enlarged several times as follows: Cloister, Board Room, and Gardiner Memorial Room added in 1930, Aymar Embury II, architect; Gertrude Mumford Memorial Room added in 1946, Aymar Embury II, architect; Hedges Room added in 1953, Aymar Embury II, architect; Dorothy Quick Room added in 1963, Aymar Embury II and Edward C. Embury, architects; the Stack Room added in 1967, Arthur Newman, architect; the Rattray Wing added in 1976, Alfred Scheffer, architect.

Refs.: *Architecture* (15 April 1911): 51–53.
 The Brickbuilder (February 1913): plates 28, 29.
 "The East Hampton Free Library, 1897–1962," EHFL.
 Star, 24 October 1935.

Photo: Harvey A. Weber.

I-237 VETAULT FLOWERS
89 Newtown Lane
Joseph Greenleaf Thorp, architect (attributed)
1927–29

Photo: Harvey A. Weber.

I-238 POST OFFICE AND SHOPS
46–50 Newtown Lane
Robert Tappan, architect
1927–29

Refs.: *American Architect* (March 1934): 65.

Photo: Samuel Gottscho, *American Architect,* March 1934.

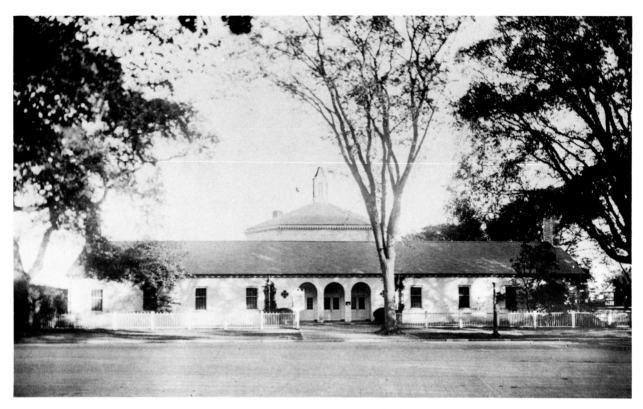

I-239 GUILD HALL
156 Main Street
Aymar Embury II, architect
Frank B. Smith, builder
1930–31; 1971 alterations

The construction of Guild Hall, a museum and theatre complex, was a logical development in the growth of East Hampton's artistic and cultural community. The center was made possible through the generosity of Mrs. Lorenzo E. Woodhouse, who donated the site and a building fund to the community in 1930. Included among her many philanthropic acts in East Hampton were the construction of the Library in 1912 and the restoration of Clinton Academy in 1921. That restoration required the destruction of the Renwick-designed addition, which housed an auditorium for cultural events, a loss which reportedly led to Mrs. Woodhouse's decision to provide the community with another cultural center. Many other residents subscribed to the building fund which Mrs. Woodhouse established, and the structure, designed by Aymar Embury II, was dedicated on August 19, 1931. The Charles Dewey wing, which significantly enlarged the building, was designed by Arthur Newman of Bridgehampton and completed in 1971.

Refs.: Rattray, *Fifty Years,* 154.
 Rattray, *Main Street,* 28.
 Star, 26 September 1930, 10 October 1930, 17 November 1930, 19 December 1930, 2 January 1931, 6 February 1931, 7 August 1931, 21 August 1931, 20 August 1981.

Photo: Courtesy of the East Hampton Free Library.

Index

References to illustrations are printed in boldface type.

Index to Buildings

Adams (Charles H.) house, **70**, **80**, 81, **167**
Alcott (Clarence F.) house, **103**, **192**
Apaquoque, The, **212**, 213
Appleton (Robert) house, 106, **107**, **195**
Aspinwall (Lawrence) house, **186**
Avery (E.S.), house, **191**
Babcock (William H.) house, 23, **137**
Baker (John T.) house, **187**
Barnes (Nathan Conklin) house, **151**, 152
Barnes (Noah) house, 29, **140**
Barnes (William) house, 22, 23, 54n, **136**, 137
Barns (Norman) house, **175**
Beardsley house, **92**
Beecher (Lyman) house, 49, **142**
Bell (J. Finley) house, **171**
Bell (W.T.) house, **186**
Benjamin (W.W.) house, 81, **184**
Bennett (William) house, 46, **47**, **155**
Bishop (Louis Faugeres) house, 200
Blakeman (Mrs. E.A.) house, **88**, **183**
Blinken (Donald) house, **204**
Bowne (Robert Southgate) house, 78, **165**
Bozzi (Bruce) house, **206**
Bradley (Andrew C.) house, **181**
Bross house, 125, **205**
Bunshaft (Gordon) house, **119**, 121, **203**
Butler, (Howard Russell) house, **82**, 85, **169**
Camman (George P.) house, **179**
Campbell (Nathaniel A.) house, **200**
Carson (William M.) house, **70**, **75**, 92, **94**, **179**, 180
Chalet, The, **163**
Chalif house, 125, **203**
Chauncey house, 118

Clinton Academy, **32**, 33, **40**, **66**, 68, **208**
Cockcroft (Edward T.) house, **101**, 103, **187**
Cody (Frederick) house, 101, **199**
Cogan (Marshall) house, **121**, 122, **204**
Congress Hall. *See* David B. Mulford house
Conklin-Eldredge house, 30, **144**
Cook (Harry F.) house, **201**
Coppell (Herbert) house, 116, **196**
Corbel Property house, **206**
Culver's Bathing Pavilion, **214**
Davies (F.H.) house, **81**, **177**
Dayton (C.S.) house, **190**
Dayton (John) house, **31**, **144**
Dayton (Jonathan) house, 35, **36**, **146**
Dayton (Josiah) house, **42**, **148**, 149
Dayton (Miller) house, **36**, 37, **147**
de Kay (Charles) house, **120**, 121
DeRose (Edward) house. *See* Jeremiah Miller house
DeRose (Edward) windmill cottage, **65**, **164**
Dominy house, 20, **21**, **56**
Dominy (W. Tyson) house, **70**, **180**, **187**
Draper (Mrs. William) house, **166**
Drew (John) house, 92, **93**
Dunbar (Arthur T.) house, **71**, **185**
Edwards Drug Store, 78, **215**
Edwards (James) house, **191**
East Hampton Free Library, **99**, 100, **217**
East Hampton Star Office. *See* Edwards Drug Store
Eidlitz (Cyrus L.W.) house, 85, **173**, 174
Eldredge (George) house, **51**, **162**, 163
Eldredge (George A.) house, **183**
Erdmann (John E.) house, 101, **102**, 103, **189**
Evans (Franklin) house, 116, **190**

Everest wagon shop, **213**
Fithian house, 23, **141**
Flannery (John) house, **190**
Flinn (Lawrence) house, **125**, **205**
Gallatin (Frederic) house, 61, **62**
Gallatin (James) house, **165**, 166
Gardiner house, **30**, 31, **144**
Gardiner (David) house, **34**, **145**
Gardiner windmill, **39**, **40**, **209**, 210
Gay (Edward) house, **183**
Gay (James E.) house, 51, **168**
Guild Hall, 114, **218**
Hackstaff (Mrs. C.L.) house, **70**, 88, **177**
Hand (George) building, **216**
Hand (J.W.) house, **175**
Hastings (Harriet) house, **188**
Hayground windmill, **211**
Hedges (Henry D.) house, **185**
Hedges Inn. *See* John D. Hedges house
Hedges (Isaac) house, **22**, **136**
Hedges (Jacob) house, **43**, 44, 45, **150**
Hedges (John D.) house, **159**
Hedges (Stafford) house, 45, **150**
Hedges (Stephen) house, 50, **51**, **157**
Hedges (William) house, 54*n*, 146
Helm (John E.) house, **194**
Herrick (Everett) house, **68**, 69, 75, **165**
Herter (Albert) house, 108, **109**, 110, **176**
Hobart-Mulford house. *See* Mulford house
Hoffman (David) house, 121, **203**, 204
Hollister (Frederick K.) house, first, **100**, **188**
Hollister (Frederick K.) house, fourth, **115**, 116, **195**
Home Sweet Home Museum, 25, **26**, **27**, 29, **136**
Hook windmill, **40**, **210**
Howes (Ezekiel) house, **154**
Huntting (Annie) house, 77, **171**
Huntting (Abraham) house, 43, **149**
Huntting (David) house, 37, **147**
Huntting Inn. *See* Nathaniel Huntting House
Huntting (James E.) house, **173**
Huntting (Nathaniel) house, **14**, **134**
Hutchinson (Samuel) house, 22, **138**, 139
Ireland house, **70**, **75**
Isaacs (Horace) house, 47, 48, **152**
Isaacs (Thomas S.) house, 48, **152**
James (Ellery) house, 104, **105**, **106**, **198**
Jefferys (C.P.B.) house, 61, **63**, 159
Jenney (William S.) house, **104**, **197**
Johnson (S. Fisher) house, second, **172**
Johnson (S. Fisher) house, third, **172**
Johnson (S. Fisher) house, fourth, **70**, **84**, 85, **86**, **185**, 186
Jones house, **45**, 46, **155**

Jones (Ezekiel) house, 44, 45, **151**
Jones (Talmage) house, 45, **151**
King (Hamilton) house, 100, **196**, 197
King (John) house, **176**
King (William) house, **158**
Krech (Shepard) house, 118, **201**
Lamont (George) house, **189**
Lanterns, The, **70**, **187**
Lardner (Ring) house, **200**
Lawrence (John Custis) house, **177**
Lee (Ulysses) house, **182**
Lloyds (Richard) house, **205**
Lockwood Villa, **89**, 90
Lyon (Marvin) house, **178**
McCall (Everett) house, **91**, 200
MacKay (W.R.) house, **60**, **161**
McLeod (James B.) house, **59**, 60, **61**, **162**
Maidstone Arms Inn. *See* William L.H. Osborn house
Maidstone Clubhouse, first, **76**, 197
Maidstone Clubhouse, second, 76, **77**, 197
Maidstone Clubhouse, third, **106**, **197**
Maidstone Inn, **39**, 76, **77**
Main Beach Pavilion. *See* Culver's Bathing Pavilion
Mayo (Mary) house, **196**
Meeting House. *See* Presbyterian Meeting House
Mercer (Norman) house, 124, 125, **205**
Mershon (Stephen) house, 60, **70**, **158**
Mill Cottage, **141**
Miller house, **28**, **29**, 30, **143**
Miller (Dudley) house, 124, **202**, 203
Miller (Isaac W.) house, **23**, **139**
Miller (Jeremiah) house, 34, **35**, **65**, 67, **90**, **145**
Miller-Poor house, **97**, 98, **139**
Moran (Thomas) house, **64**, 67, **164**
Most Holy Trinity Church. *See* Saint Philomena's Church
Motherwell (Robert) house, **118**, 119, 120, **201**, 202
Mulford house, **15**, 16, **59**, **134**
Mulford (David B.) house, **143**
Mulford (Edward) house, **41**, **148**
Mulford (James P.) house, 43, **148**
Mulford (Jeremiah) house, 50, **157**
Mulford (Samuel G.) house, **150**, 151
Mulford (Timothy) house, **142**
Mulford-Huntting house, 14, 15, 116, **135**
Munroe (George E.) house, 69, **74**, 75, **165**
Nash (Thomas) house, **70**, 92, 94, **95**, **181**
Nesbit (Mrs. R.W.) house, **174**
Newton (Francis) house, 88, 90, **188**
Newton (R. Heber) house, **82**, 84, 85
Nugent (Paul) house, **199**
Oakley (Lawrence) house, **115**, 116, **198**

Odd Fellows Hall, 128*n*, **214**
Ogden (Clara F.) house, 78, **79**, **176**
Osborn house, 23, **138**
Osborn (Daniel) house, 37, **147**
Osborn (Isaac S.) house, **155**
Osborn (Jonathan) house, Main Street, **138**
Osborn (Jonathan) house, Mill Hill Lane, 21, **22**, **140**
Osborn (Joseph) house, 22, **140**
Osborn (William L.H.) house, **48**, 49, **153**
Osborne (Mrs. B.M.) house, **186**
Osborne (Charles) house, **154**
Osborne (Joseph S.) house, **175**
Osborne Office, 23, **24**, 25, **137**
Pantigo windmill, 38, **40**, **209**, **210**
Pardue house, **202**
Parsons (Sylvanus) house, 43
Paxton (John R.) house, first, **161**
Paxton (John R.) house, second, 84, 85, **182**
Phillips (F. Stanhope) house, first, **174**
Phillips (F. Stanhope) house, second, 78, **191**
Post Office (1908), **216**
Post Office and Shops (1927–1929), **217**
Potter (E. Clifford) house, 70, 88, **178**
Potter (Frederick G.) house, first, **70**, 88, **94**, **177**, 178
Potter (Frederick G.) house, second, 88, **187**
Presbyterian Church of East Hampton, First, 51, **52**, **212**
Presbyterian Manse (1836), **47**, 48
Presbyterian Manse (present). *See* Thomas S. Isaacs house
Presbyterian Meeting House, **17**, 18, **40**
Quackenbush (Schuyler) house, first, **70**, 83, 85, **175**
Quackenbush (Schuyler) house, second, **191**, 192
Randell (Mrs. C.B.) house, **187**
Reid (Wallace) house, 114, **194**
Rice (C.C.) house, **110**, 111
Rice (Grantland) house, **199**
Richards (Benjamin) house, 111, **180**
Richey (Alban) house, **172**
Richey (Thomas) house, **170**
Roberts (George) house, **114**, 116, **200**
Rosenberg (Robert) house, 121, **202**
Ross (Fred) house, **184**
Rowdy Hall. *See* Osborn house
Saint Luke's Episcopal Church, 98, 99, **216**
Saint Luke's Episcopal Church, Rectory, **193**
Saint Philomena's Church, **213**
Salembier (Paul) house, **111**, **198**
Salzman (Renny) house, **122**, 123, **204**
Satterthwaite-Thompson house, 61, **62**, **87**, 89, **162**
Schmidt (Max) house, 77, **184**
Schurman (George W.) house, **113**, 194
Schurman (Jacob G.) house, 113, 118

Scull (Robert) house, 121, **203**
Sea Spray Inn, **71**
Sedgwick (Laura) house, **82**, 85, **168**
Session House, **211**
1770 Inn. *See* Jonathan Dayton house
Shepard (Myrtle) house, **201**
Sherrill house, 37, **146**
Simmons (Edward) house, **182**
Skidmore (John D.) house, 77, **78**, **170**
Smith (T.) house, **172**
Smith (Warren G.) house, 70, **166**
Solley house, **117**, 118
Spaeth (Otto) house, first, **123**, **124**, **202**
Spaeth (Otto) house, second, **204**
Stanton (F.L.) house, **193**
Stokes (John D.) house, **181**
Stratton-Dayton house, 19, **135**
Strong (Mrs. George A.) house, **171**
Strong (James Madison) house, **173**
Talmage (Baldwin C.) house, 44, **149**
Talmage (Daniel) house, **160**, 161
Talmage (Mary B.) house, 116, **189**
Talmage (T. DeWitt) house, 59, 60, **160**
Terbell (Henry S.) house, 61, 63, 90, **157**, 158
Terry house, **69**
Thomas (Augustus) house, **183**
Thomas (George) house, **179**
Thompson (David G.) house, 49, **153**
Thorp (Joseph Greenleaf) house, **96**, 98, **168**, 169
Tillinghast (Stafford) house, 51, **163**
Tishman (Peter) house, **206**
Town House, 18, **19**, **208**
Tuthill (Henry B.) house, **153**
United Methodist Church of East Hampton, **215**
Van Brunt (Arthur) house, **188**
Vaughan (Mrs. E.J.) house, **70**, 78, **94**, **168**
Vetault Flowers, **217**
Voorhees (J.D.) house, 101, **190**
Warner (Eltinge) house, 116, **117**, **199**
Wessell house, 78, **79**
Wheelock (William A.) house, 75, **166**, 167
Wheelock (William E.) house, 75, **167**
White (Mrs. W.C.) house, **185**
Wiborg house, **113**
Wickham (Thomas) house, **142**
Woodhouse (Lorenzo E.) bungalow, **192**
Woodhouse (Lorenzo E.) house, **91**
Woodhouse (Lorenzo E.) playhouse, 107, **108**, **193**, 194
Woodhouse (Lorenzo G.) house, 76, **169**
Woodin (William H.) gardener's cottage, **198**
Woodin (William H.) house, **112**, 113, **192**
Worthington (Benjamin) house, **163**

Worthington (Louise) house, first, **180**
Worthington (Louise) house, second, **178**
Youngs (John) house, **154**

Index to Builders

Aldrich, C.H., 167
Aldrich, John, 164, 166, 213
Babcock, Everett, 180
Babcock, Thomas E., 169, 183, 185–88, 216
Breckenridge and Ashby, 184
Breece, R.V., 62, 162
Coburn and Hurst, 212
Dominy, Nathaniel V, 39, 40, 209
Duryea, E.E., 167, 178
Eldredge, George, 30, 45, 144, 154, 157, 160, 162, 208
Eldredge, George A., 78, 81, 139, 158, 160–63, 167–69, 171, 172, 174–79, 181–85, 188, 215
Gay, Edward M., 161, 188–91, 194–96, 198–200, 212
Gillies and Campbell, 193
Glover, Benjamin, 42, 148
Gould, Charles O., 185
Grimshaw, Frank, 162, 169, 170, 172, 176, 183
Halsey, George E., 213
Huntting, James E., 173
Jander, Henry, 179
Johnson, Frank, 198, 200
Jones, A.O., 158, 167, 169, 176, 179, 181, 185, 215
Jones, Lewis, 155
King, John C., 47, 48, 152
L'Hommedieu, James, 165, 166
Loper Brothers, 177
Ritch, Philip, 166, 170, 171, 191
Rogers and Blydenburgh, 197
Schellinger, Samuel, 37, 38, 147, 209
Smith, Frank B., 192, 197–99, 218
Smith and Davis, 188, 189, 190
Street, H.E., 185
Tillinghast, Stafford, 163, 164
Van Orden, Jabez E., 180
Woodhull, Charles, 180

Index to Architects

Albro, Lewis Colt, 100, 104, 196, 197. *See also* Albro and Lindeberg
Albro and Lindeberg, 187–89
Atterbury, Grosvenor, 90, 108, 110, 111, 113, 176, 180, 188, 192, 198

Bedenkapp, John, 204
Bellows, R.S., 143
Bosworth, William Welles, 90, 188
Brady, Walter E., 90, 158, 180, 185
Briggs and Corman, 62, 162
Brookfield, G. Piers, 201
Bullard, Roger, 104, 106, 111, 197, 198
Bunshaft, Gordon, 121, 203
Chadwick, Gordon, 123, 202
Chareau, Pierre, 118, 119, 201
De Vido, Alfredo, 125, 205
Eidlitz, Cyrus L.W., 85, 173–75
Eldredge, George A. *See* Index to Builders
Embury, Aymar, II, 23, 43, 99, 114, 116, 118, 139, 148, 167, 197, 200, 201, 217, 218
Futterman, Eugene, 206
Green, I.H., Jr., 69, 75–78, 81, 87, 145, 164–67, 169–71, 184, 191
Gwathmey, Charles, 121, 204
Hagmann, John S., 205
Hardy, Hugh. *See* Hardy, Holzman and Pfeiffer
Hardy, Holzman and Pfeiffer, 204
Hoffman, F. Burrall, 107, 193
Jackson, Arthur C., 113, 118, 194, 201
Jaffe, Norman, 205
LaFarge, L. Bancel, 200
Lawrence, John Custis, 78, 81, 88, 101, 116, 162, 166, 172, 177, 184–96, 198, 199, 208, 215, 216
Lindeberg, Harrie T., 100, 101, 103, 104, 108, 192. *See also* Albro and Lindeberg
Lord, James Brown, 92
McKim, Mead and White, 89, 162
Mayers and Schiff, 206
Meier, Richard, 121, 123, 203, 204
Nash, Thomas, 94, 99, 181, 193, 216
Nelson, George, 123, 202
Neski, Barbara, 125, 203
Neski, Julian, 125, 203
Newman, Arthur, 52, 212, 217, 218
Newman, Frank E., 107, 195
Perry, E. Ritzema, 172, 201
Polhemus and Coffin, 104, 197
Renwick, James Jr., 61, 68, 208
Robertson, Jaquelin, 125, 205
Rosenberg, Robert, 121, 202
Scheffer, Alfred, 202, 217
Short, William, 124, 202
Siegal, Robert, 121, 204
Stern, Robert A.M., 125, 167, 169, 181, 205, 206
Strom, William, 92
Talmage, Mary B., 116, 148, 189
Tappan, Robert, 116, 196, 199, 200, 217
Thorp, Joseph Greenleaf, 81, 85, 86, 88, 91, 92, 98,

113, 116, 135, 138, 139, 141, 145, 160, 161, 166, 168, 169, 172, 174, 177, 178, 181, 182, 187, 190, 199, 208, 214, 216, 217
Truscott, Arthur, 113, 194

Tuthill, William B., 81, 82, 167
Venturi, Robert, 124, 202
Weiner, Paul Lester, 121, 203
Weston, Theodore, 171

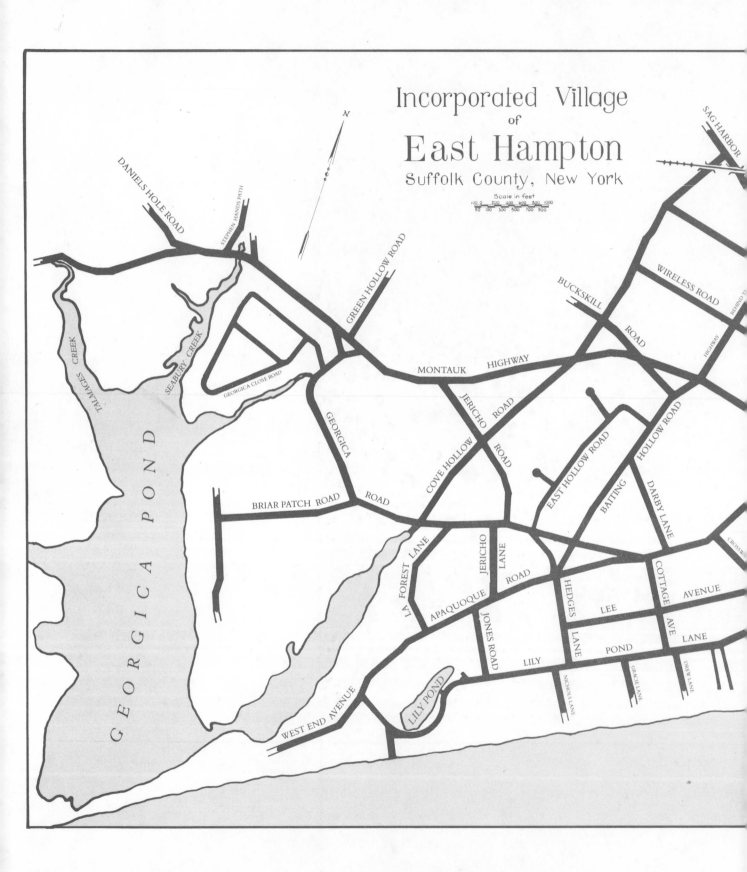

Incorporated Village
of
East Hampton
Suffolk County, New York

Scale in feet